K9-5

NEW YORK DOGS AT WORK

To Mickey —

Enjoy!

Mele K

PHOTOGRAPHS BY MICHELLE ROSE

PRODUCED BY KELLY KOESTER PREFACE BY BASHKIM DIBRA

POINTED LEAF PRESS

CONTENTS

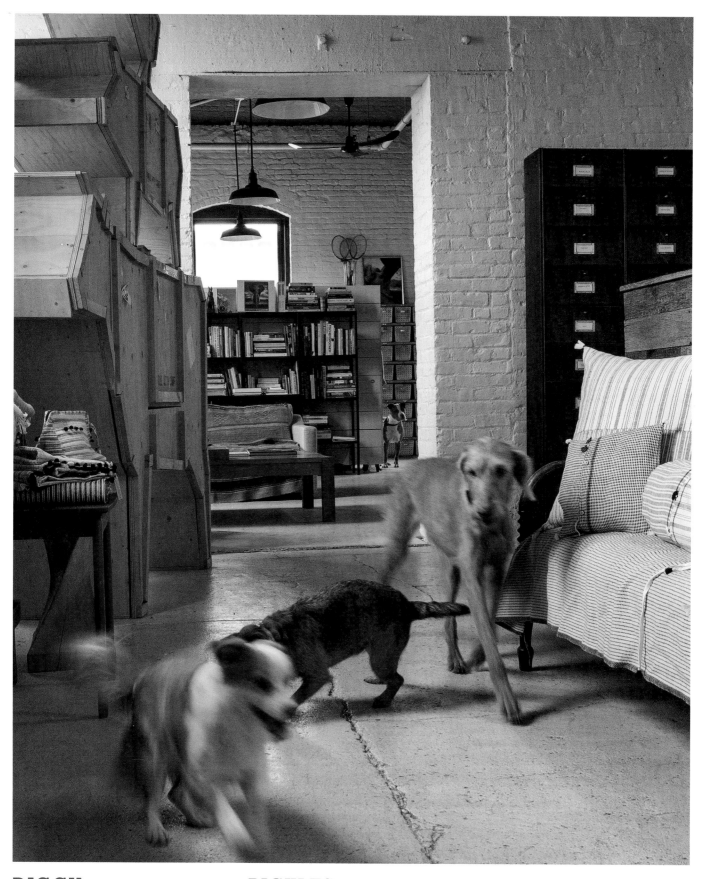

DIGGY, PITBULL, 3 YEARS OLD, *TOP* **PICKLES**, JACK RUSSELL TERRIER / AUSTRALIAN SHEPHERD /
DACHSHUND MIX, 2 YEARS OLD, *ABOVE LEFT* **PIPPA**, BORDER TERRIER, 3 YEARS OLD, *ABOVE CENTER*
EDIE, WIRE HAIRED LISZLA, 7 YEARS OLD, *ABOVE RIGHT*
AESTHETIC MOVEMENT, CREATIVE CONSULTANCY & REPRESENTATION FIRM, LONG ISLAND CITY

PREFACE

K9-5: New York Dogs at Work is an exquisite celebration, both intimate and exuberant, of the human–animal bond, and the very special place our companion animals hold, not only in our hearts and homes, but in our workplaces, as well.

Since time immemorial, the dog has been the only species that has chosen to separate himself from his own pack, and to live and work alongside mankind. From the earliest days of hunting-gathering and sharing food and fire, dogs have stoically and unflinchingly protected our homes and cities, ranches and livestock, and served in our military, police force, and fire departments. And in the infancy of the new millennium, courageous search-and-rescue dogs have proved themselves an integral force in disaster preparedness. And yet, despite their frequent (and deservedly so) headline-grabbing heroism on the world stage, it is their silent valor in the one-on-one "pack of two" working relationships they share with us that dogs really shine. They guide the blind and the hearing impaired, and as service dogs they uplift us from the confines of catastrophic physical disabilities. But it is perhaps when they serve as therapy dogs that we have finally discovered the role the dog was born to play in our lives, both personally and professionally—the niche the dog was destined to fill in our hearts, homes, and workplaces. For it is in the dog's God given talent—to nurture us through our shortcomings, soothe our tumultuous anxieties, sustain us through paralyzing fears, and rescue us from our human frailties—that we have found man's best friend's true and intrinsic calling. And what better qualities to put before "human resources" in looking for a business partner?

Indeed, in the pages of *K9-5* you'll find that the crème de la crème of New York's most successful and creative entrepreneurs and executives have done just that, and "hired" their dogs! Michelle Rose's beautiful photographs provide readers a rare and privileged glimpse into the upper echelons of businesses where chic, sophistication, and avant-garde have taken a back seat to the revealing revels of dogs in their masters' and mistresses' workplaces. And why not?

In the past century, as the industrial revolution and then the technology revolution expanded exponentially, and more Americans followed jobs from the country to the city, the environment of the once-"average" American workplace may have changed from farming, ranching, and agriculture, but the character of the dog that made him such an invaluable work partner in America's heartland has remained constant, and integrates beautifully into today's urbane workforce of arts and sciences. Indeed, the quaint (and now archaic) Classified job listings of the past for "blue collar" (labor,

men only), "white collar" (office, just men, usually) and "pink collar" (women only) would be immediately redeemed if the collars they were looking for were worn by dogs with employee ID tags!

I am blessed, in that my avocation is my vocation. My passion is dogs, and my trade is that of a dog trainer. So dogs are always in my workplace. But many of the dogs I train are professional "actors," and when we arrive, dogs in tow, on the set of a movie, television show or commercial, print advertisement or music video, the prevailing mood amongst the cast and crew never fails to brighten considerably and energize the entire production. Admittedly, I am biased, but the rousingly positive reinforcement from the casts and crews, film- and art directors that I have worked with overwhelmingly confirm what science has finally noted, from anecdotal to a data-driven standard: Dogs do have a measurable impact on healing the human condition.

It is in this way that *K9-5* beautifully illustrates how dogs—with their non-judgmental, unconditional love, team spirit, sense of humor, and the ability to lower blood pressure among "co-workers"—can immediately transform any workplace into an "executive retreat." Indeed, I can safely say that the addition of the dog to the workplace is the ultimate office feng shui.

Finally, dogs inspire us; they "speak" to us. Whether your workplace is within a large company, warehouse, studio or home office, the shared, intangible symbiosis between us and our dogs reaps very tangible benefits for both people and pets. Many years ago, I was privileged to raise and train a grey wolf cub I named Mariah for the Children's Educational Television. Wordsworth famously noted that "the child is father of the man," and just as the wolf is the "father" of the modern domesticated dog, I was also in my infancy as a trainer when I trained Mariah. I was a child to her cub, learning as much from her as she from me. She became my "muse." And although she had a vast and varied career in the entertainment industry, her greatest accomplishment was being named the Goodwill Ambassador for the 1984 Winter Olympics and championing humane education all across the country.

Your dog, too, can be your muse, inspiring you to work harder, play heartier, and, above all, to seize the day. I often say that all dogs are "diamonds in the ruff," and, with a little "polishing," can shine like stars anywhere, anytime, including the workplace. *K9-5: New York Dogs at Work* is a treasured addition to my library, and should be an inspiring addition to yours.—BASHKIM DIBRA

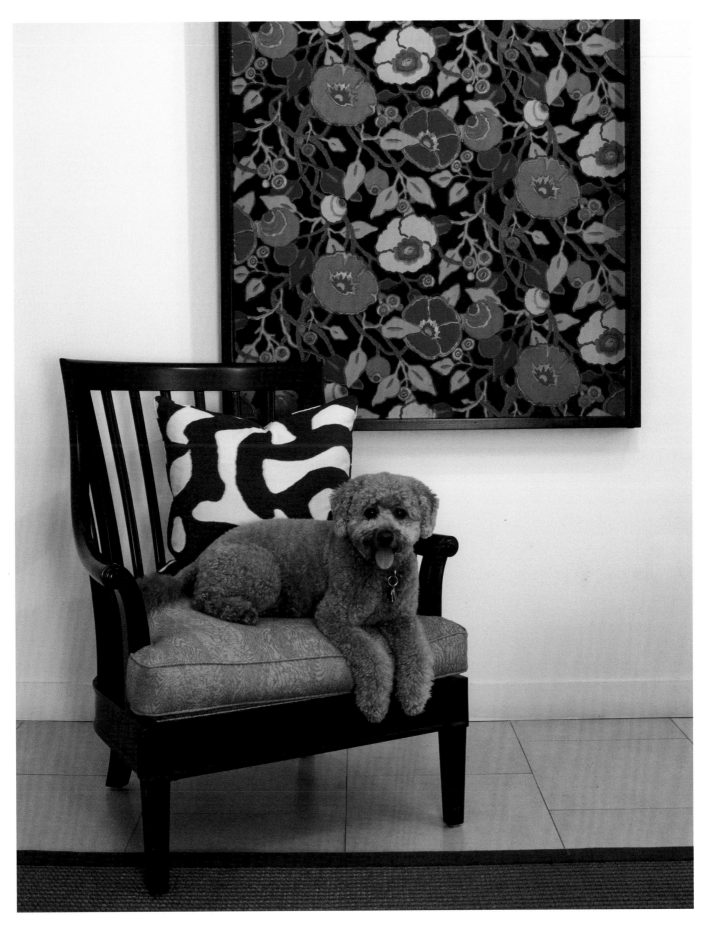

OSKAR, MINI AUSTRALIAN LABRADOODLE, 5 YEARS OLD
JED JOHNSON ASSOCIATES, INTERIOR DESIGN, TRIBECA

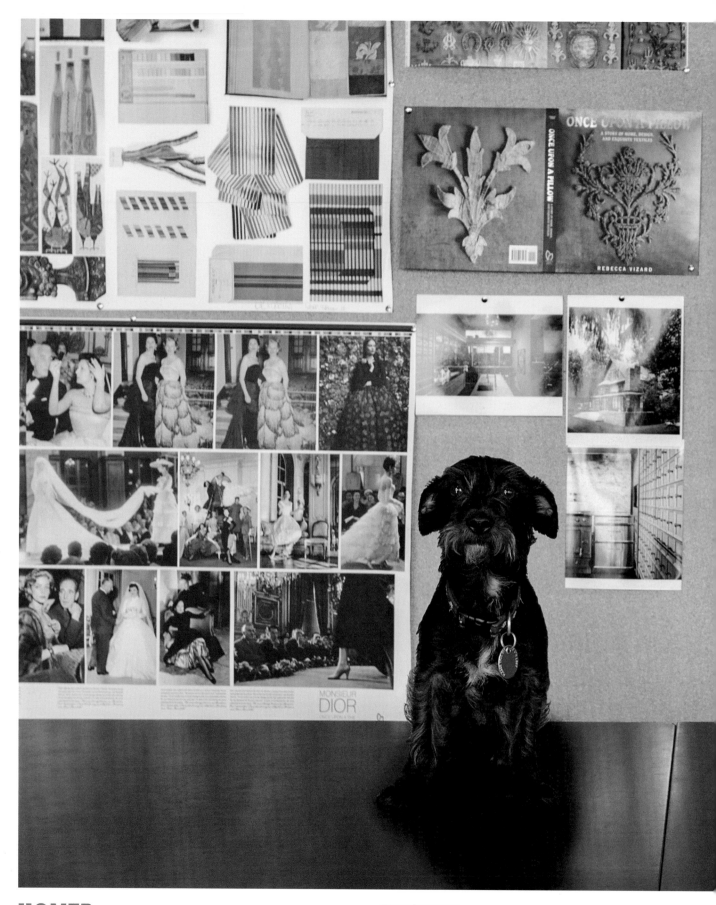

HOMER, TERRIER / DACHSHUND MIX, 3 YEARS OLD, *ABOVE* HESTER, CAIRN TERRIER, 6 YEARS OLD,
OPPOSITE LEFT BAMBOLA, MINI LONG HAIRED DACHSHUND, 8 YEARS OLD, *OPPOSITE RIGHT*
POINTED LEAF PRESS LLC., PUBLISHERS, CHINATOWN

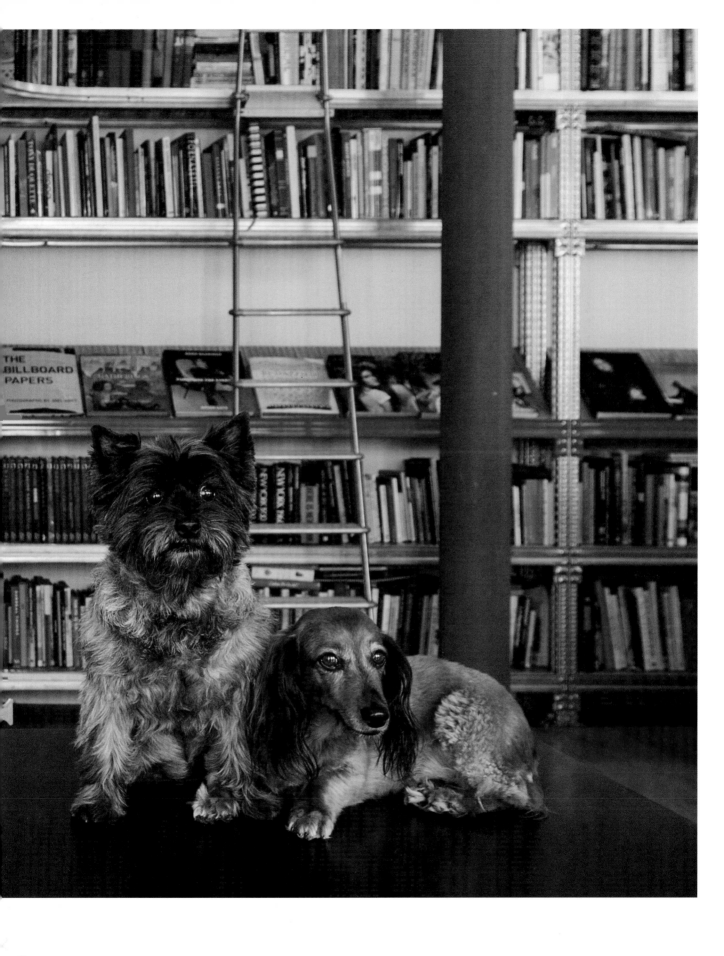

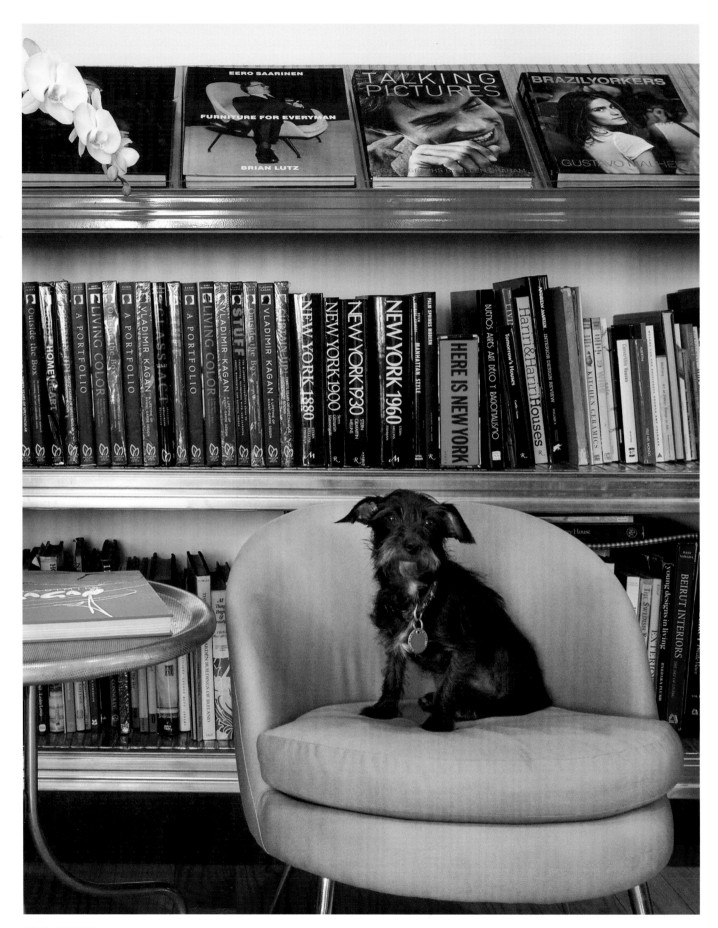

HOMER, TERRIER / DACHSHUND MIX, 3 YEARS OLD
POINTED LEAF PRESS LLC., PUBLISHERS, CHINATOWN

9–5: WHAT A WAY TO MAKE A LIVIN'

Being left at home. That's bad news for most dogs whose owners must do just that when they go to work. But some New Yorkers (pets and people) are lucky. They can actually spend the day together in work spaces that run the gamut, from glamorous high-rise office buildings, to spacious loft spaces, to gorgeous art galleries—most of which illustrate Mel Brooks' famous dictum in his *Silent Movie*, by being "nicer than most people's homes."

At Pointed Leaf Press, a small, independent publishing house located in Chinatown, we are part of a fortunate group that spends their workday in the company of their dogs: Hester, a 6-year-old Cairn terrier, and Bambola, an 8-year-old long haired dachshund and, sometimes, Homer, an about-3-year-old rescue terrier/dachshund mix who divides his time between New York and Cambridge, Massachusetts.

They pretty much all ignore each other, except for when a ball flies through the air, or when lunch is delivered.

The idea for this book came to us last winter—after we came back from a meeting at an office where seven dogs of all shapes and sizes were running or lounging about. We noticed how this was a happy madhouse. We called our friend, Michelle Rose, a talented photographer whom we convinced to spend the next ten months working on *K9–5: New York Dogs at Work*.

So off we went, trekking all over the city, from midtown Manhattan to way out in Queens—to see how dogs spent their days in beautifully designed—of course—interior design offices and grittier artists' studios, including a civil rights law office, a hair salon, a television studio, and lots and lots of other different workplaces in between. Needless to say, many of these offices revolved around their canine "employees." There were dog bowls and

stuffed toys, treats, dog beds, and special pillows everywhere. We had fun and so did they—as their proud owners plied them with treat after treat and endearing words of encouragement.

We learned that Boo, a 3-year-old Great Dane, *page 117*, has a certificate that allows him to travel on the subway, his usual work commute; that Teddy, a 12-year-old Yorkshire Terrier, *page 36*, dons a custom-made Burberry raincoat before he's exposed to inclement weather; that Oskar, a 5-year-old Miniature Australian Labradoodle, *page 106*, divides his work days between his two dads, at an interior design firm and a career consulting office; that Kweli, an 11-year-old Chow-Shepherd-Golden Collie Mix, *page 133*, has been going to work every day for over 10 years at *The Daily Show*; that, even though Sydney, a 13-year-old Double Dappled Dachshund, *page 34*, is blind, he can deftly navigate the designer furniture showroom, aided by the voice of his "mama"; and that Rocky, an 11-year-old Dandie Dinmont Terrier, *page 160*, spends his days in a gallery surrounded by Old Master paintings of high-society purebreds. Some dogs had more responsibility than others—like Nelly, Dakota, and Niko, who are part of A Fair Shake for Youth, a not-for-profit organization that offers Middle School students an opportunity to work, hands-on, with therapy dogs in a structured weekly program. These dogs truly get in a full day's work.

We could not help ourselves being caught up with the personalities of some of our subjects, and the ways they commandeered the workplace—so much so that we assigned them, admittedly kind of arbitrarily, office "positions," from C.E.O. to a member of the oh-so-necessary secretarial pool. Who knows what really transpired around the water cooler—*oops*—we mean the water bowl?

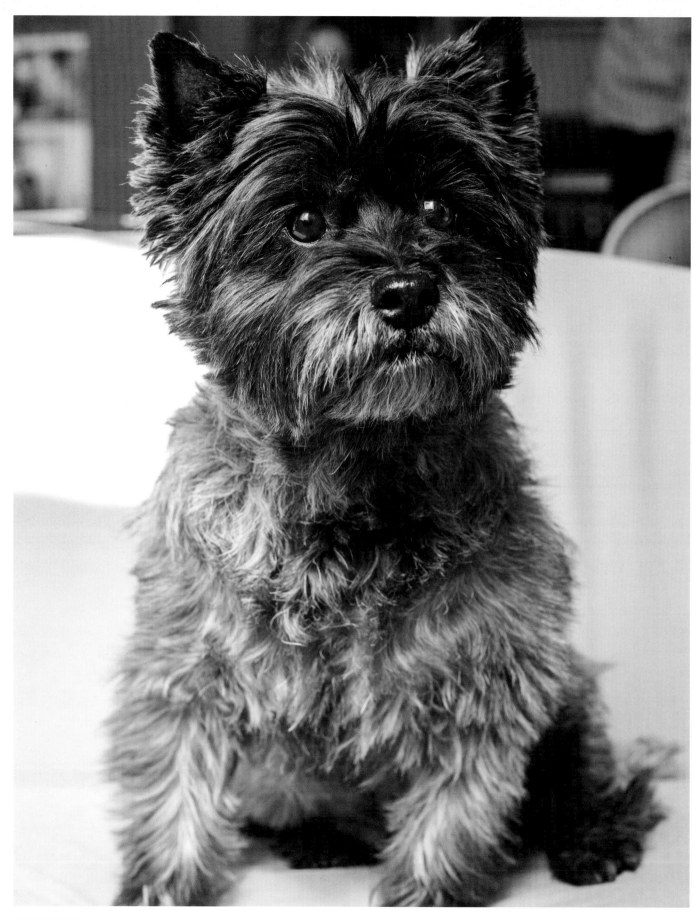

HESTER, CAIRN TERRIER, 6 YEARS OLD
POINTED LEAF PRESS LLC., PUBLISHERS, CHINATOWN

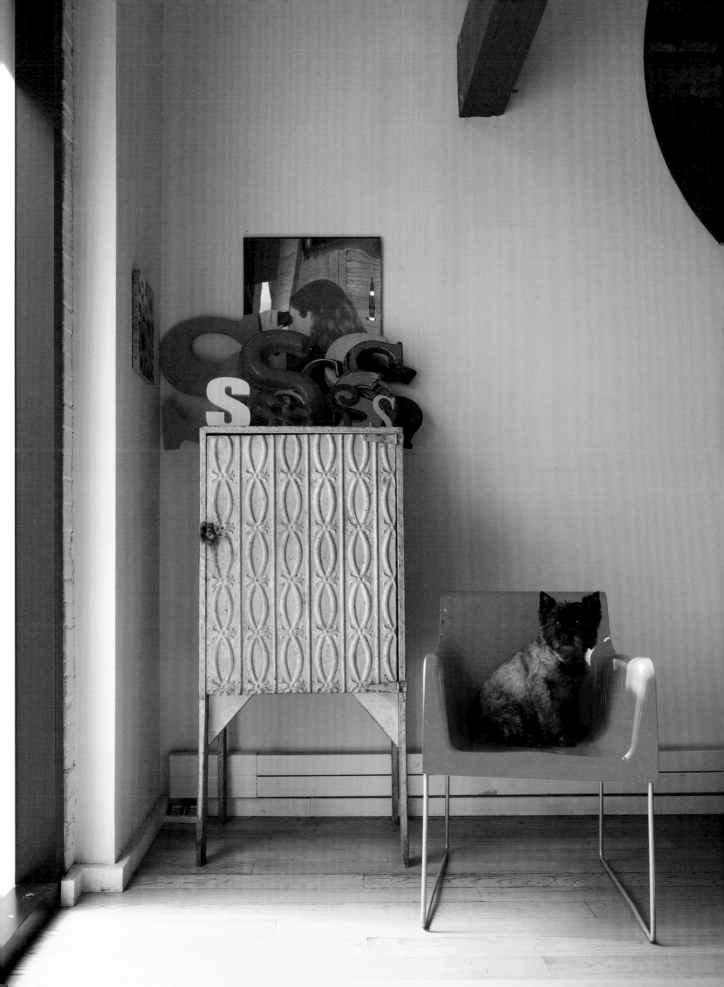

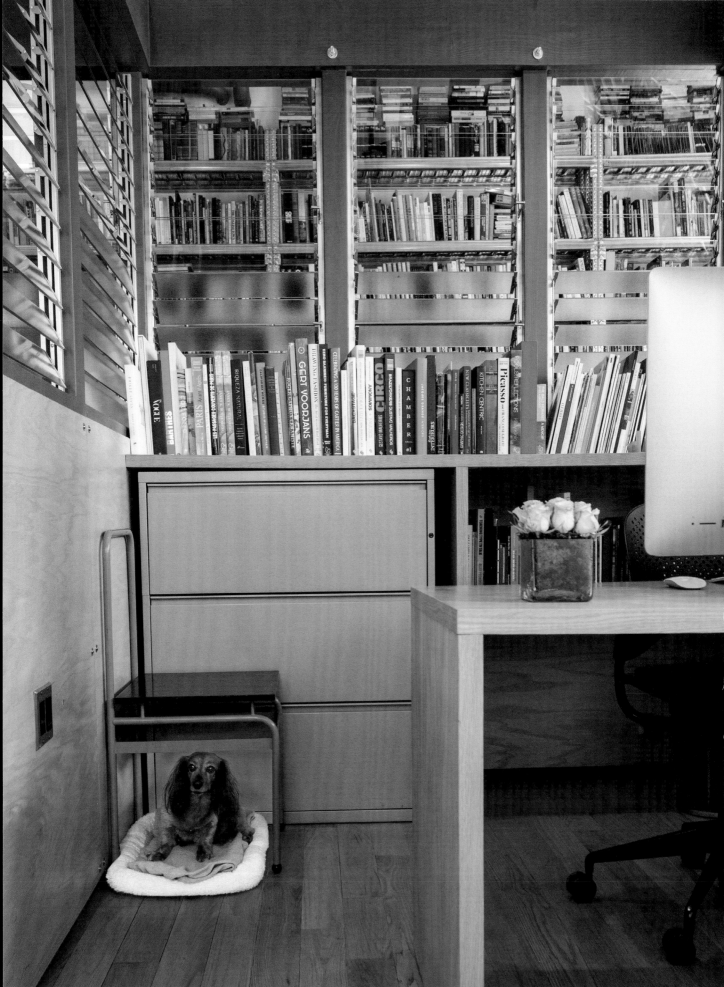

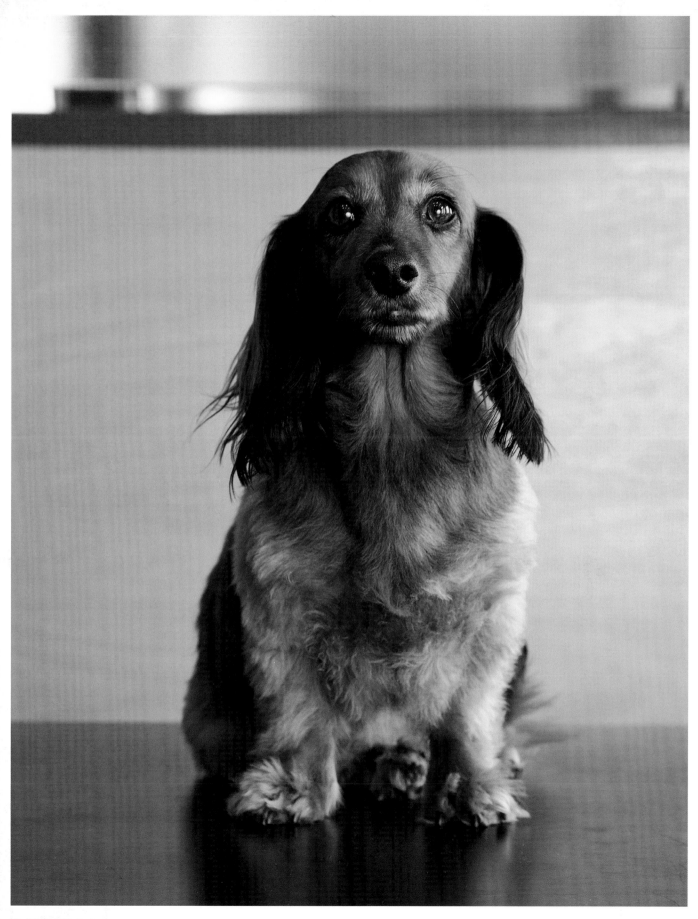

BAMBOLA, MINI LONG HAIRED DACHSHUND, 8 YEARS OLD
POINTED LEAF PRESS LLC., PUBLISHERS, CHINATOWN

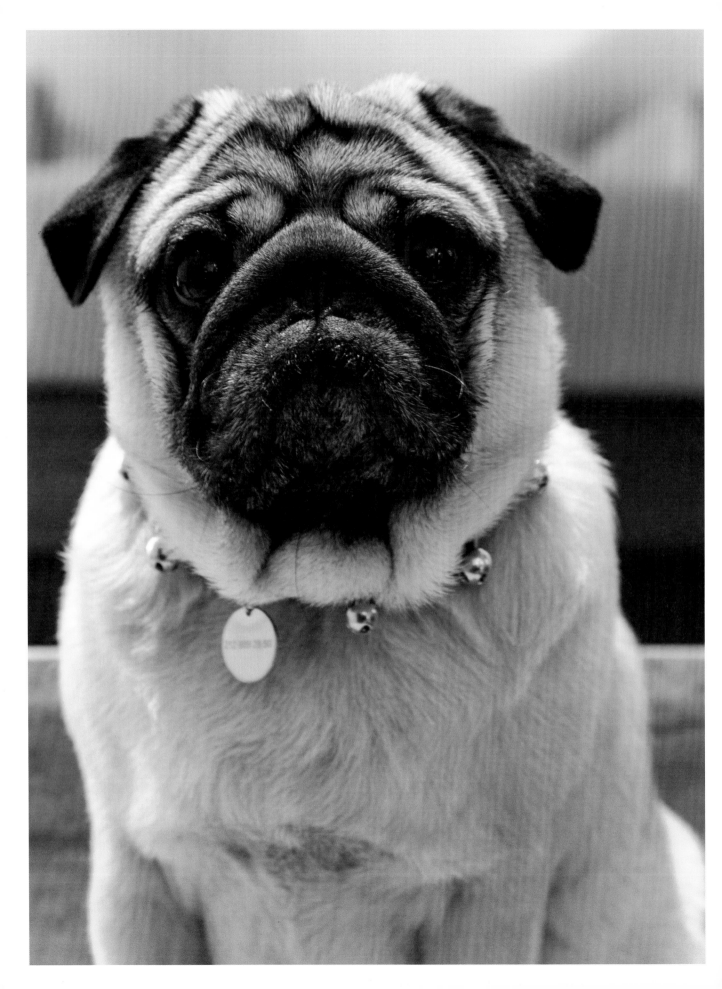

CEOs

HUGO, PUG, 2 YEARS OLD
GARREN NEW YORK, HAIR SALON, MIDTOWN

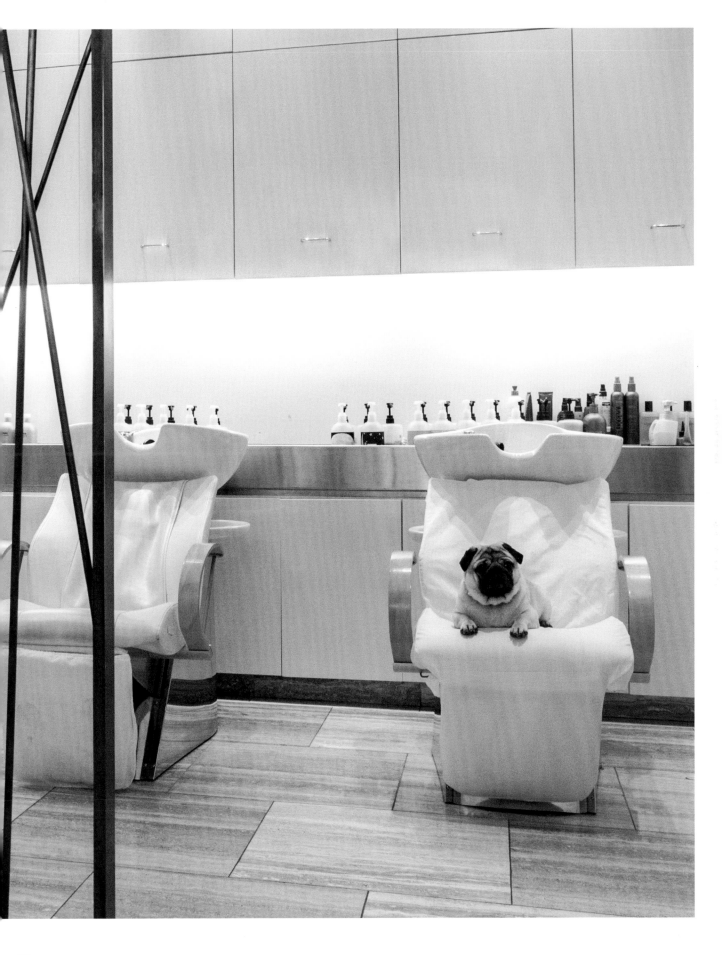

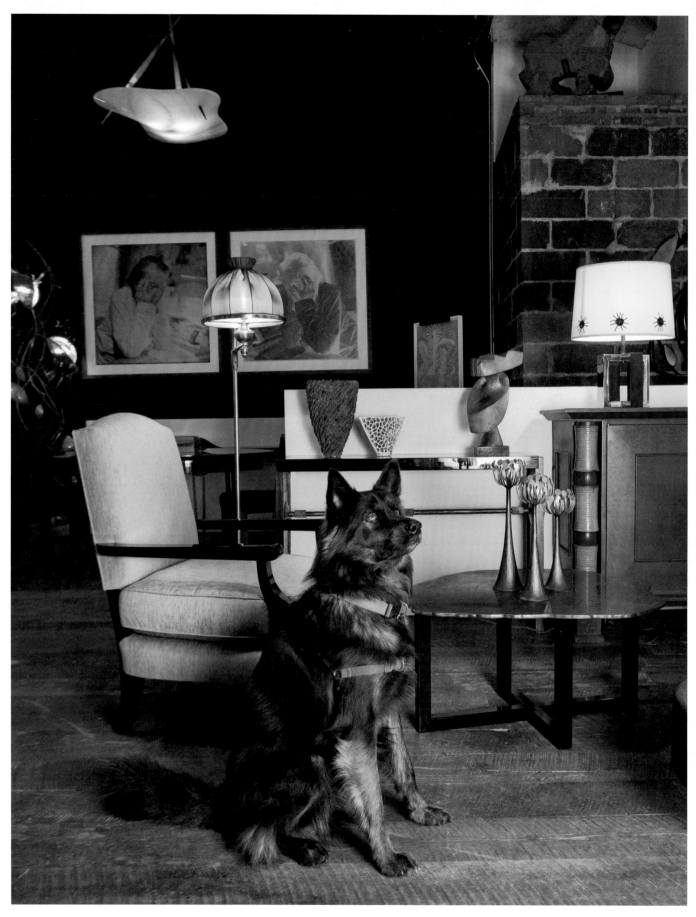

MAXINE, GERMAN SHEPHERD / HUSKY MIX, 3 YEARS OLD
MAISON GERARD, ANTIQUES AND DESIGN GALLERY, GREENWICH VILLAGE

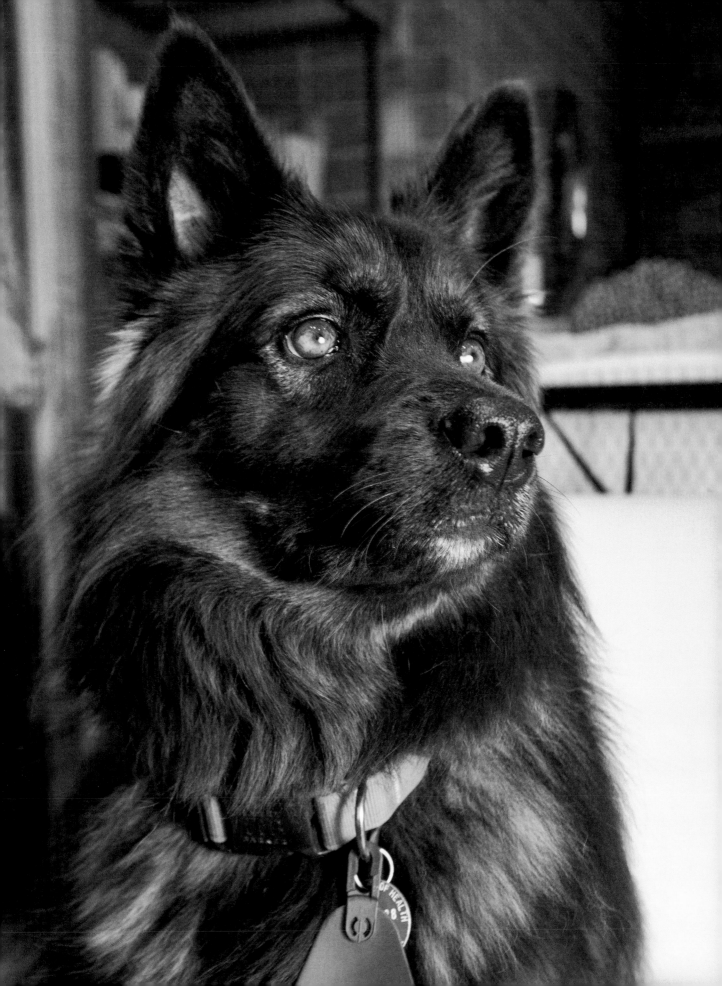

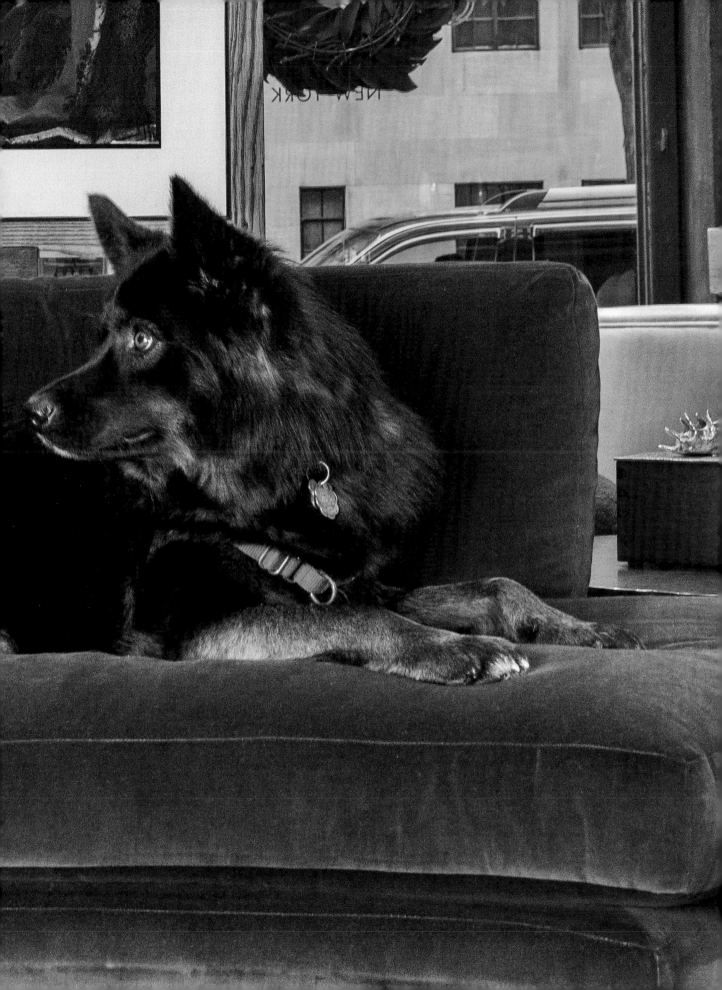

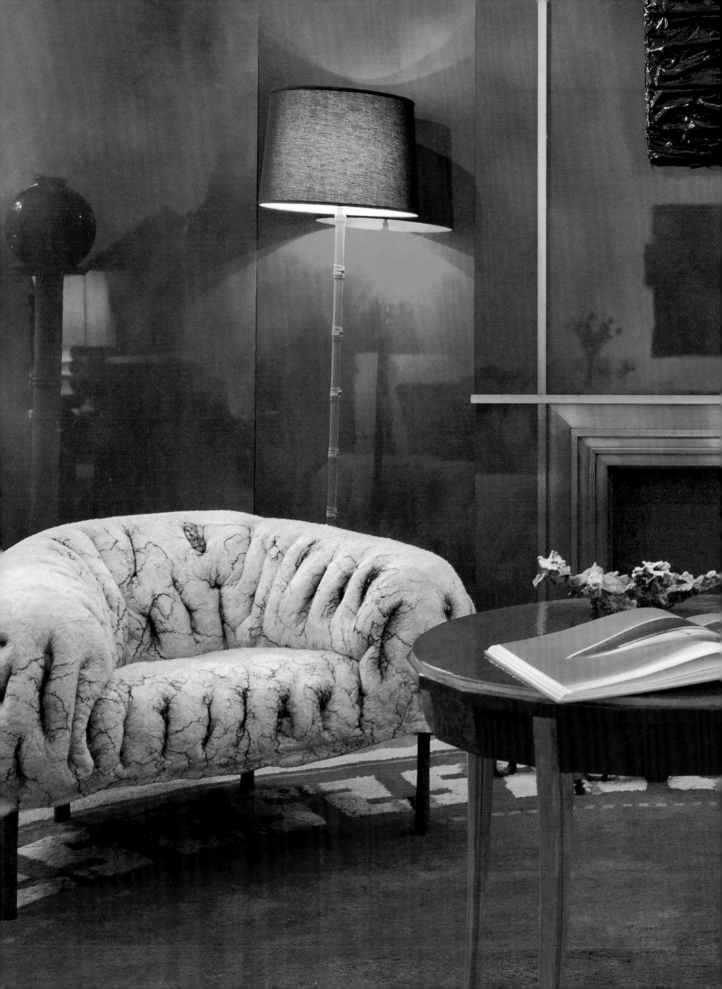

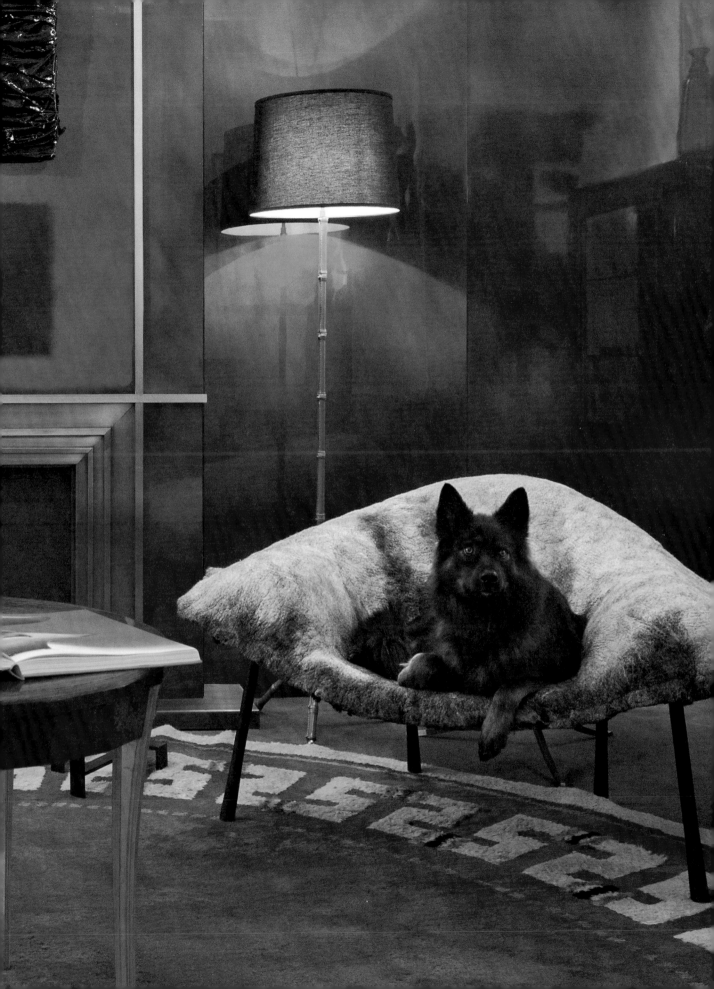

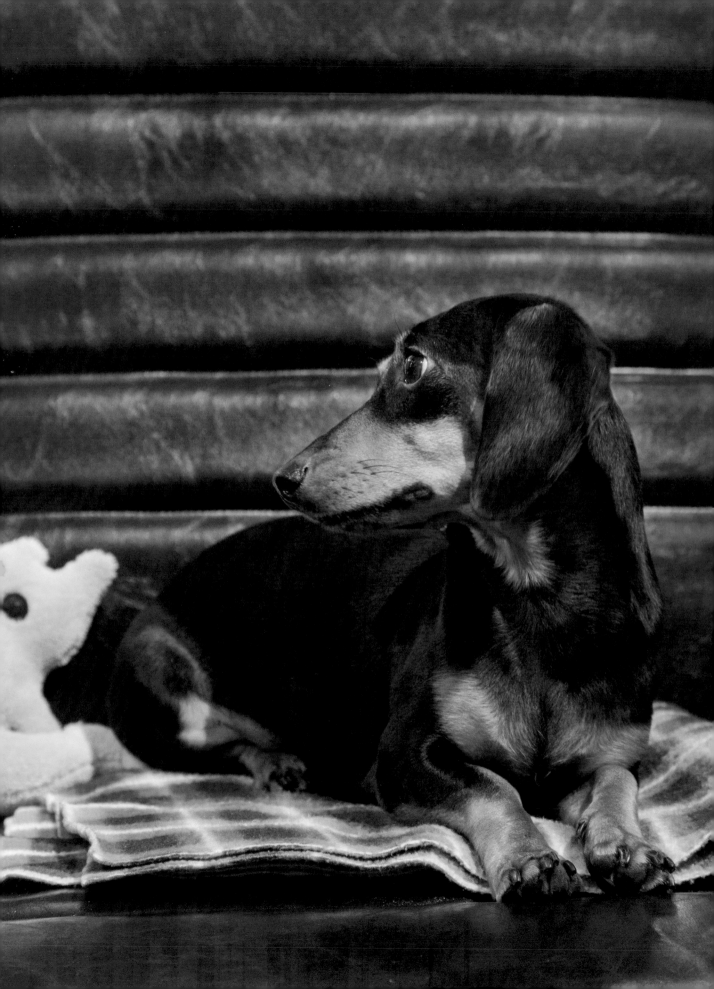

BAILEY, MINI SMOOTH HAIRED DACHSHUND, 3 YEARS OLD
SCOTT SANDERS LLC, INTERIOR DESIGN FIRM, CHELSEA

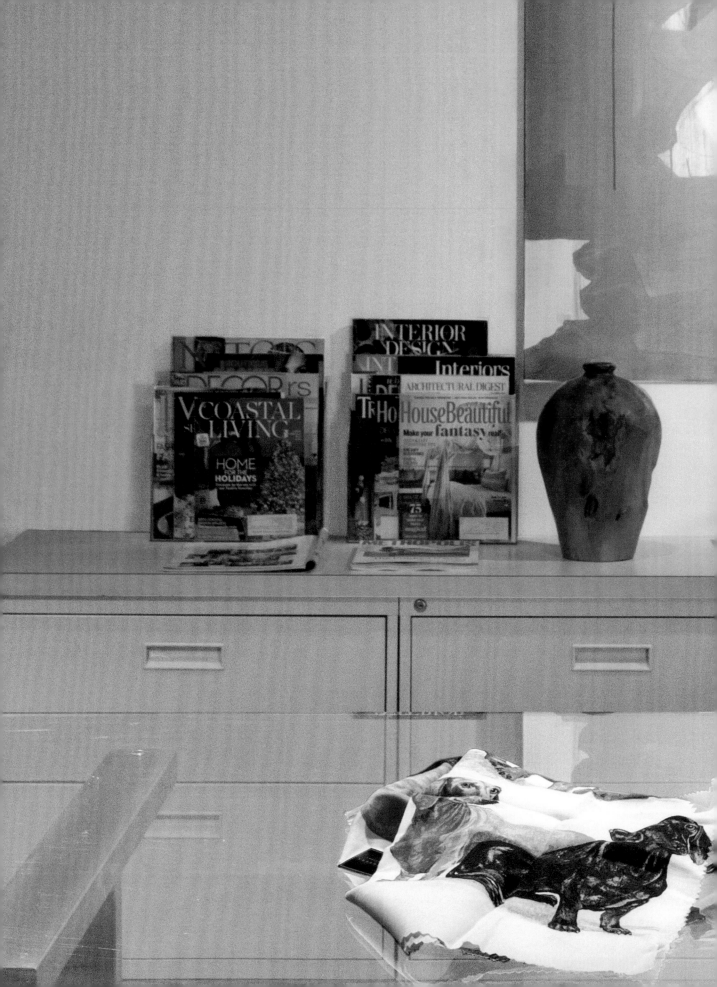

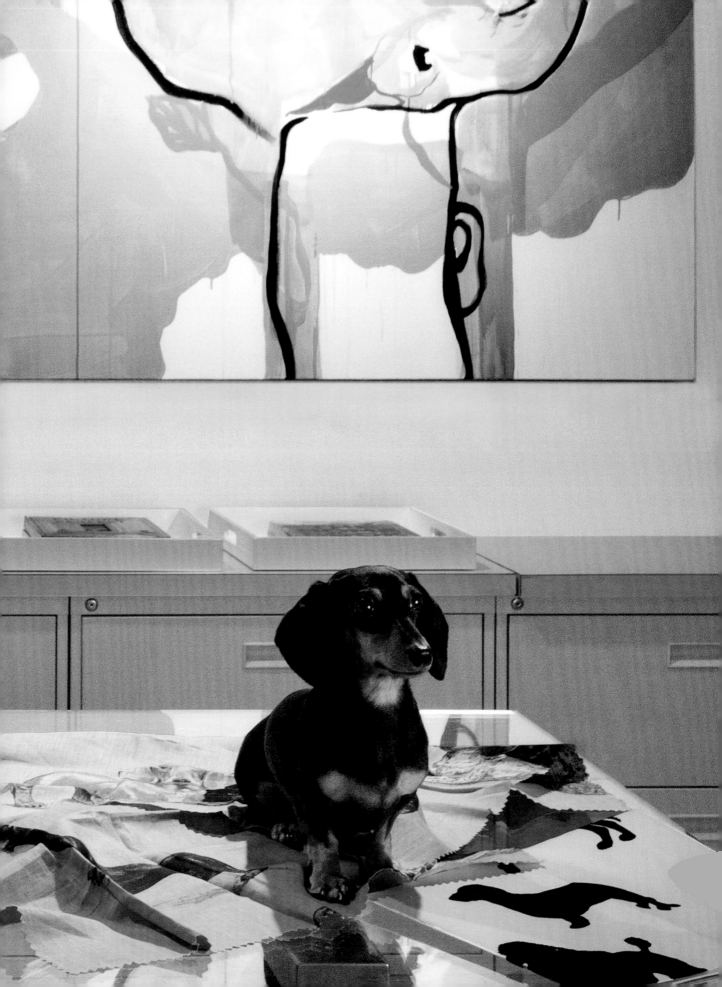

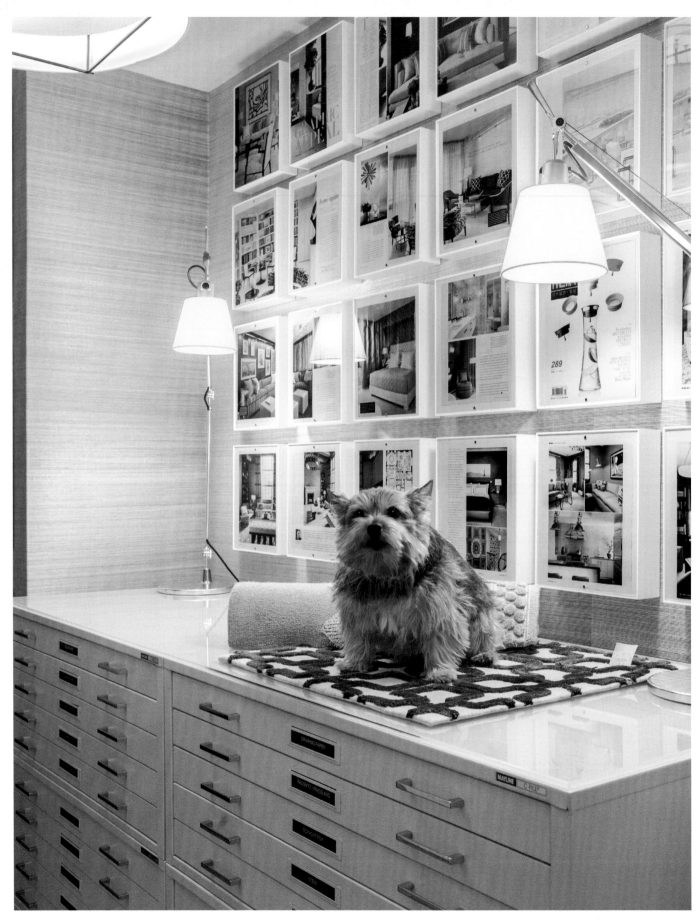

OLIVE, NORWICH TERRIER, 6 YEARS OLD
MICHAEL ROSENBERG & ASSOCIATES, INTERIOR DESIGN, MIDTOWN

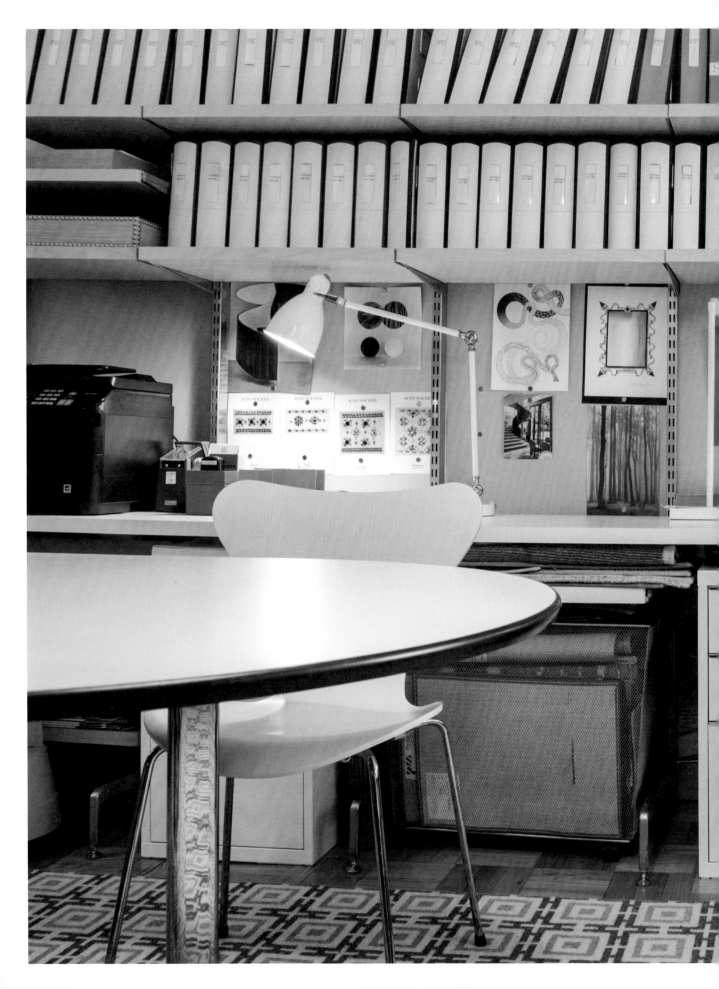

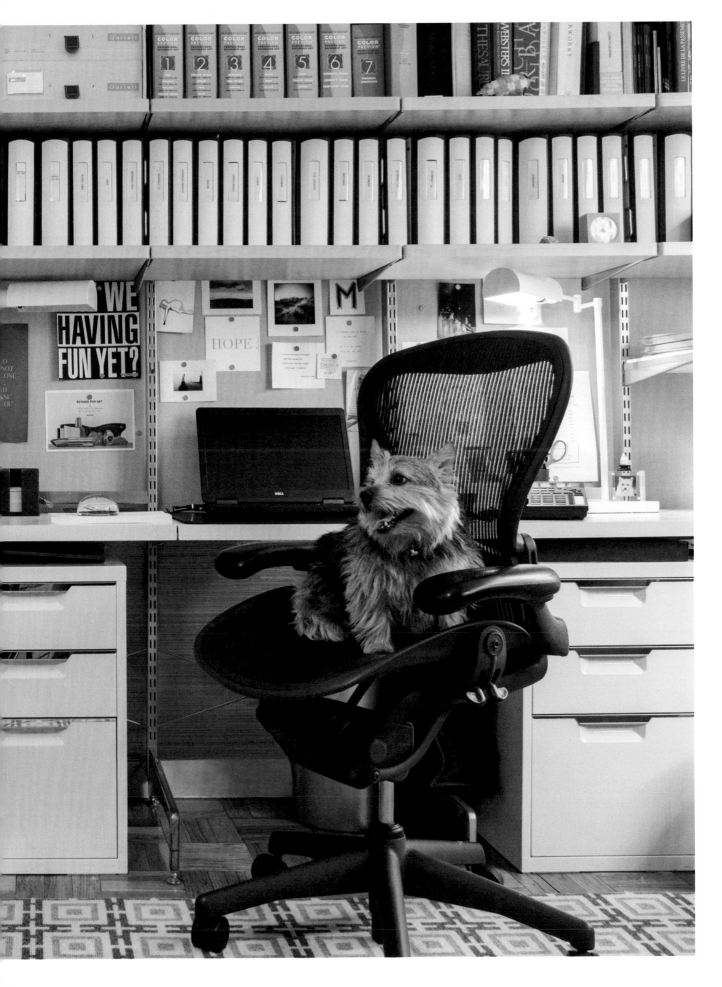

SYDNEY, DOUBLE DAPPLE DACHSHUND, 13 YEARS OLD
LORIN MARSH, FURNITURE AND ACCESSORIES SHOWROOM, MIDTOWN

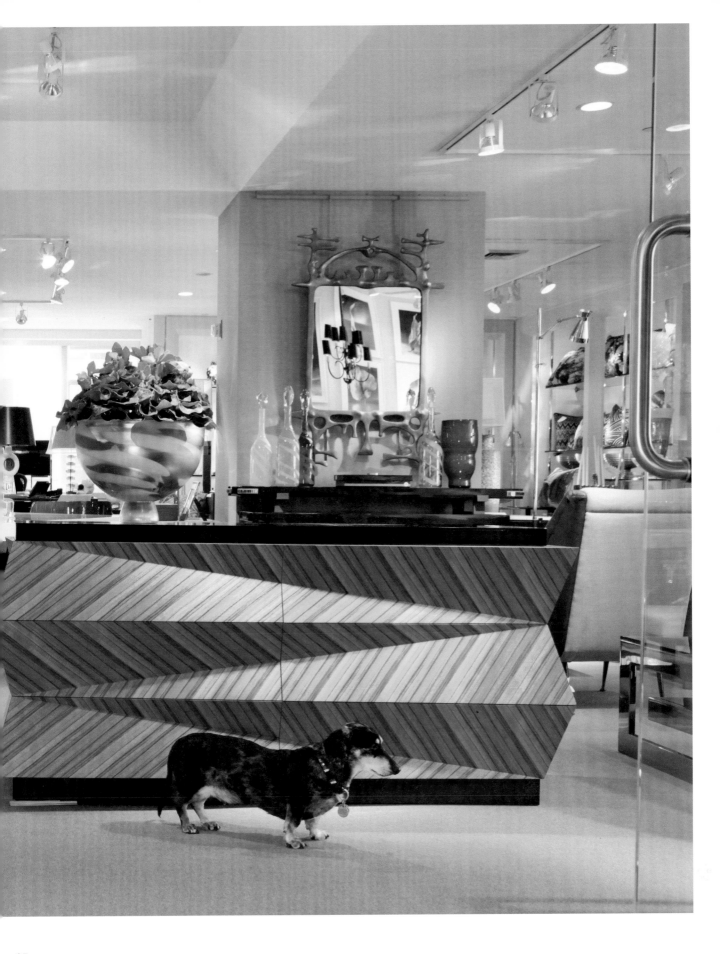

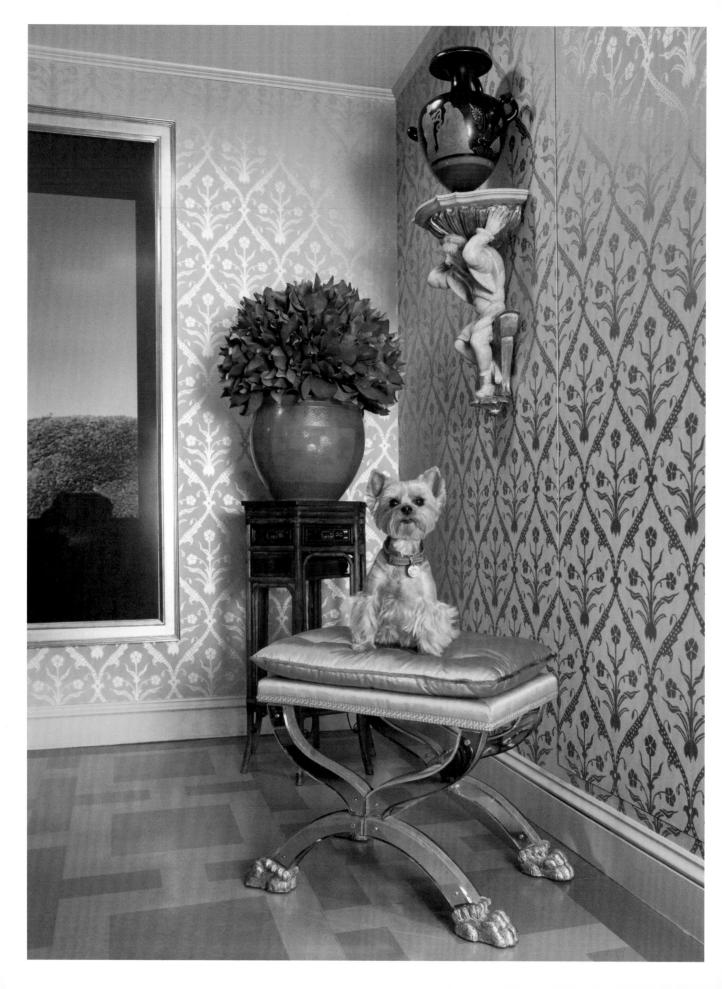

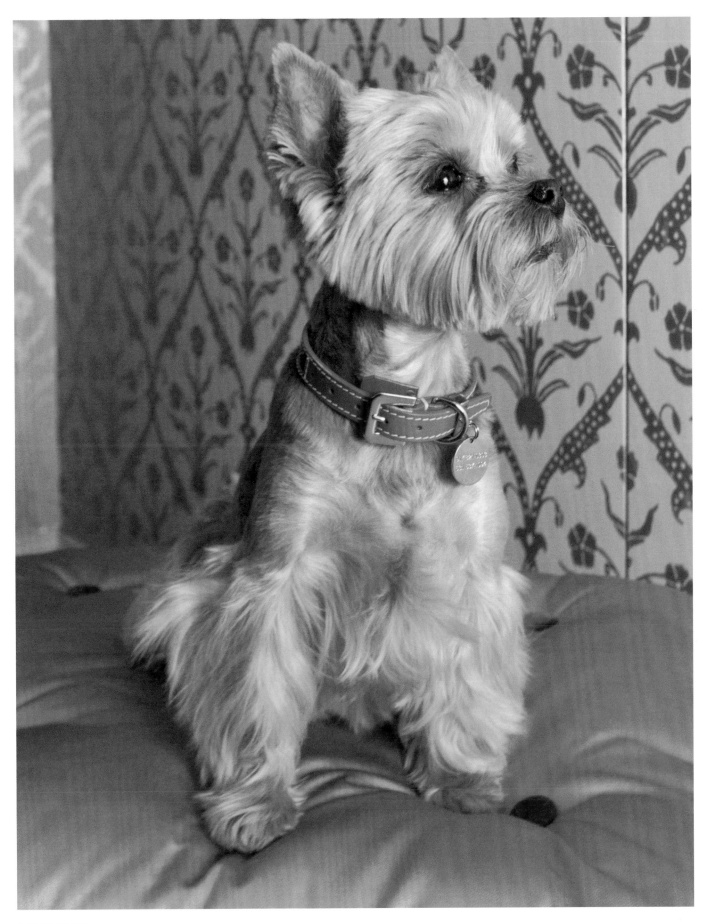

TEDDY, YORKSHIRE TERRIER, 12 YEARS OLD
ALEX PAPACHRISTIDIS INTERIORS, INTERIOR DESIGN, MIDTOWN

TEDDY, AND GYPSY MARLOW, SHETLAND SHEEPDOG, 5 YEARS OLD
ALEX PAPACHRISTIDIS INTERIORS, INTERIOR DESIGN, MIDTOWN

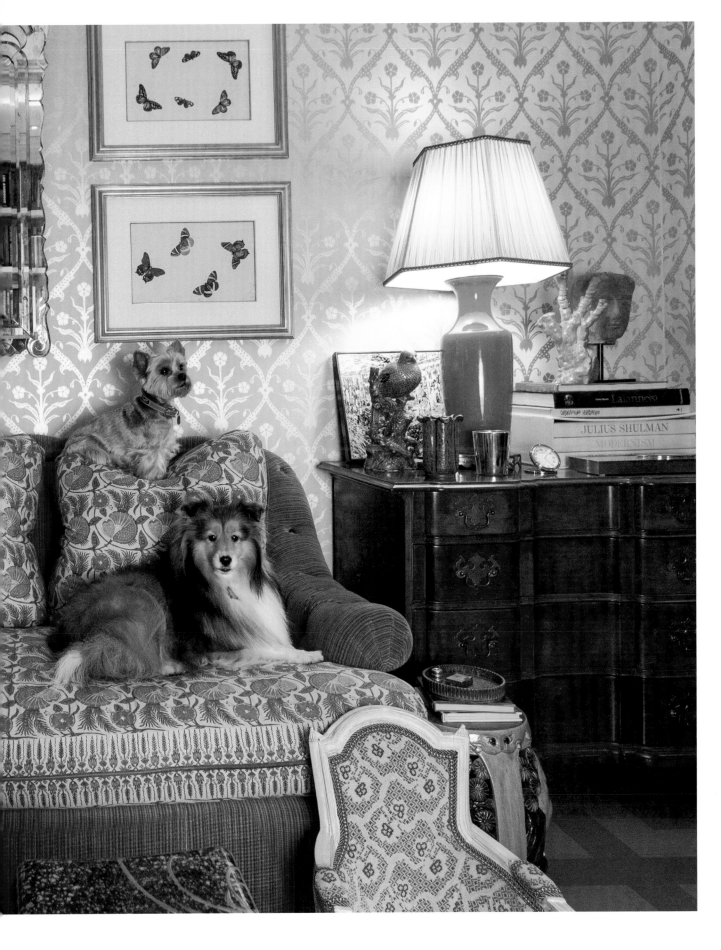

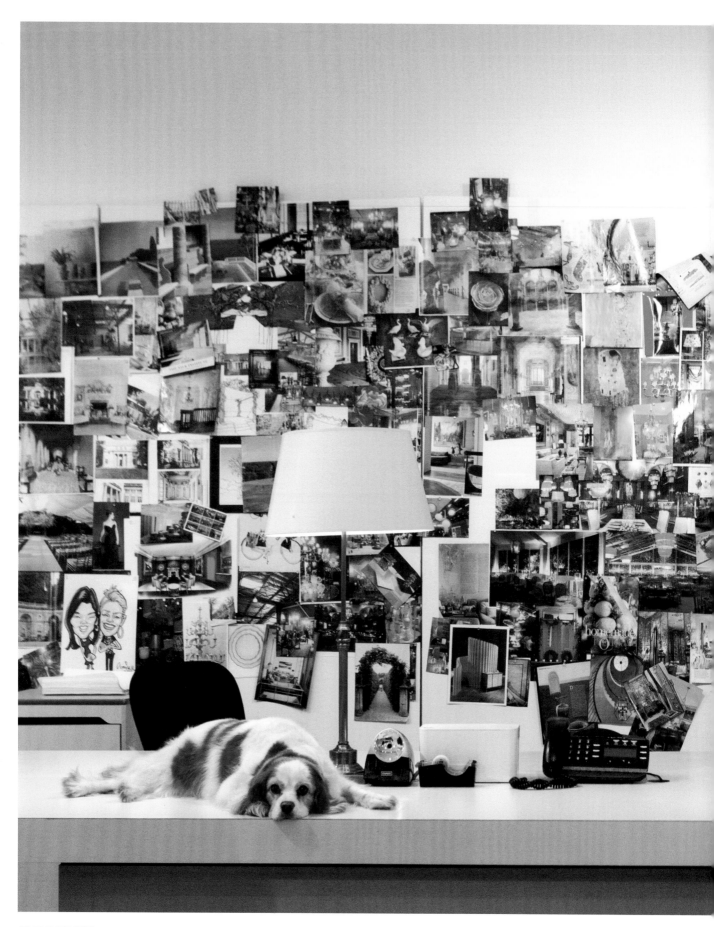

SAMMY, CAVALIER KING CHARLES SPANIEL, 13 YEARS OLD
DAVID MONN LLC, EVENT PLANNING, CHELSEA

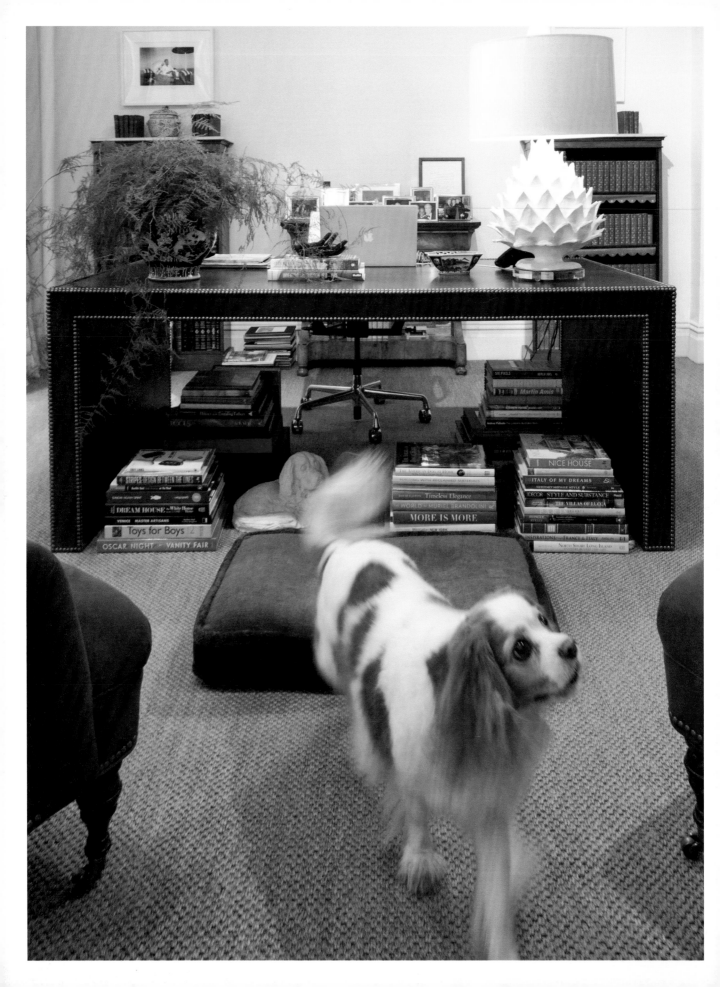

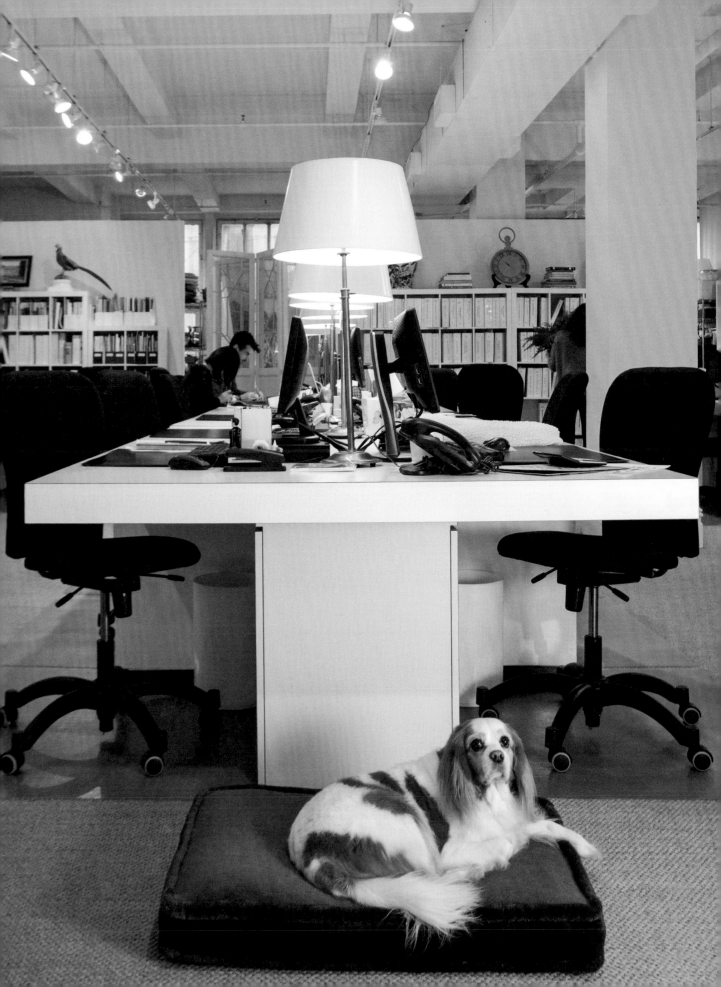

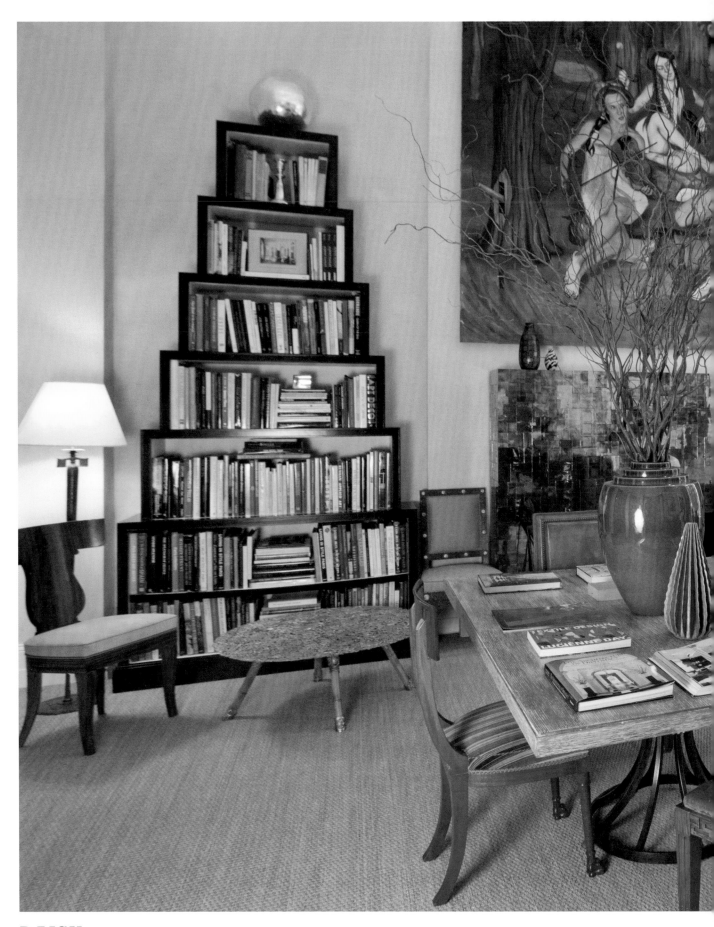

DAISY, POODLE MIX, 6 YEARS OLD
BRIAN J. MCCARTHY INC., INTERIOR DESIGN, MIDTOWN

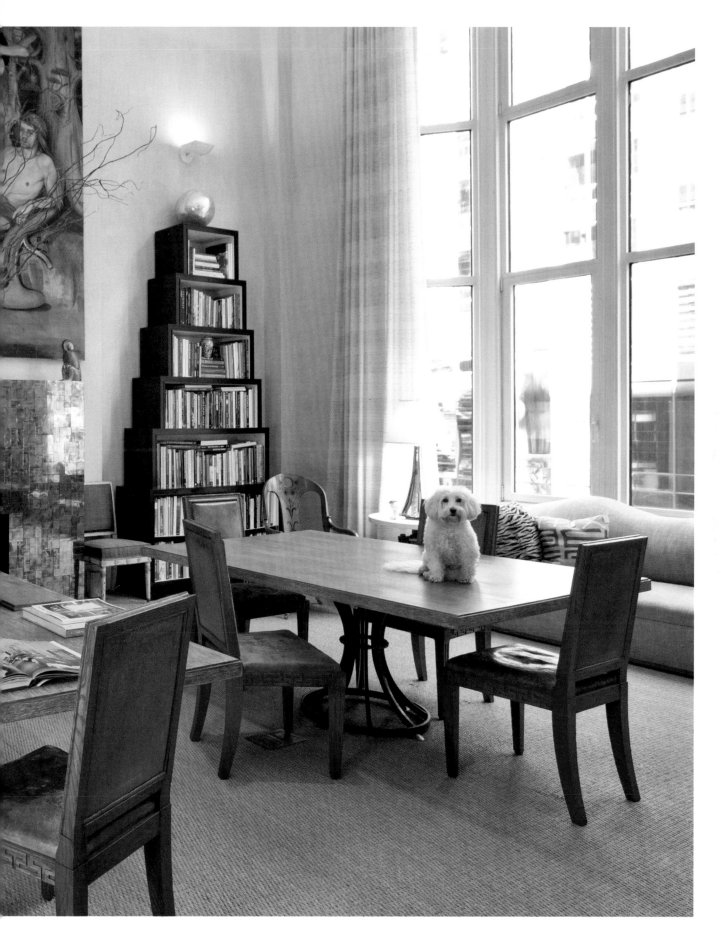

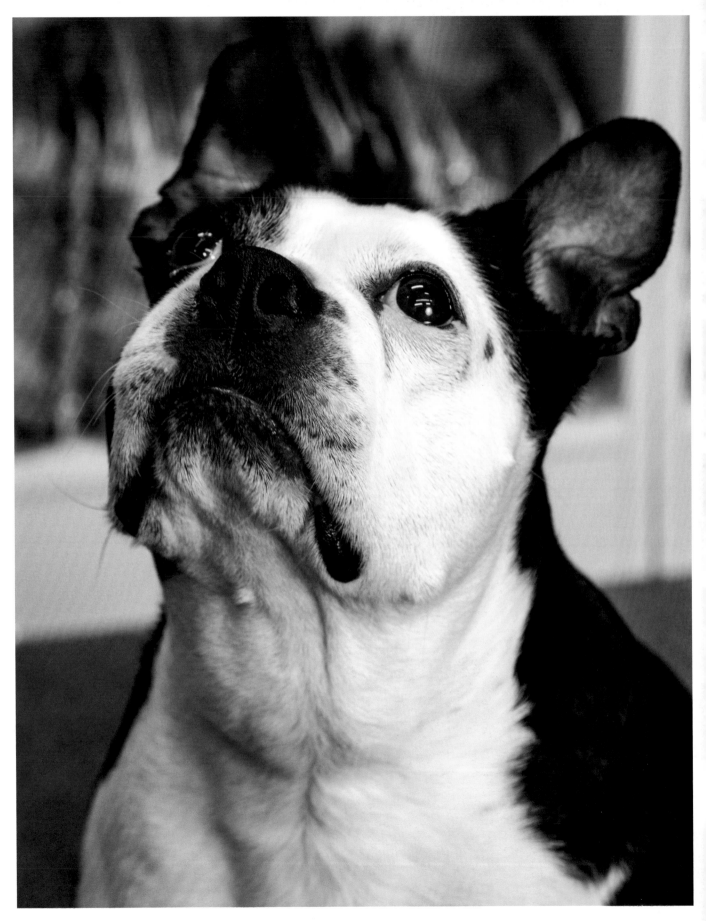

SWATCH SAUMA, BOSTON TERRIER, 7 YEARS OLD
MOOD FABRICS, GARMENT DISTRICT

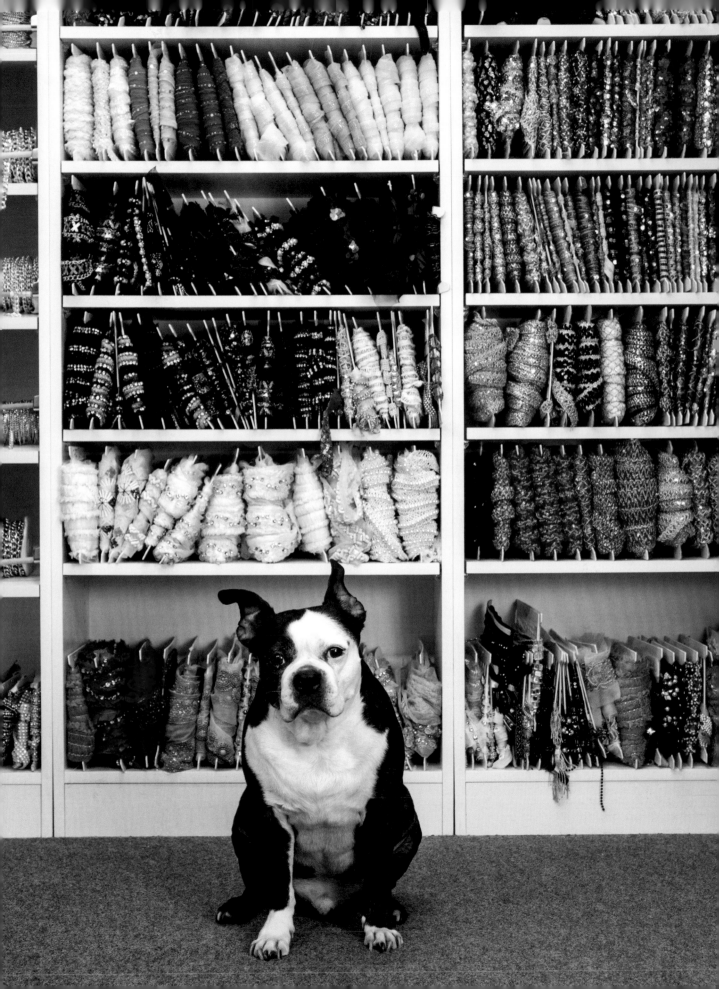

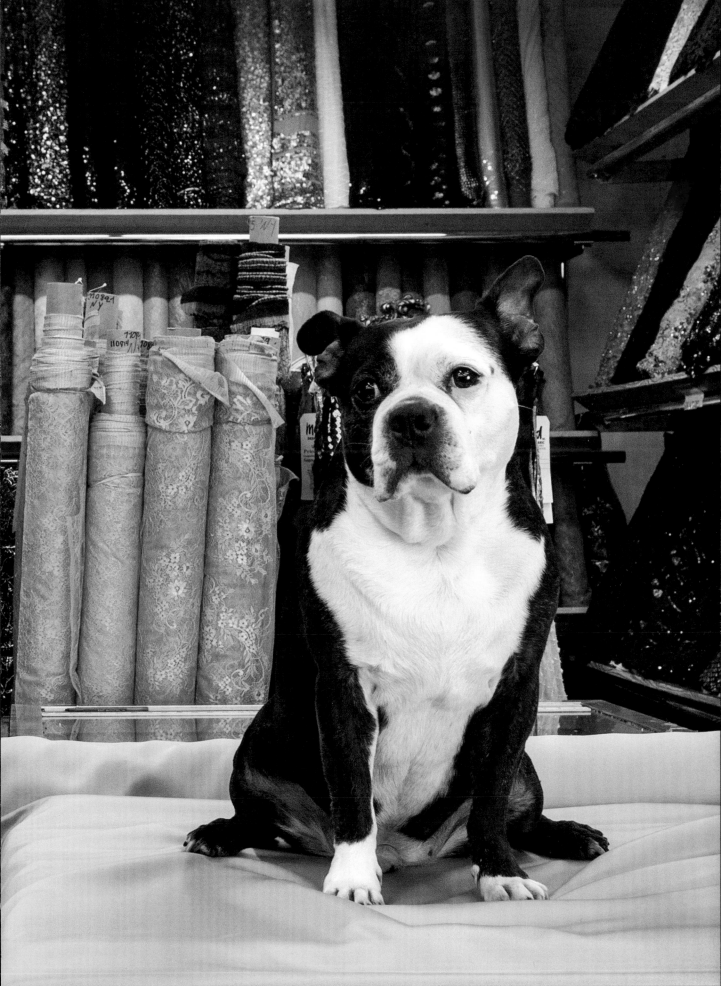

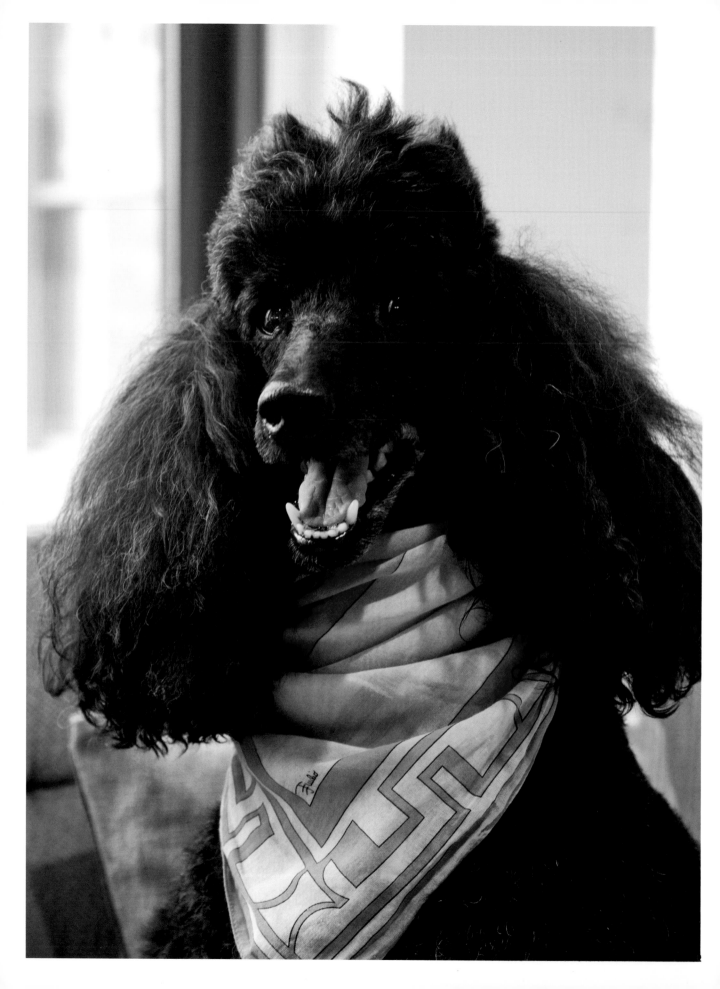

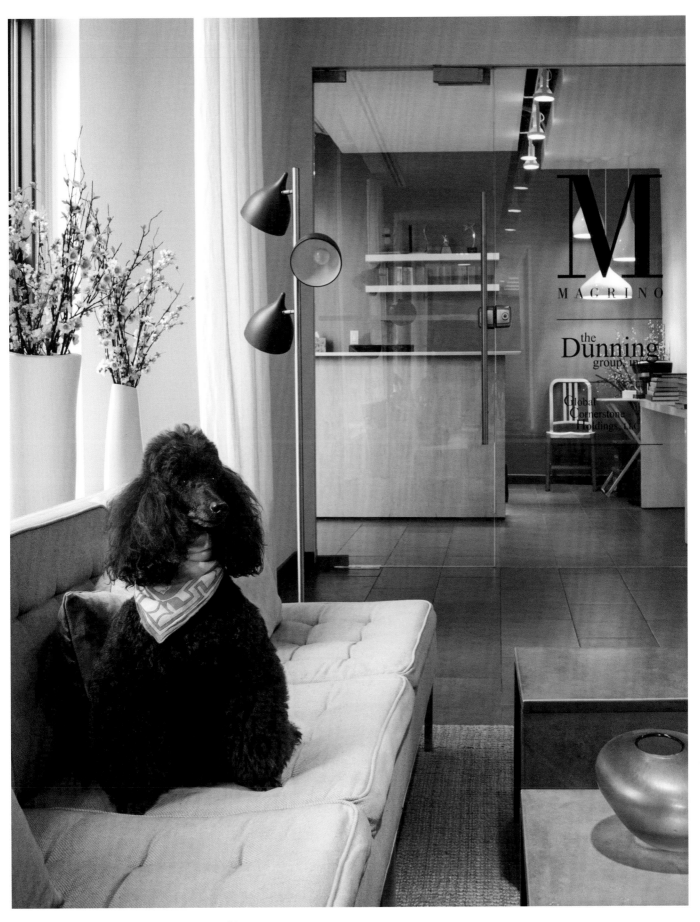

CHURCHILL DUNNING, POODLE, 12 YEARS OLD
MAGRINO AGENCY, PUBLIC RELATIONS, FLATIRON DISTRICT

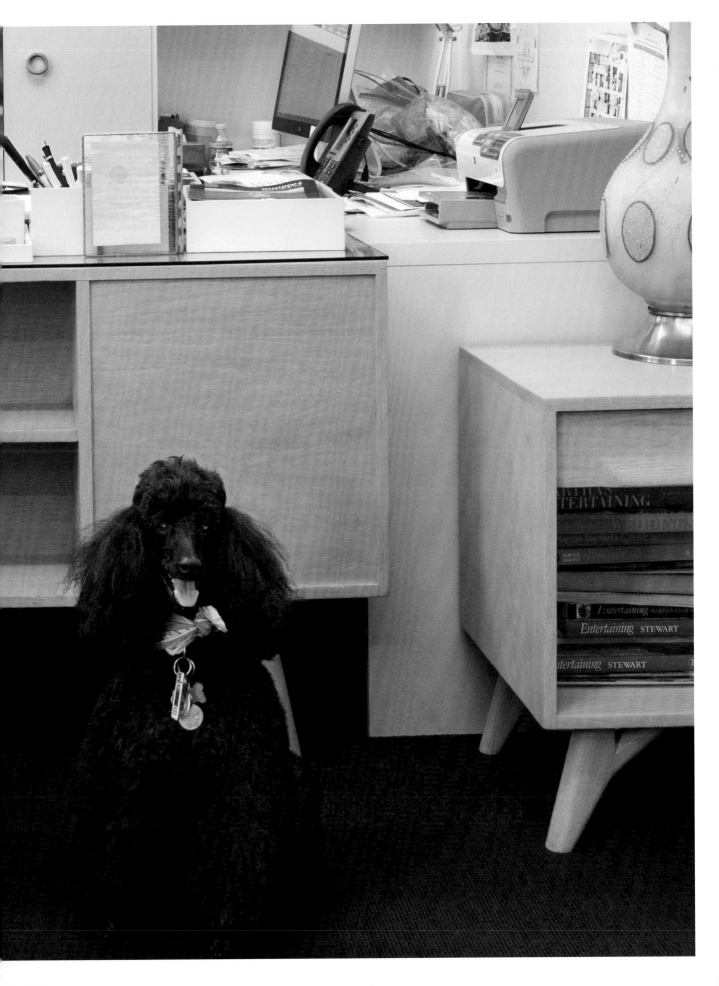

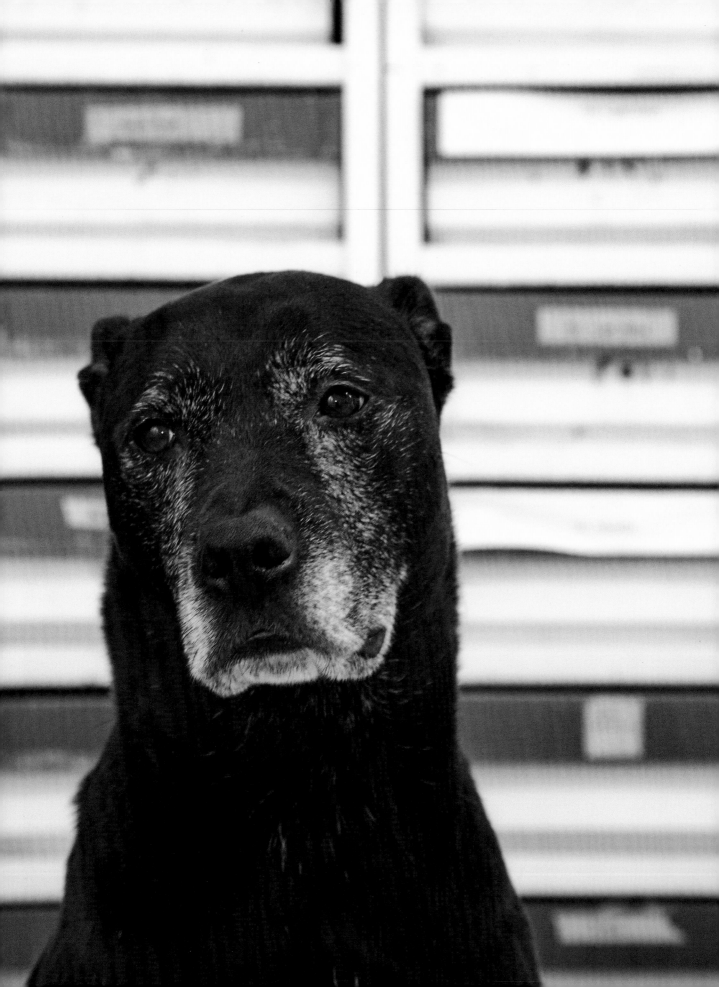

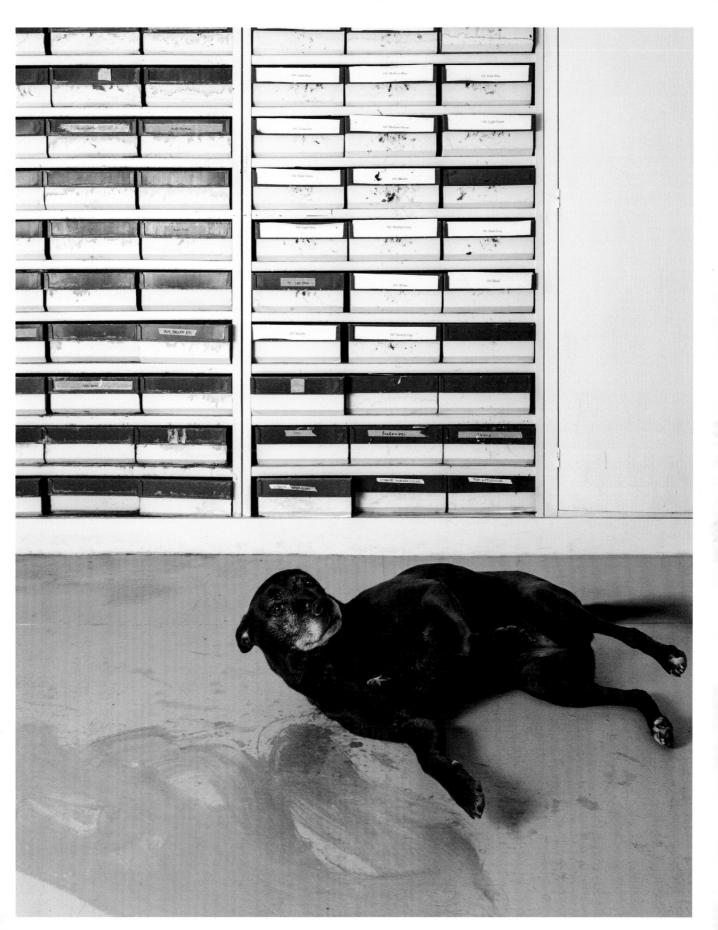

PADME, MUTT, 11 YEARS OLD
ALEXIS ROCKMAN, ARTIST'S STUDIO, TRIBECA

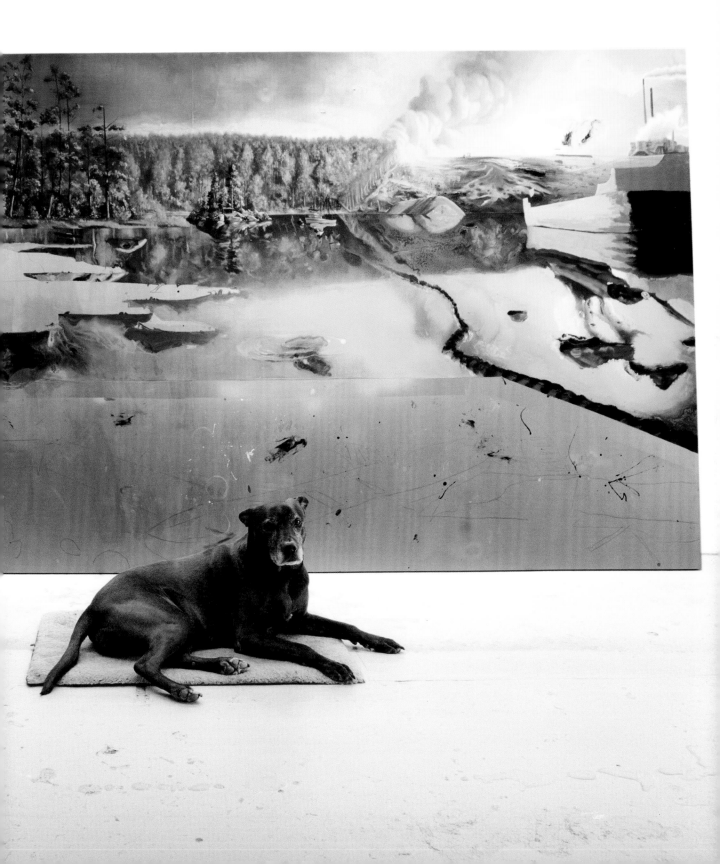

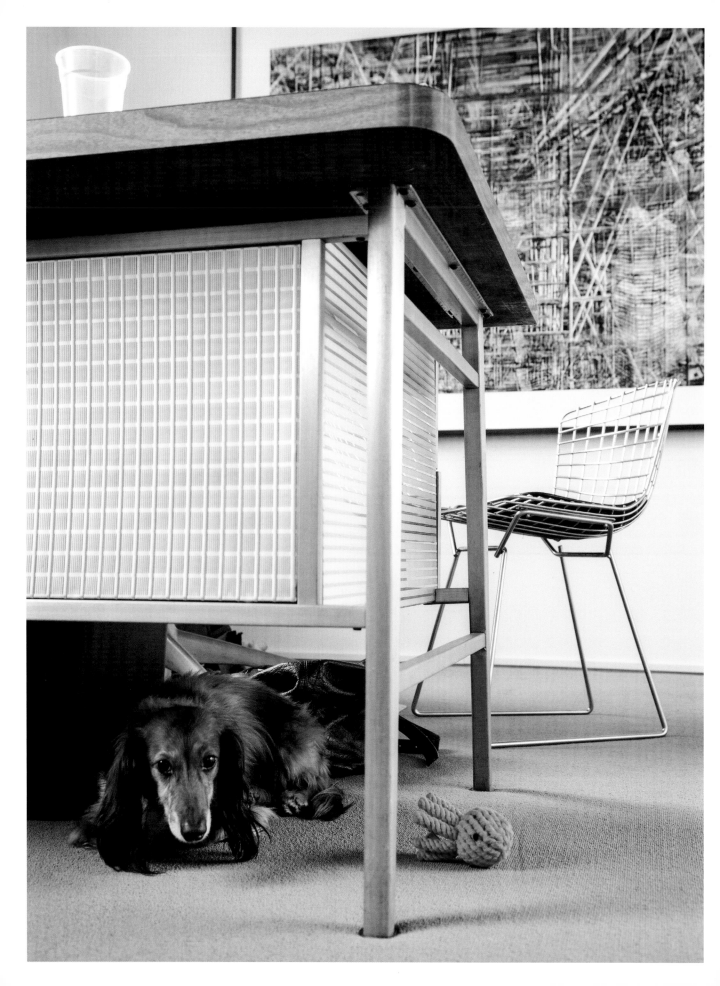

PERSONAL ASSISTANTS

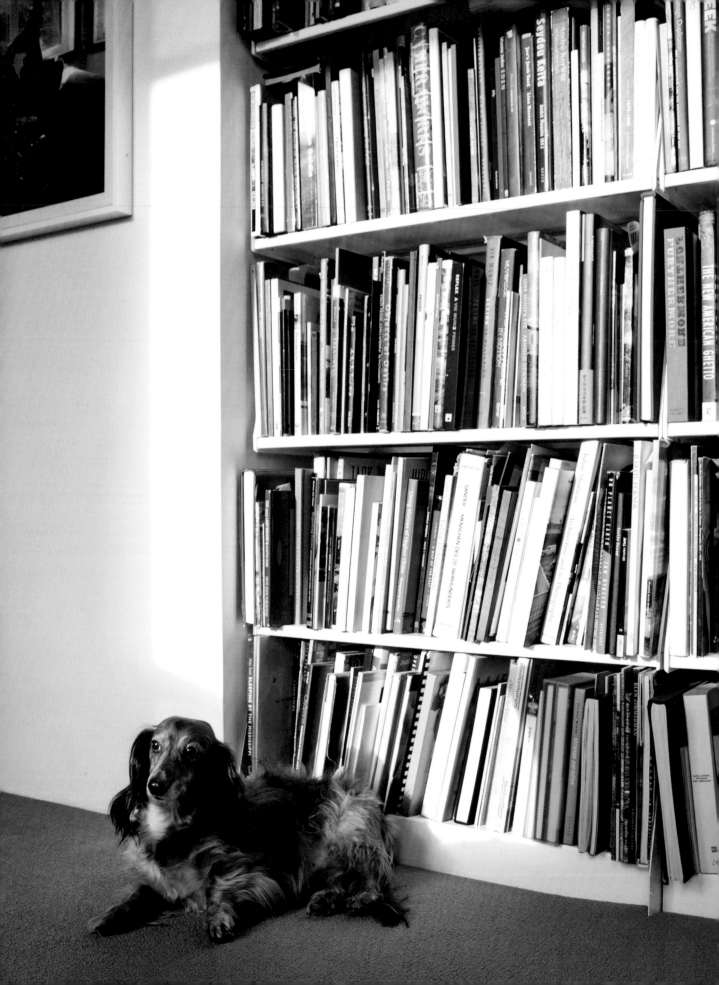

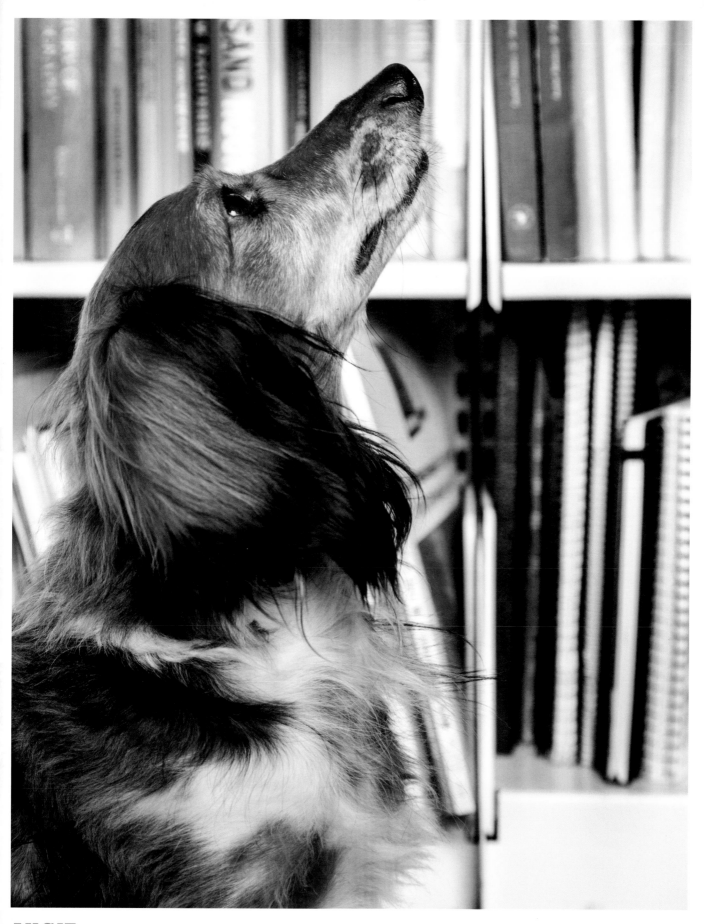

AUGIE, LONG HAIRED DACHSHUND, 4 YEARS OLD
JULIE SAUL GALLERY, CHELSEA

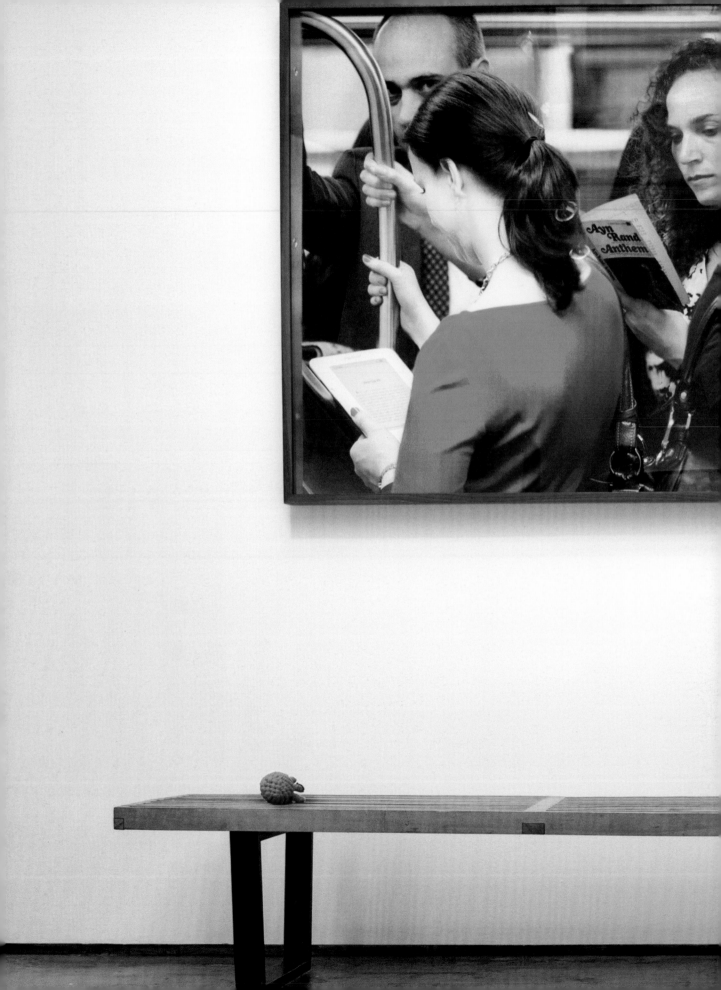

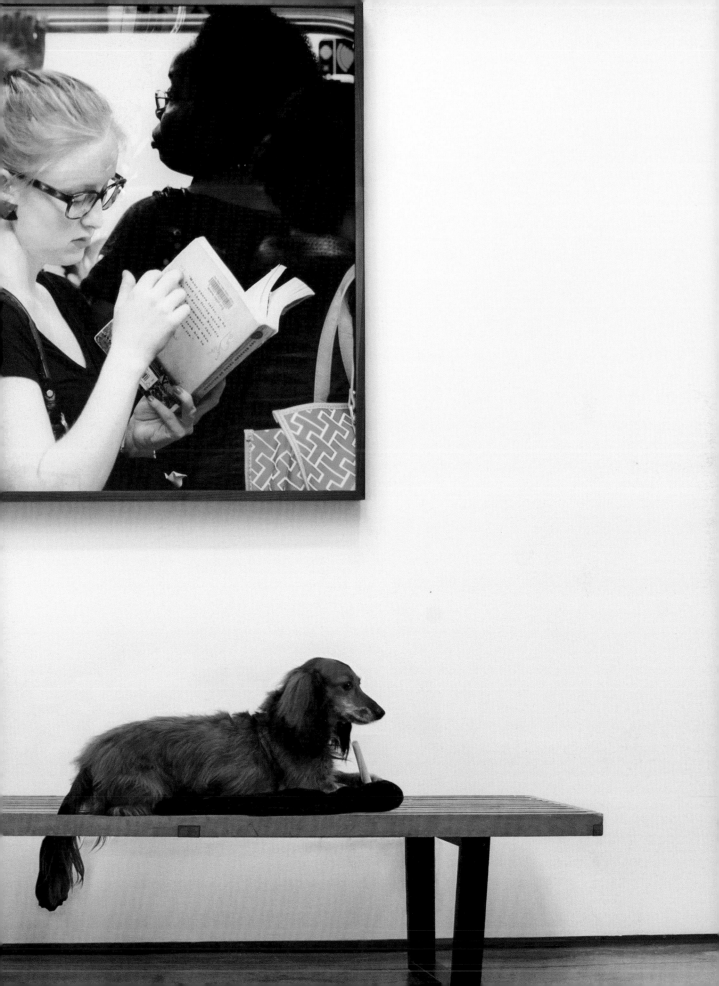

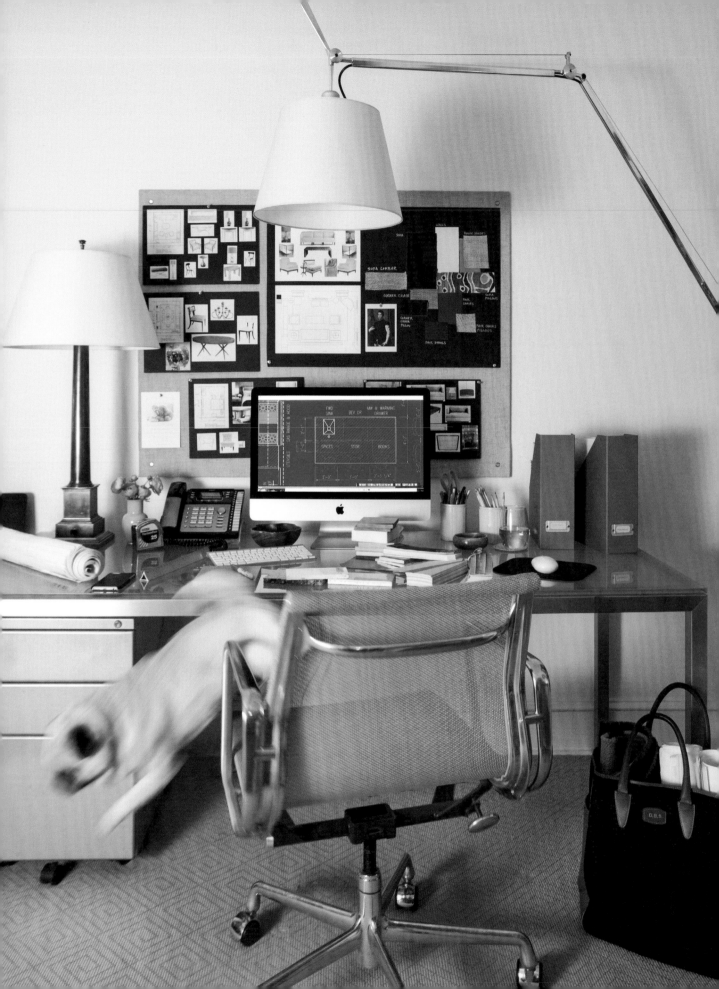

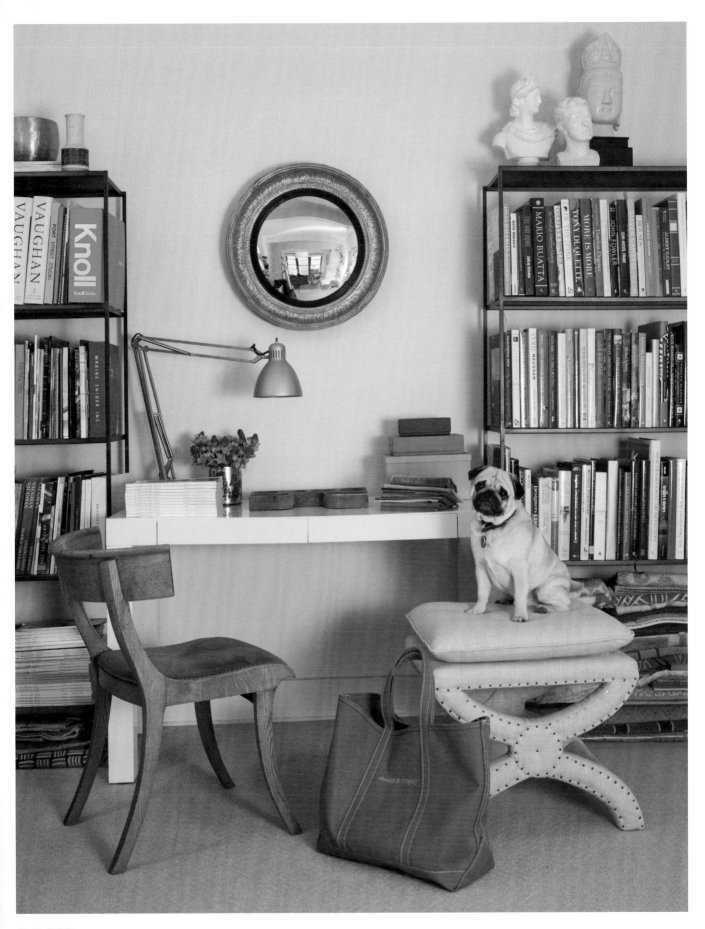

BASIL, PUG, 3 YEARS OLD
SHOSTAK & COMPANY, INTERIOR DESIGN, MIDTOWN

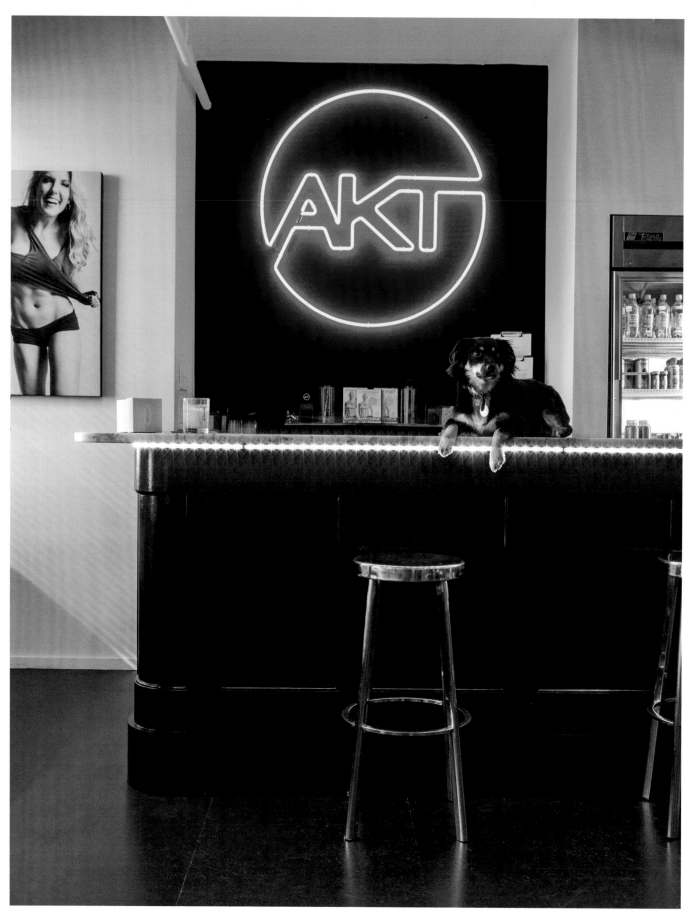

HARLIE, MINI AUSTRALIAN SHEPHERD, 1 YEAR OLD
AKT INMOTION, GYM & DANCE STUDIO, UPPER EAST SIDE

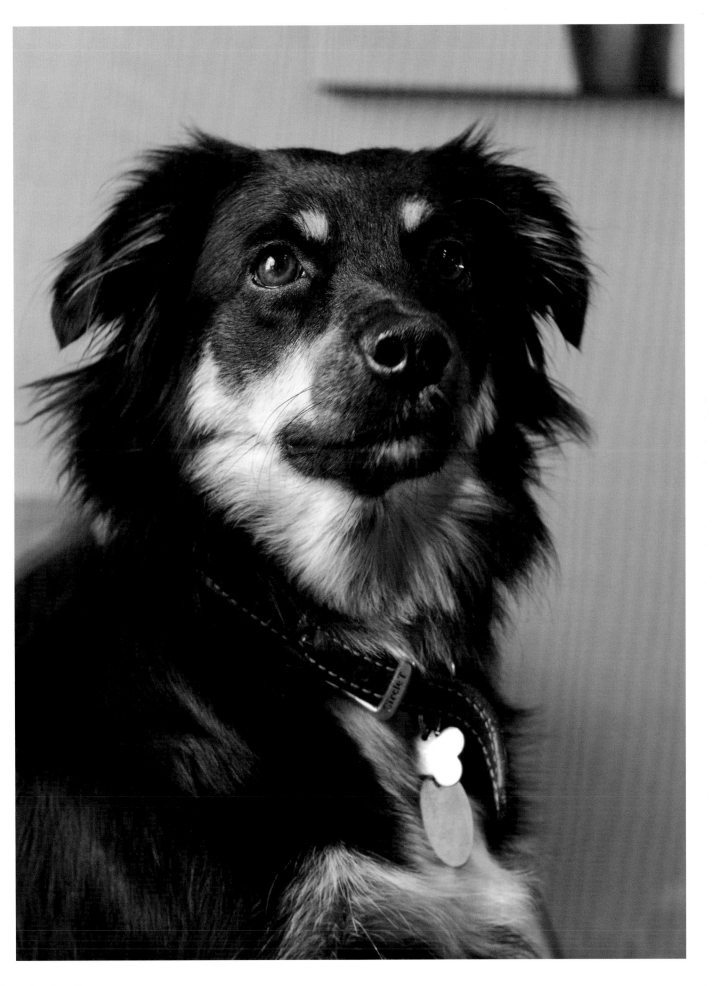

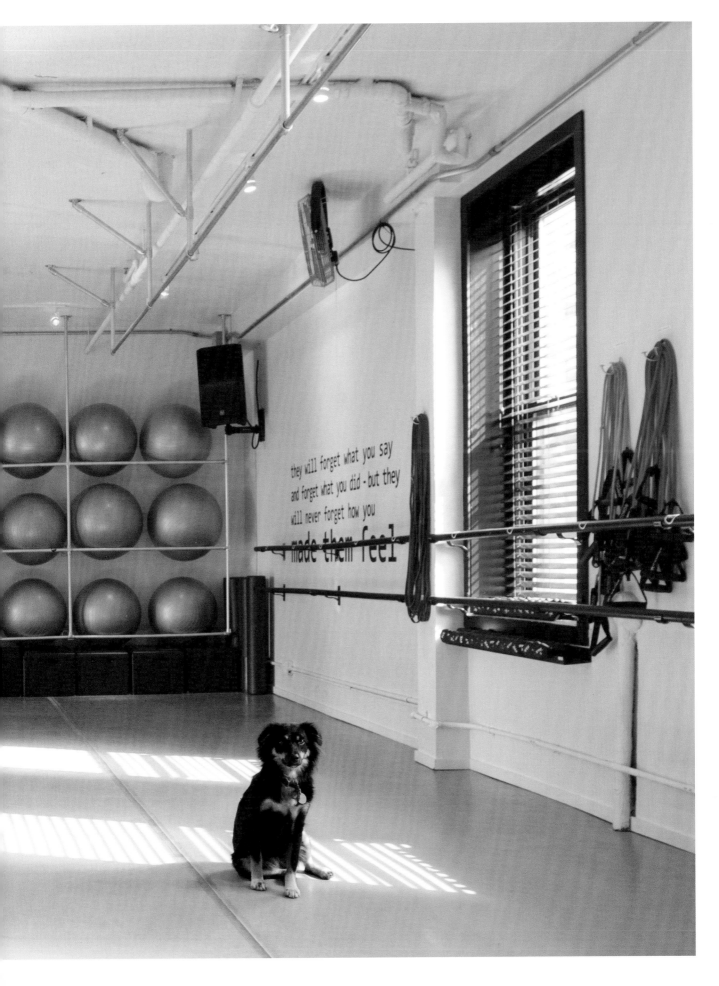

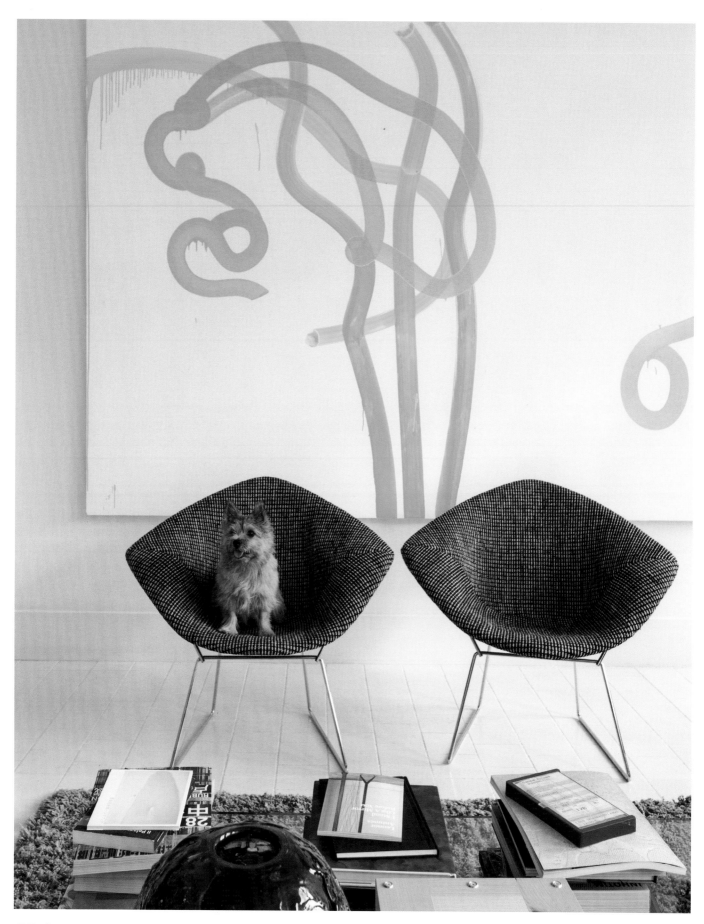

SPORT, NORWICH TERRIER, 4 YEARS OLD
BARBARA TOLL FINE ARTS, INDEPENDENT ART CONSULTANT AND CURATOR, SOHO

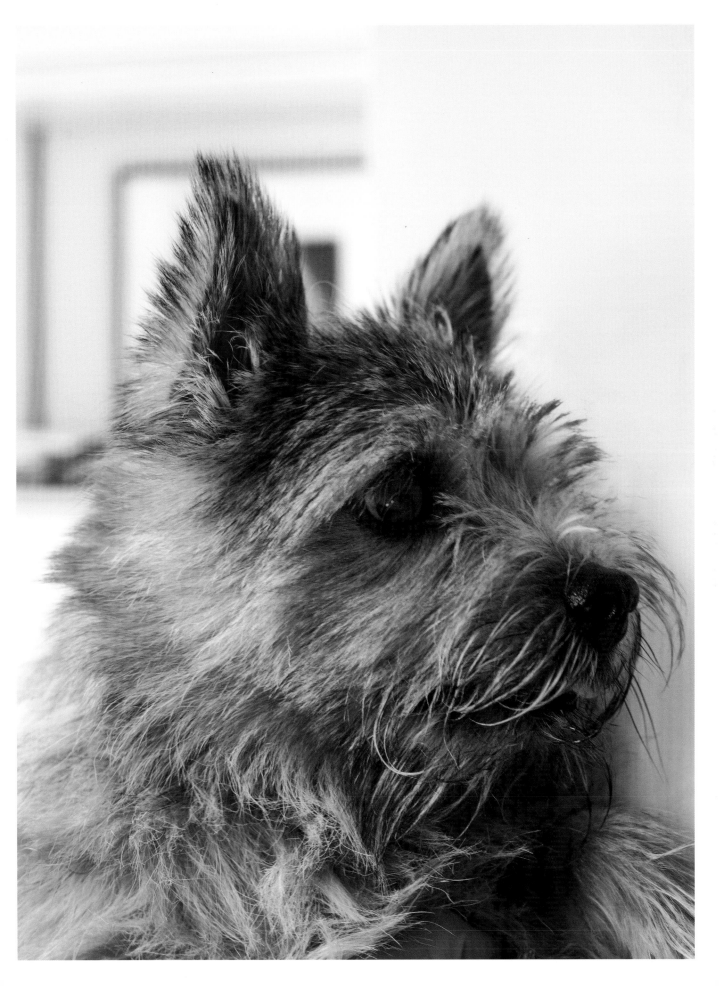

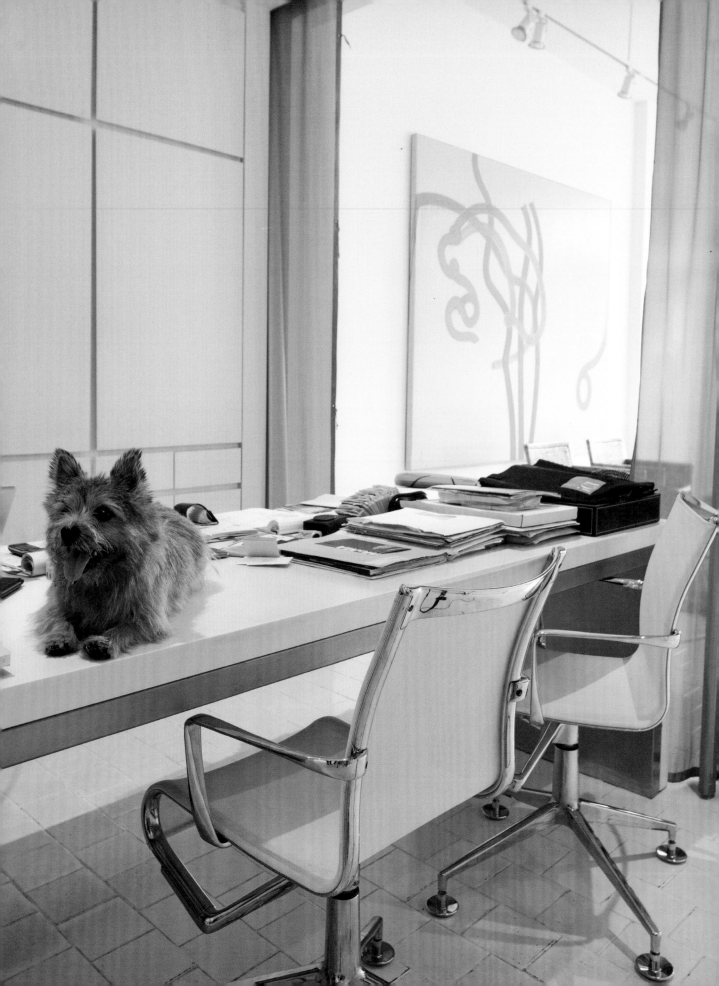

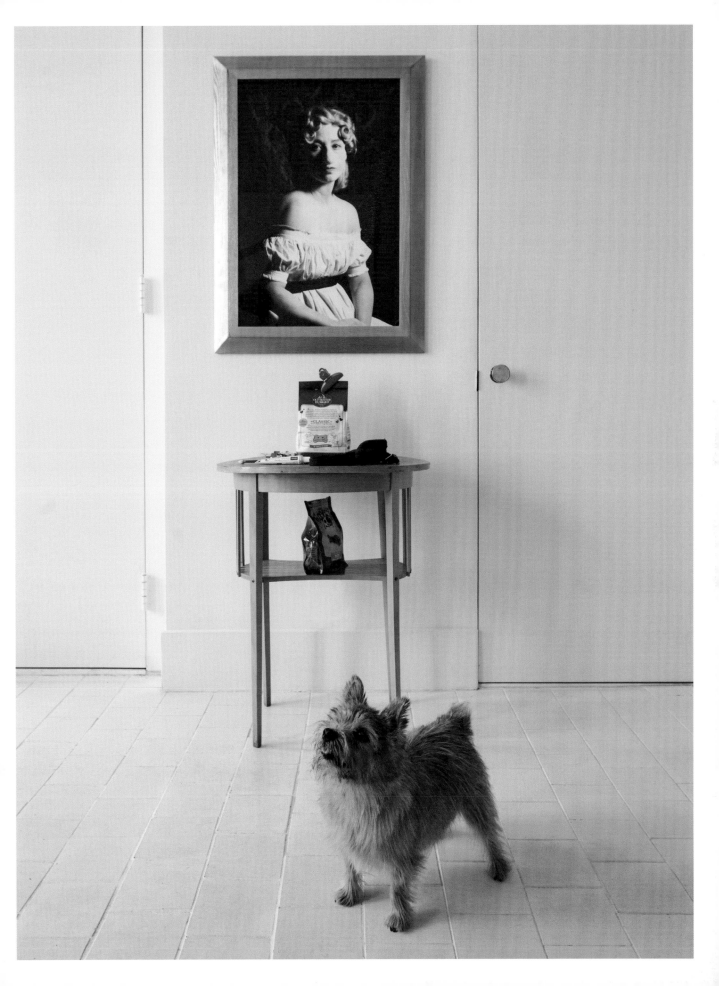

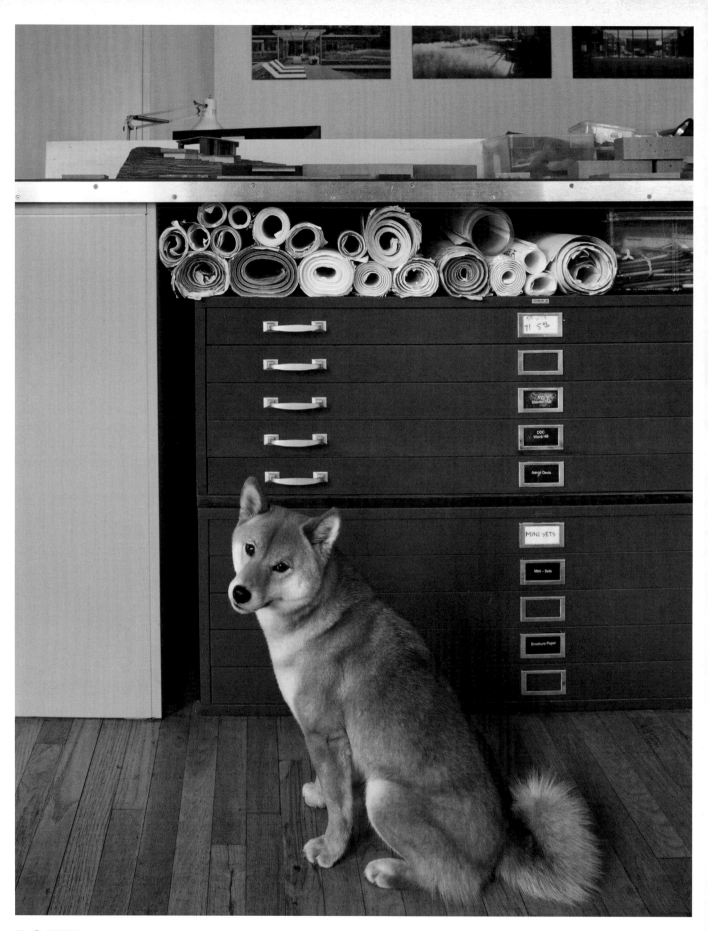

ROXIE, SHIBA INU, 2 YEARS OLD
DUBOIS ARCHITECTS, NOHO

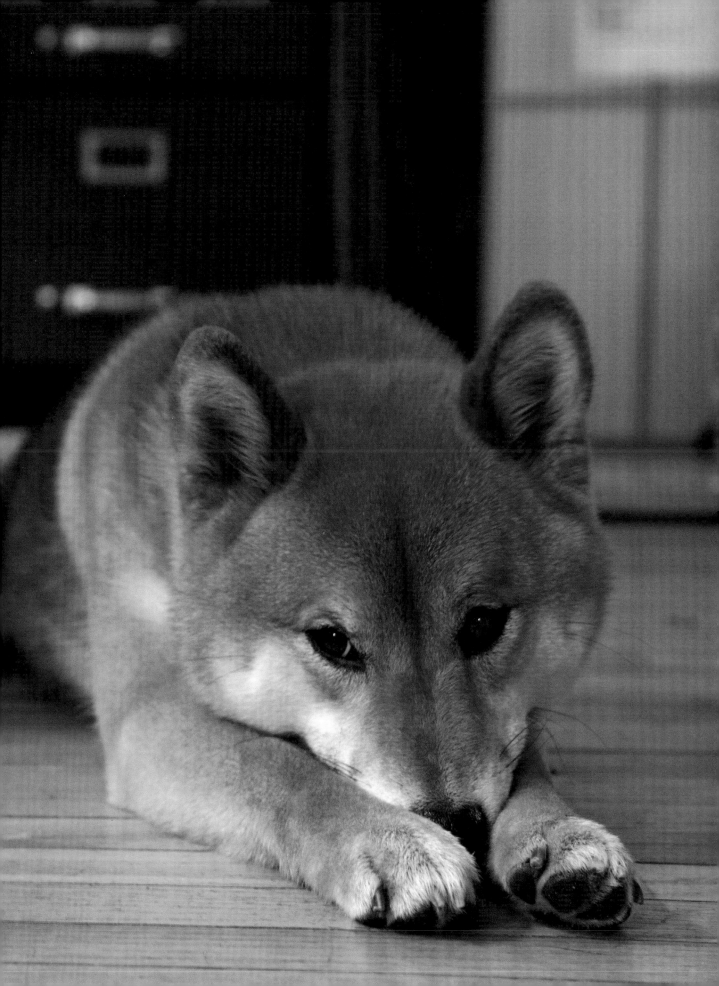

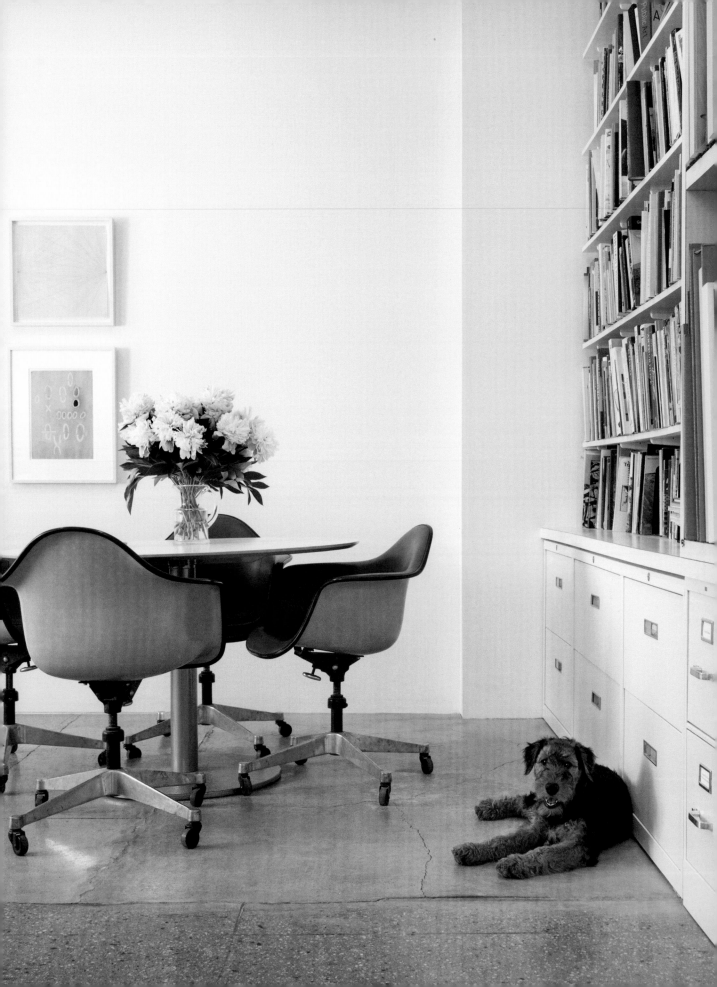

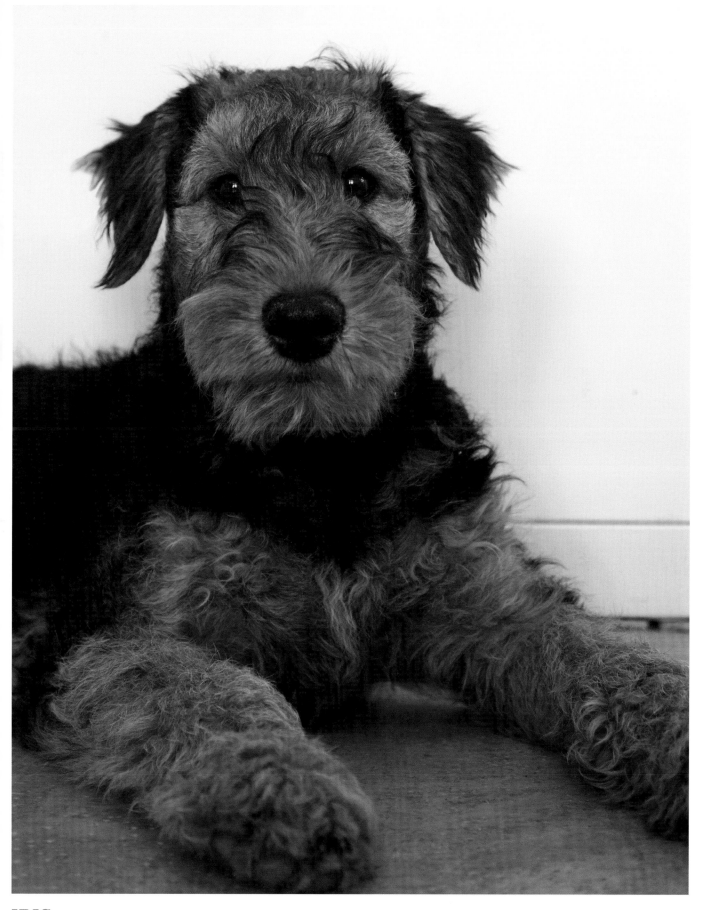

IRIS, AIREDALE, 4 MONTHS OLD
SENIOR & SHOPMAKER GALLERY, CHELSEA

Georgia Marsh

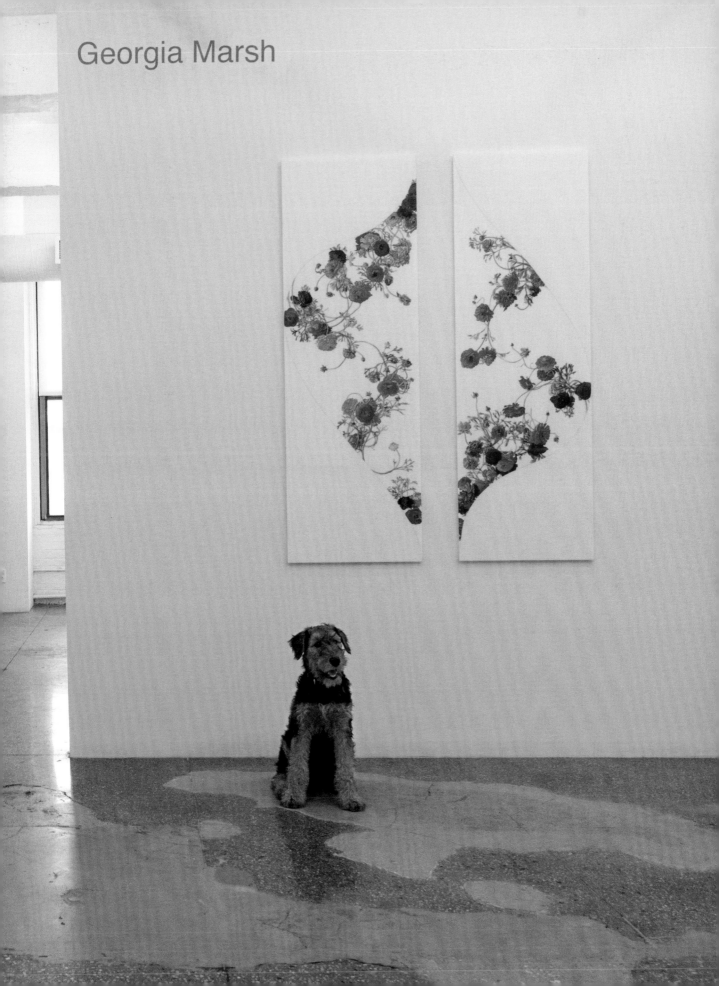

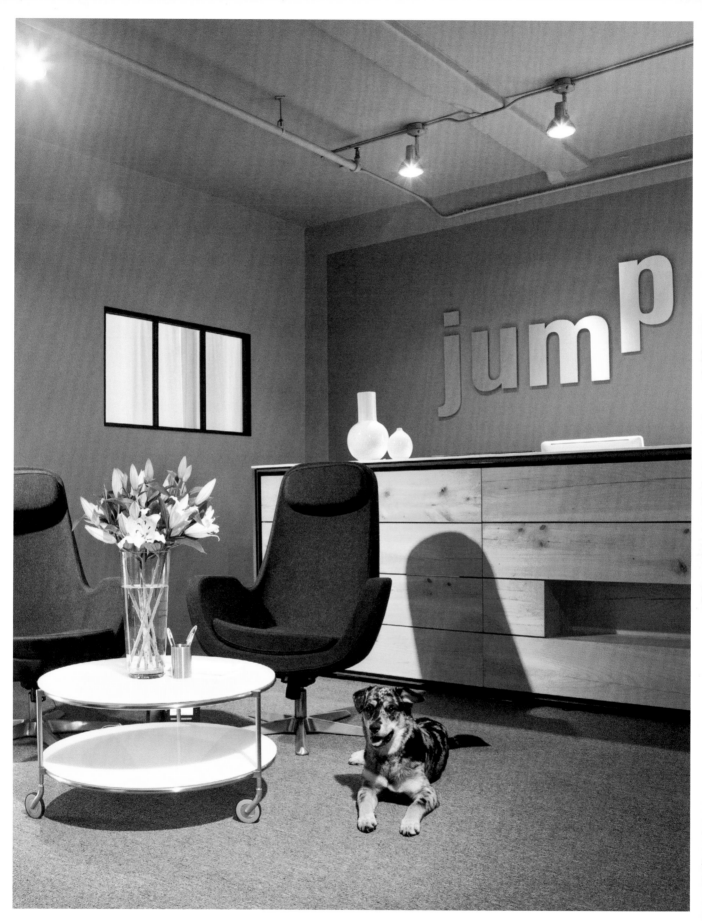

PANDA WEST-JOHNSTON, AUSTRALIAN SHEPHERD MIX, 7 MONTHS OLD
JUMP, MEDIA PRODUCTIONS AGENCY, NOHO

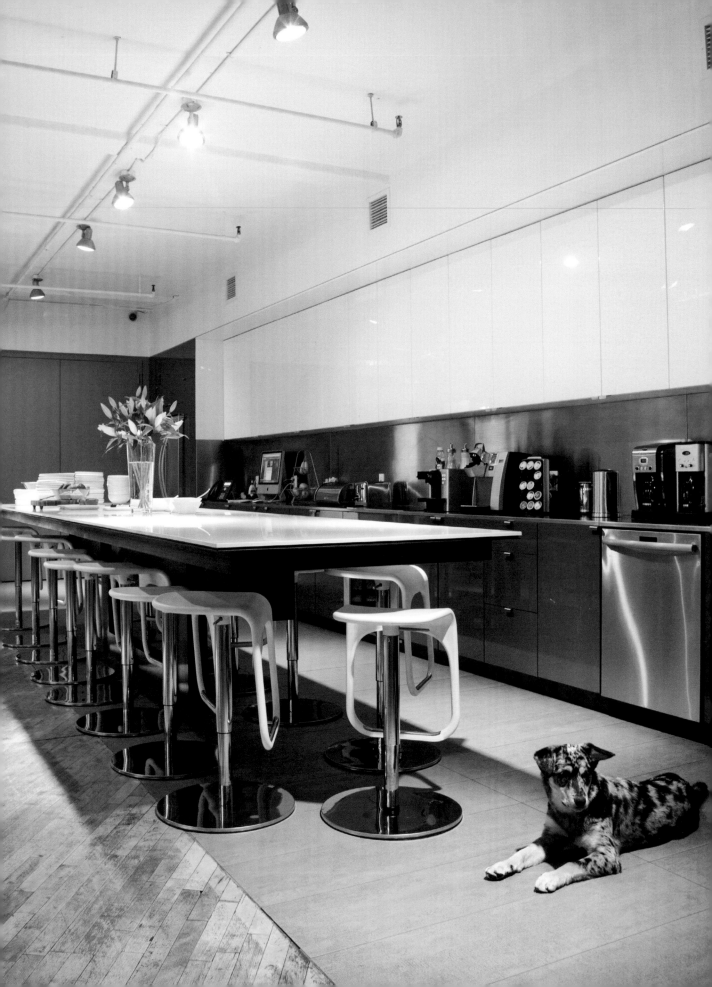

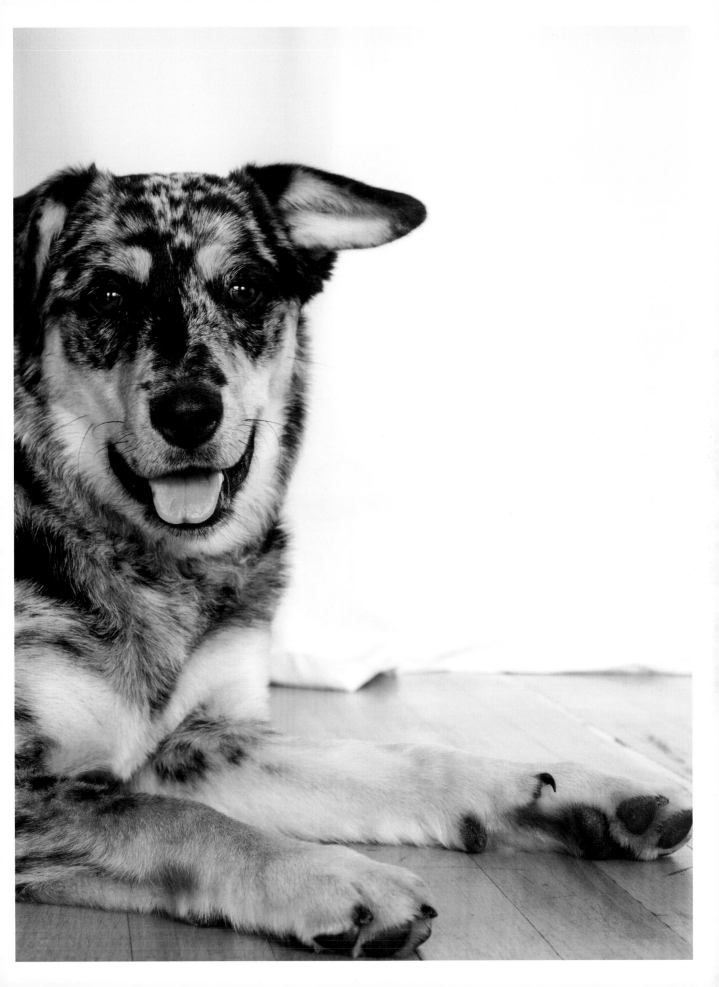

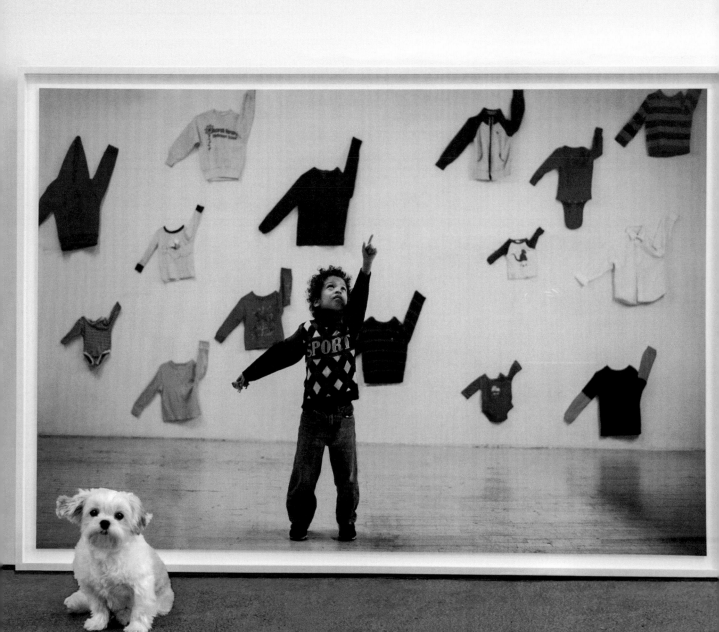

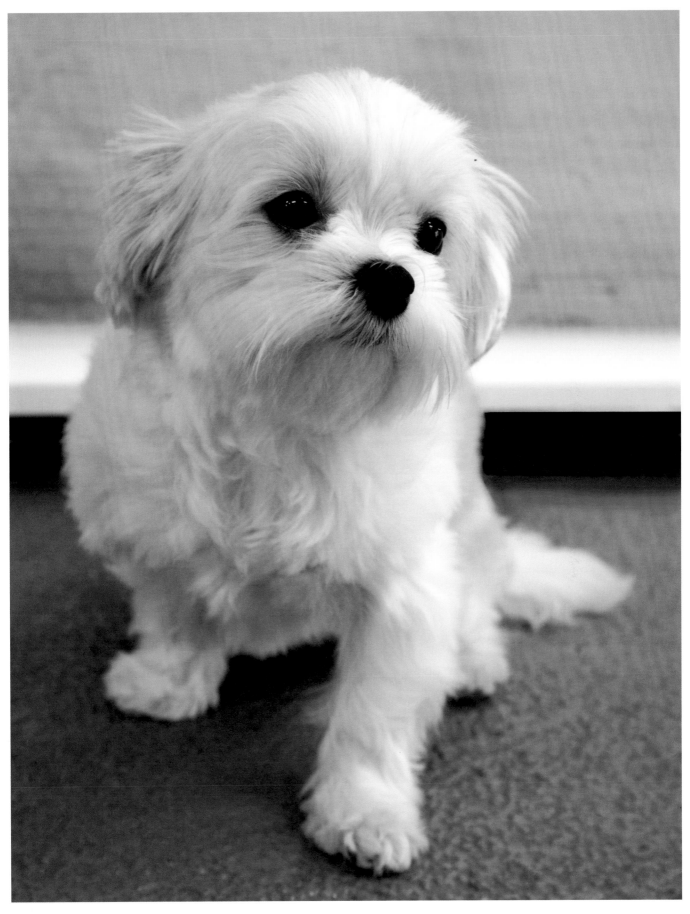

MAN RAY, MI-KI, 4 YEARS OLD
LYNCH THAM GALLERY, LOWER EAST SIDE

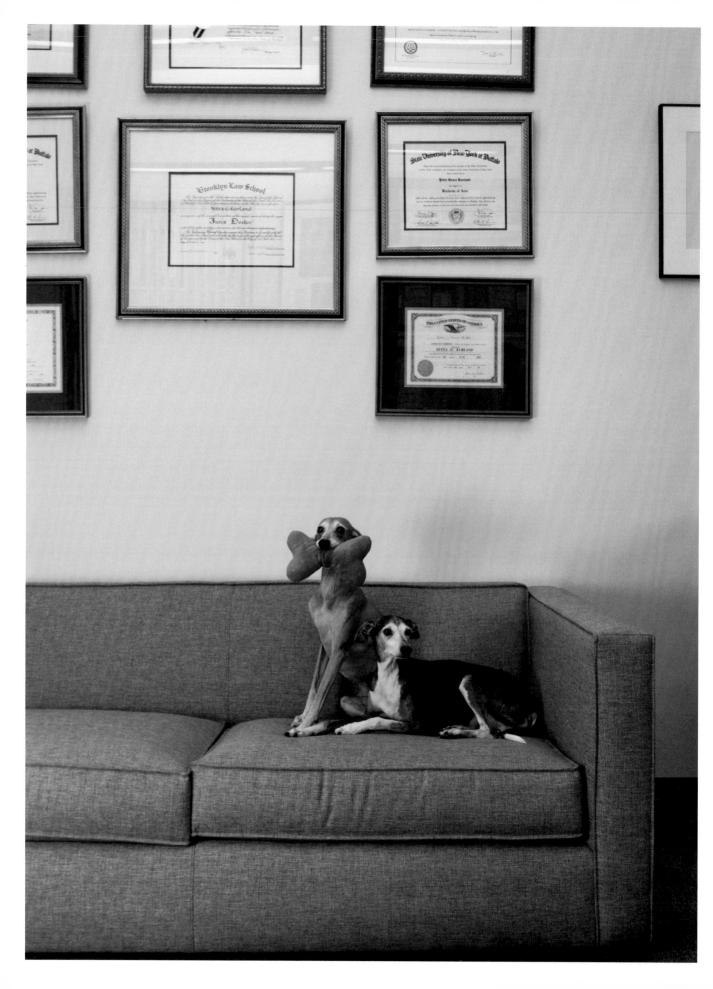

PARTNERS

SALVATORE, ITALIAN GREYHOUND, 10 YEARS OLD. *LEFT*
LUCA, ITALIAN GREYHOUND, 10 YEARS OLD, *RIGHT*
THE KURLAND GROUP, LGBT CIVIL RIGHTS FIRM, FINANCIAL DISTRICT

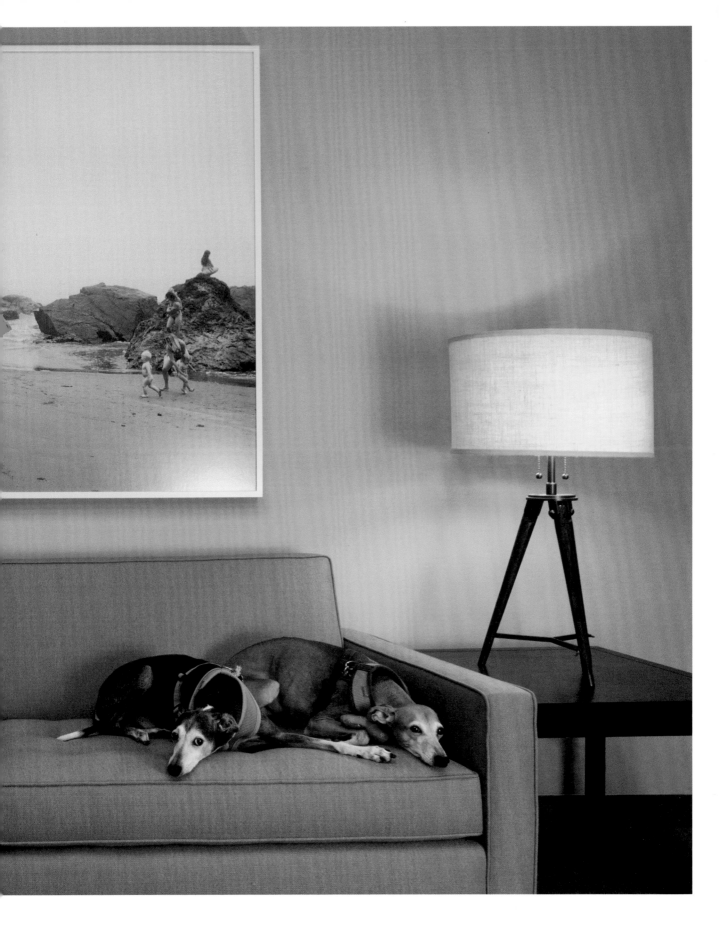

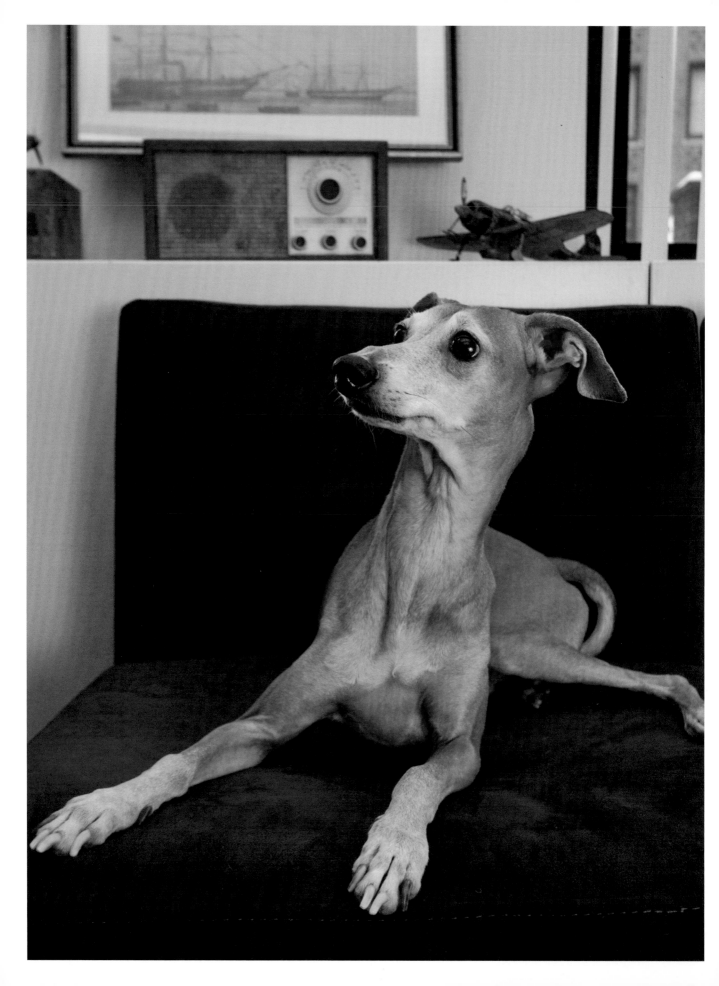

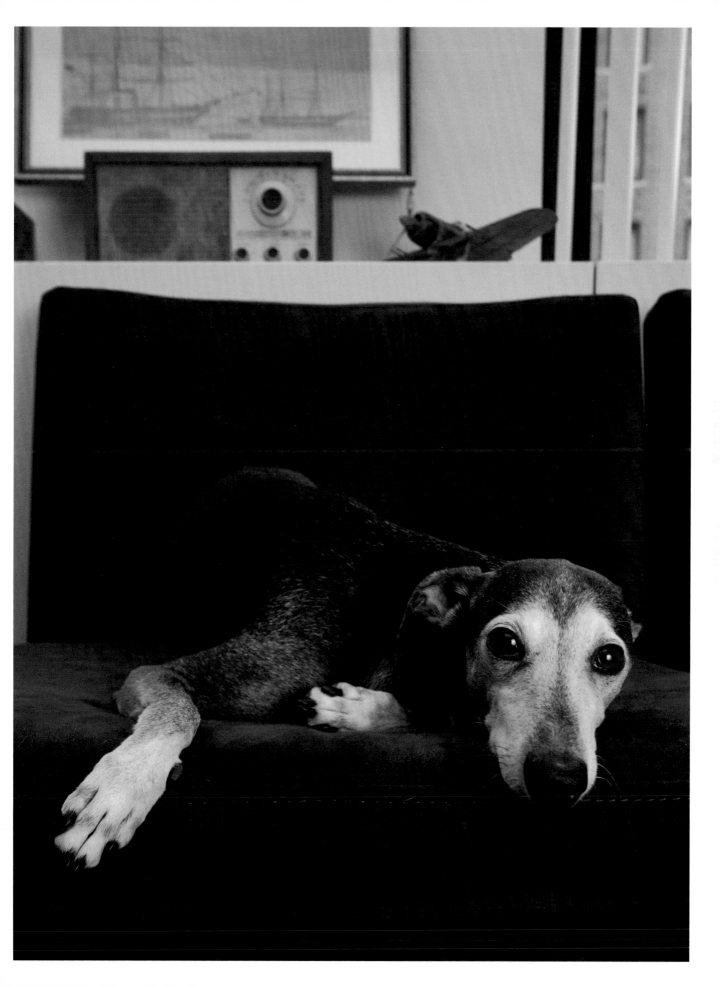

GUSTI, GERMAN WIRE HAIRED POINTER, 11 YEARS OLD, *ABOVE*
HUGO, GERMAN WIRE HAIRED POINTER, 5 YEARS OLD, *OPPOSITE*
RICHARD WRIGHTMAN DESIGN, FURNITURE MAKER, LONG ISLAND CITY

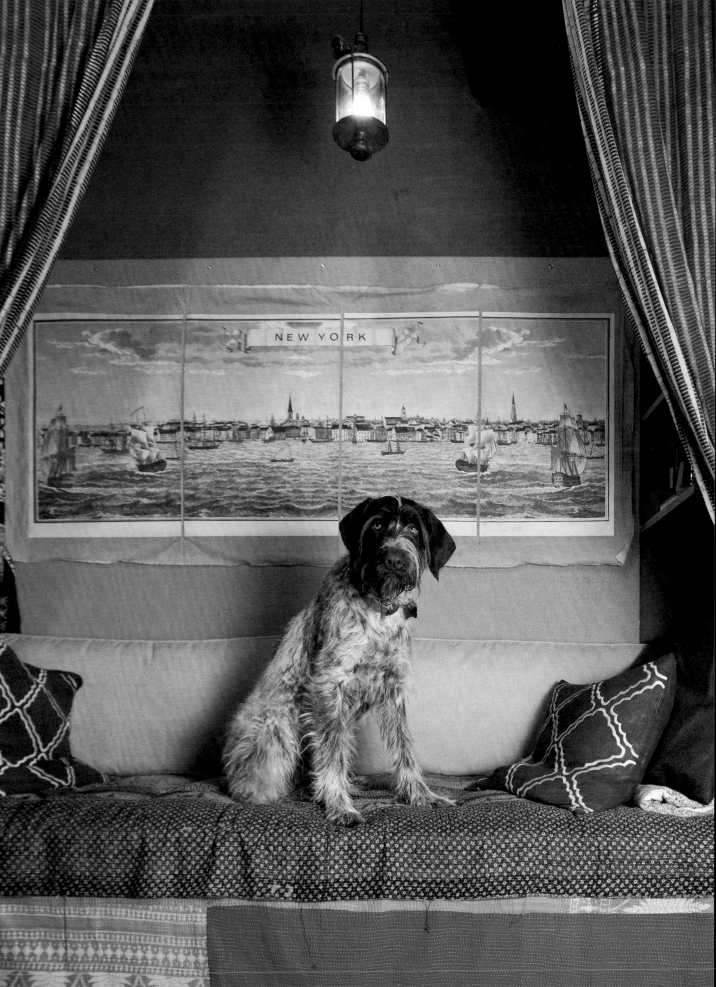

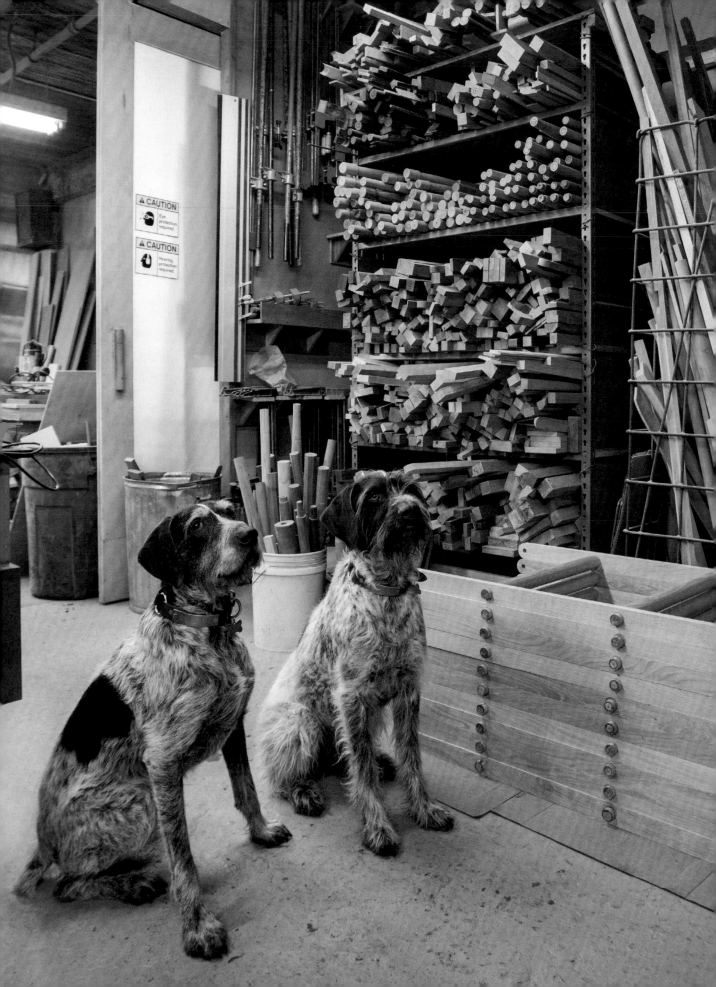

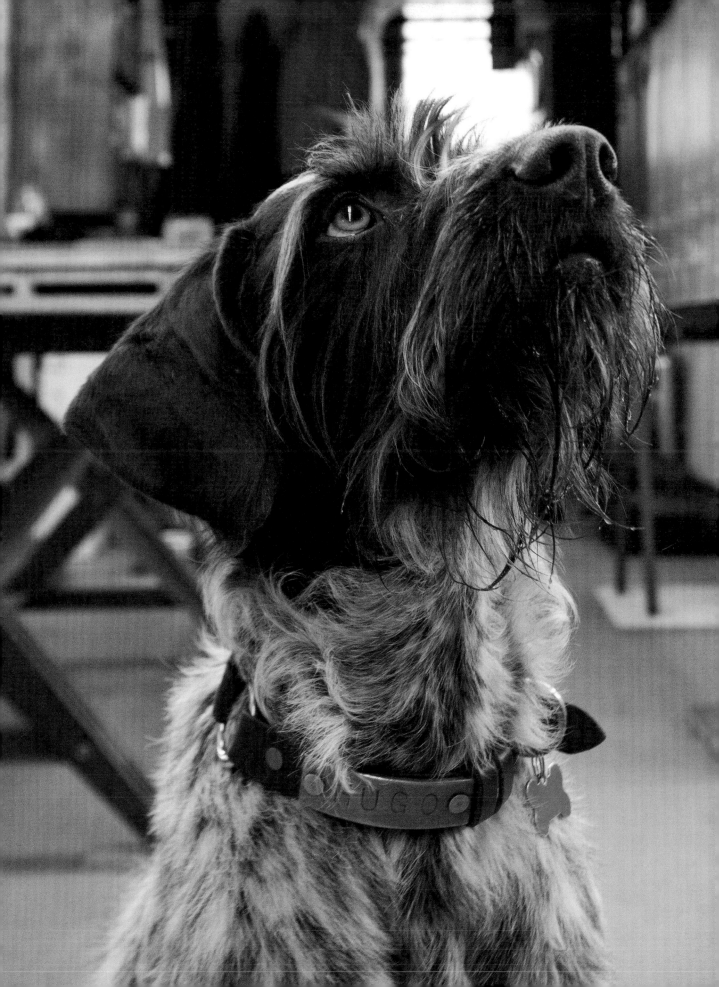

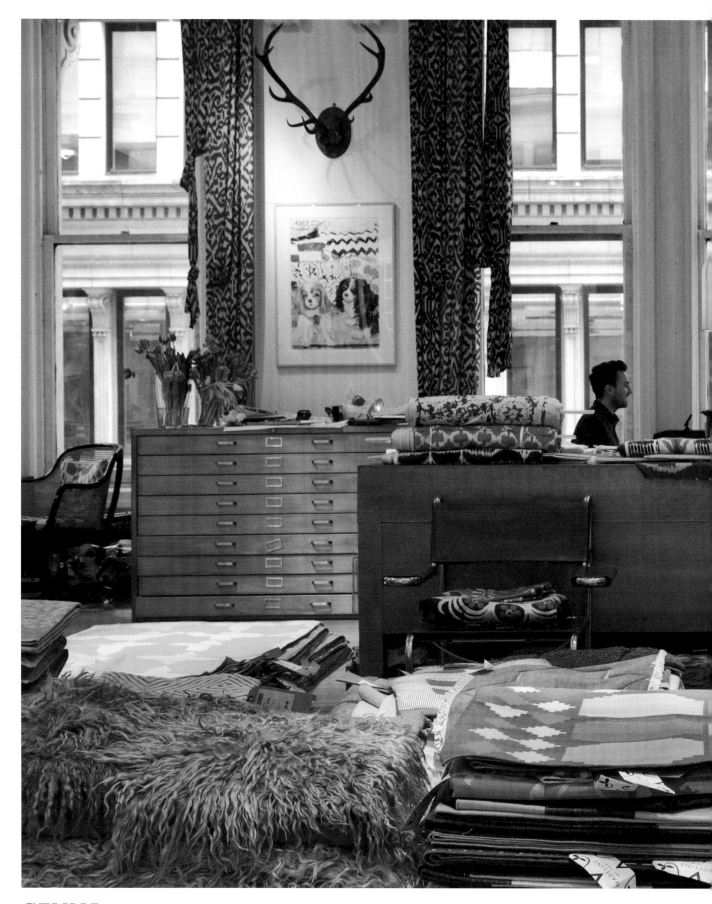

GEMMA, CAVALIER KING CHARLES SPANIEL, 7 YEARS OLD, *LEFT*
DAPHNE, CAVALIER KING CHARLES SPANIEL, 11 YEARS OLD, *RIGHT*
MADELINE WEINRIB SHOWROOM, TEXTILE DESIGN, UNION SQUARE

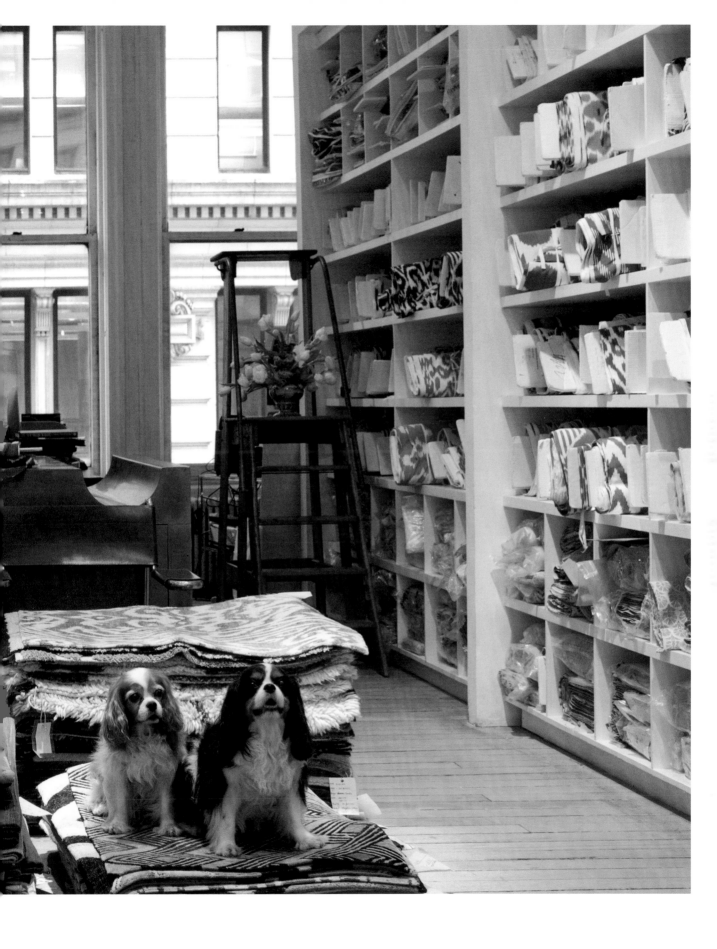

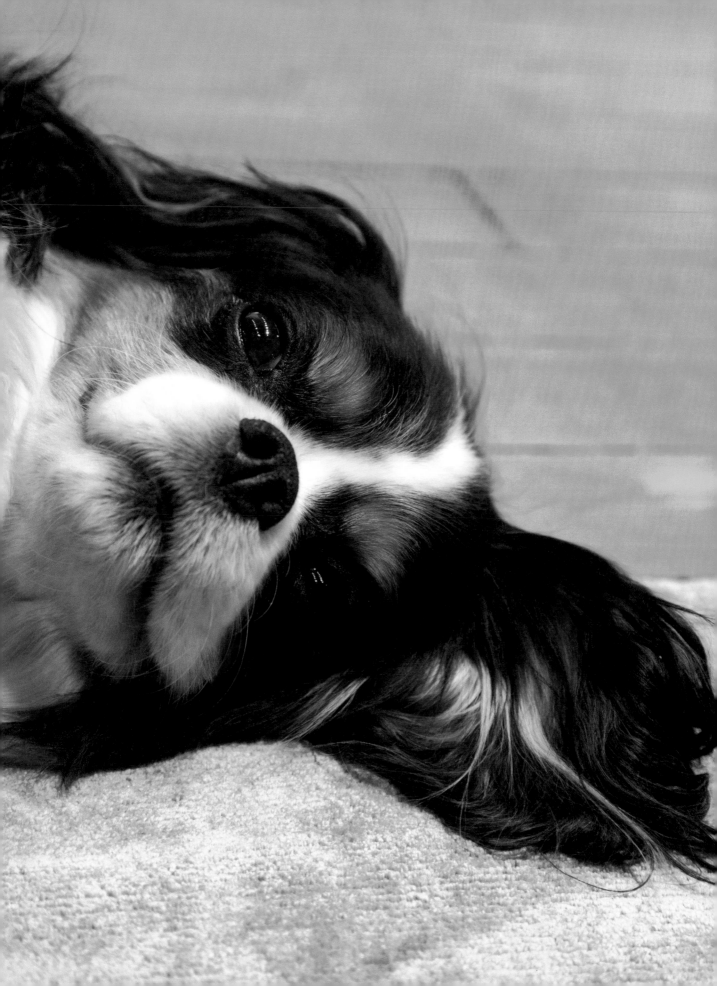

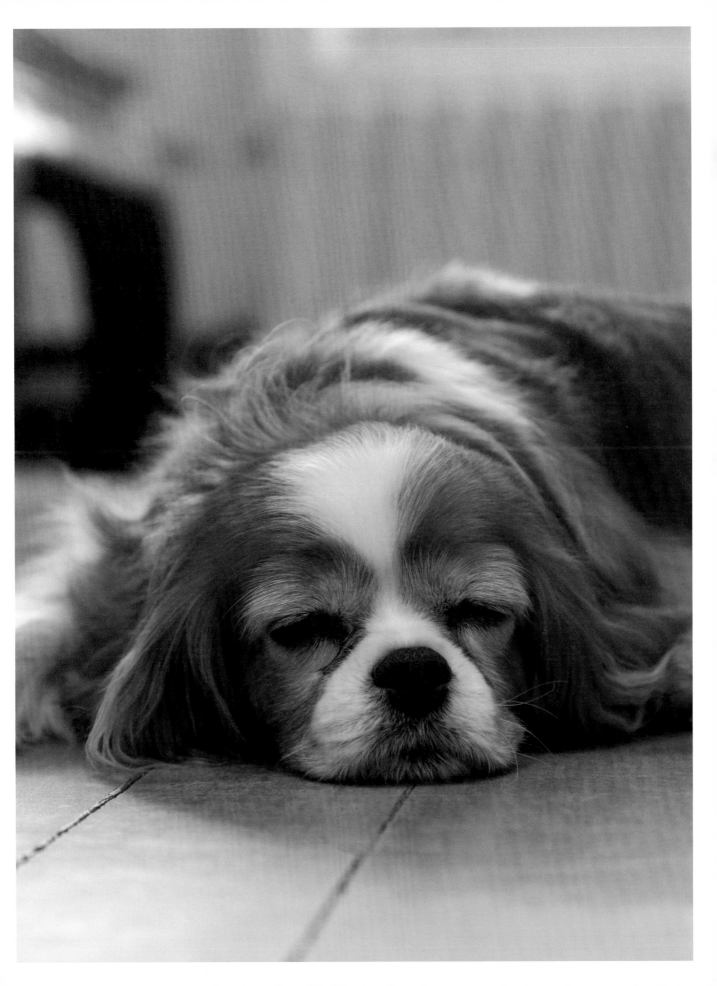

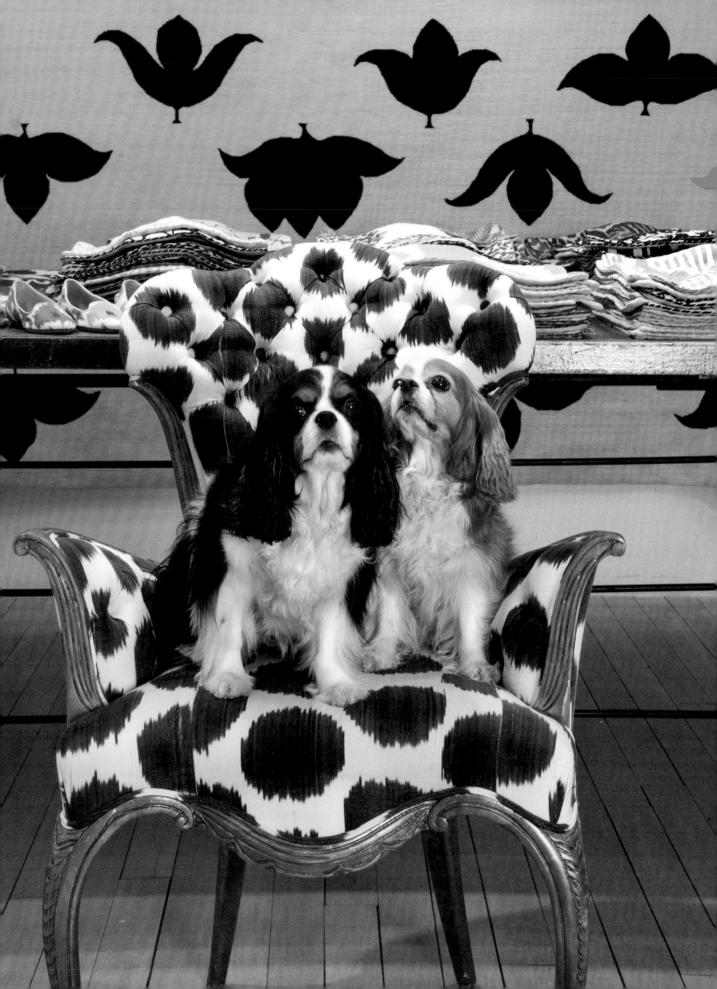

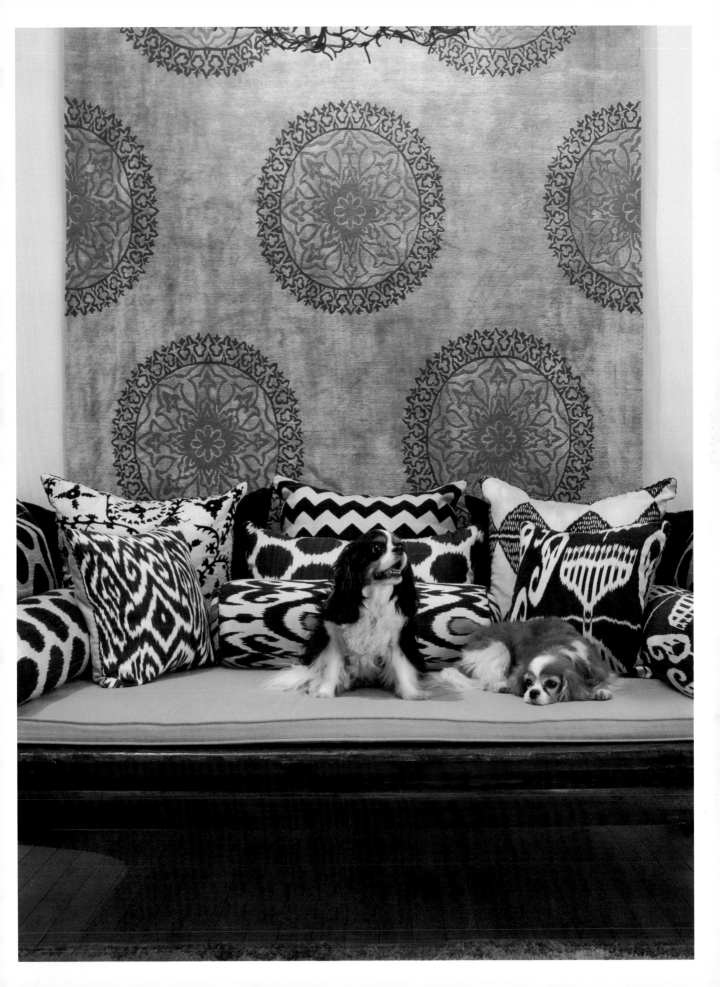

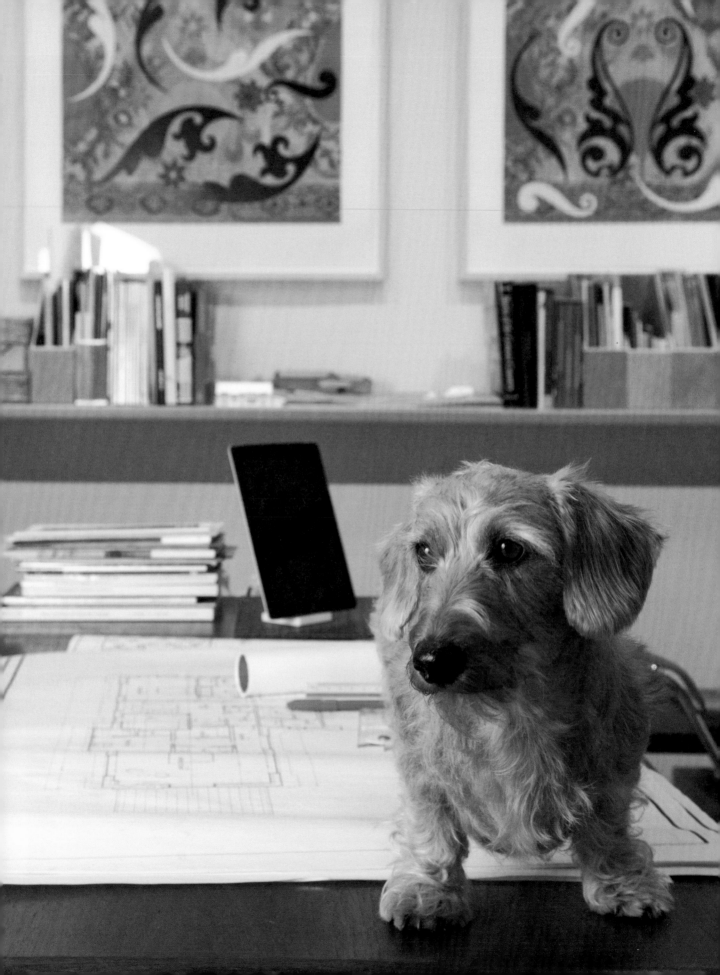

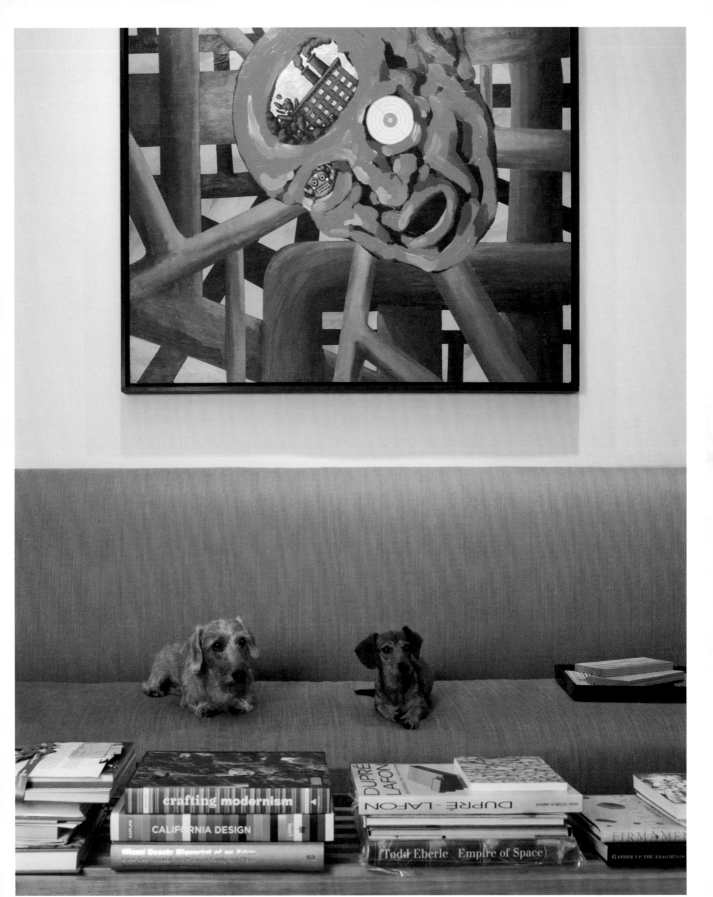

ERNIE, WIRE HAIRED DACHSHUND, 5 YEARS OLD, *OPPOSITE*

SKIPPY, MINI WIRE HAIRED DACHSHUND, 3 YEARS OLD, *ABOVE RIGHT*

ALAN WANZENBERG ARCHITECT & DESIGN, HELL'S KITCHEN

OSKAR, MINI AUSTRALIAN LABRADOODLE, 5 YEARS OLD
JED JOHNSON ASSOCIATES, INTERIOR DESIGN, TRIBECA

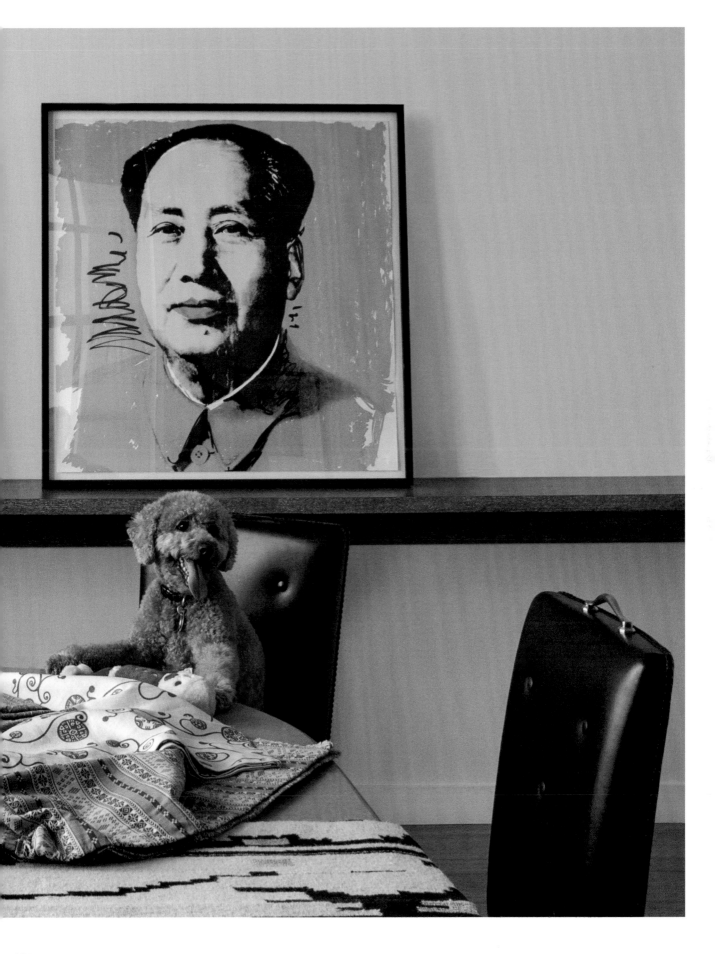

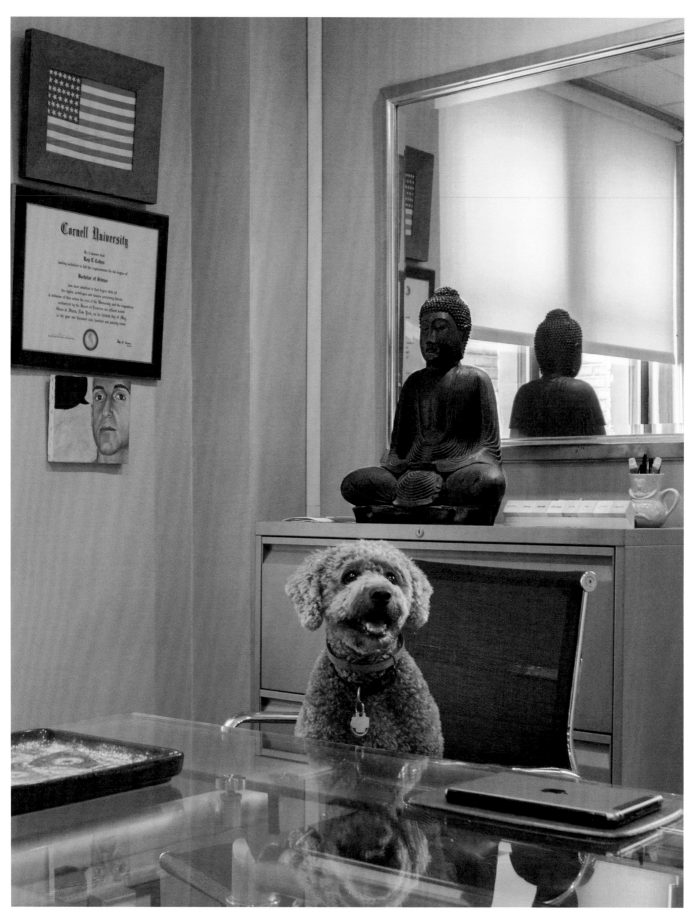

OSKAR, MINI AUSTRALIAN LABRADOODLE, 5 YEARS OLD
ROY COHEN, CAREER COACH AND AUTHOR, MIDTOWN

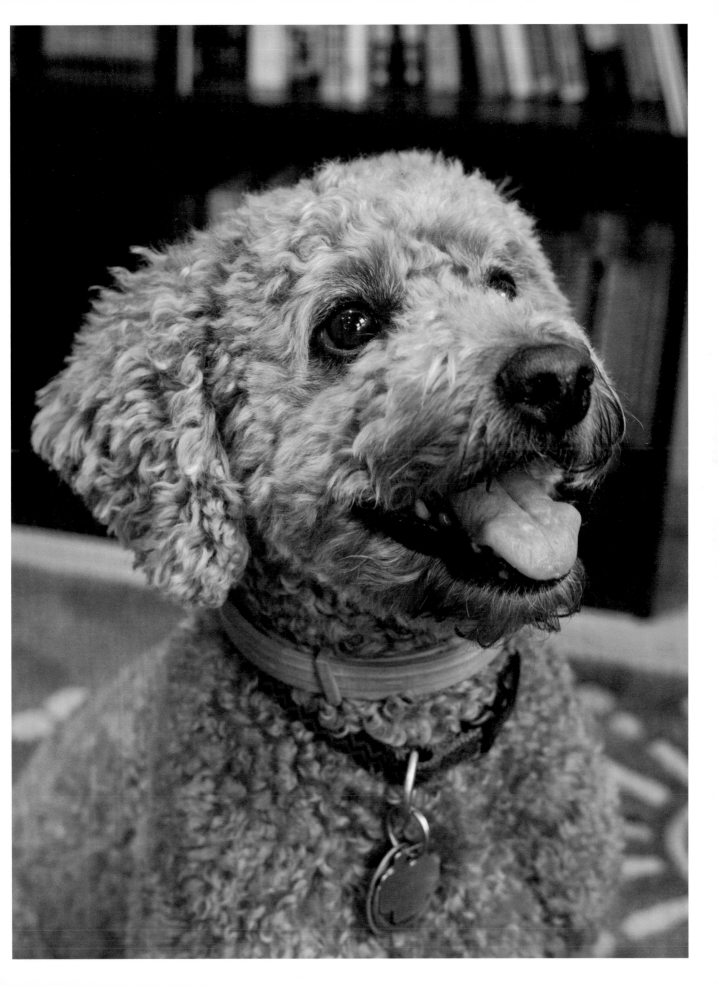

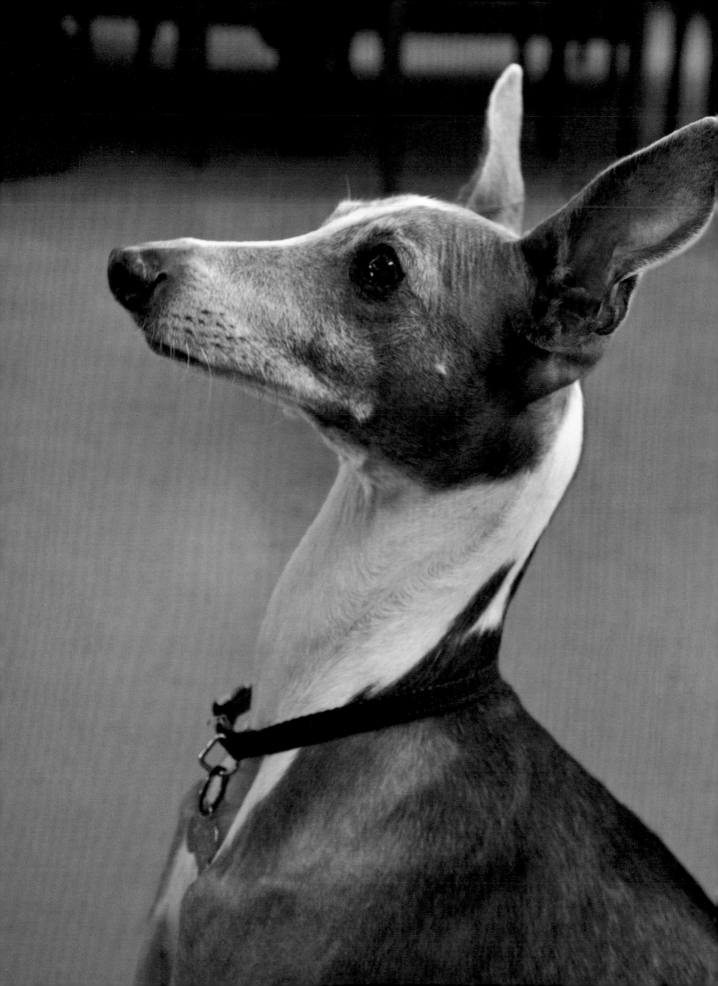

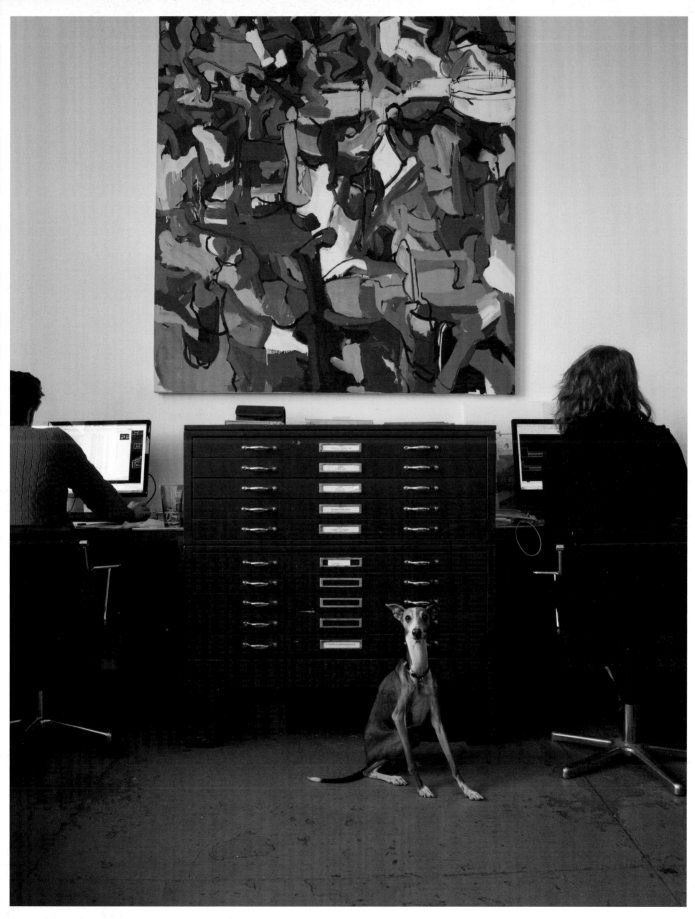

GEOFFREY, ITALIAN GREYHOUND, 8 YEARS OLD
ARCHITECTURE IN FORMATION, CHELSEA

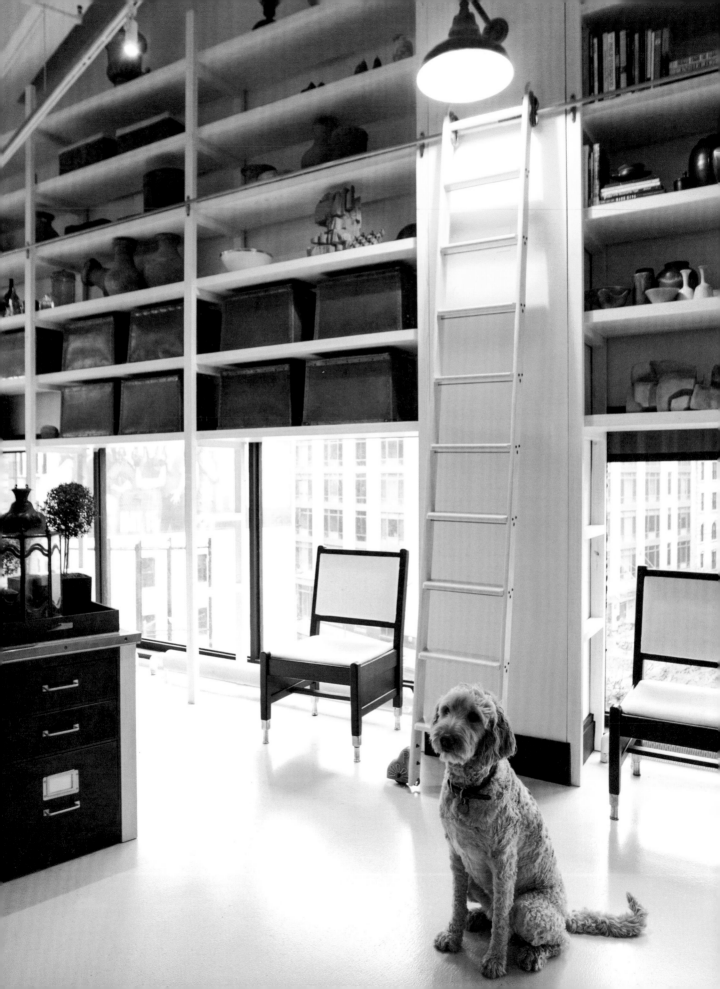

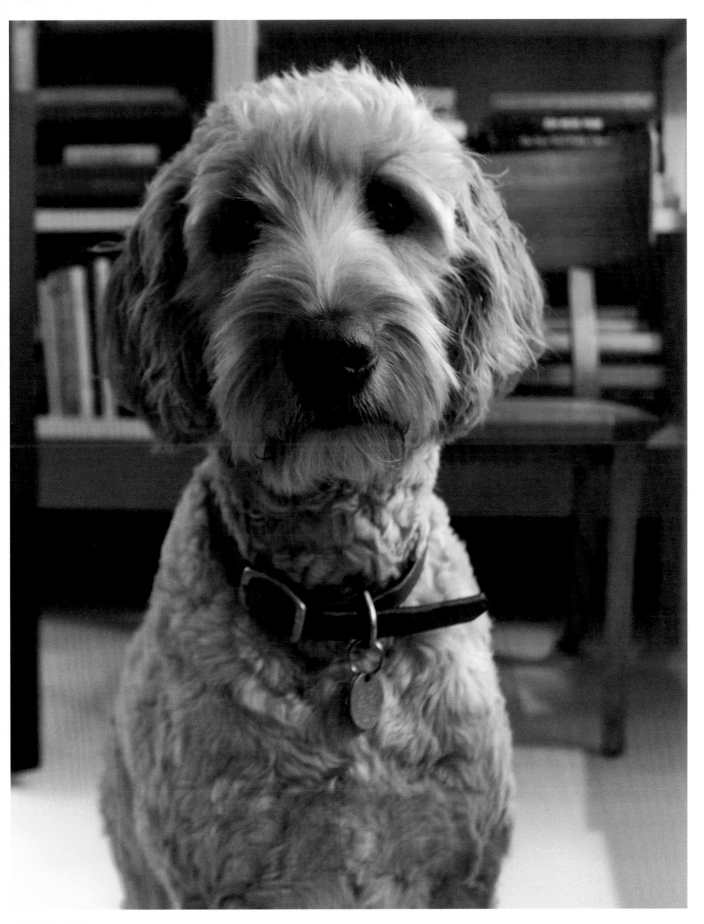

SAILOR, LABRADOODLE, 2 YEARS OLD
S.R. GAMBREL, INTERIOR DESIGN, SOHO

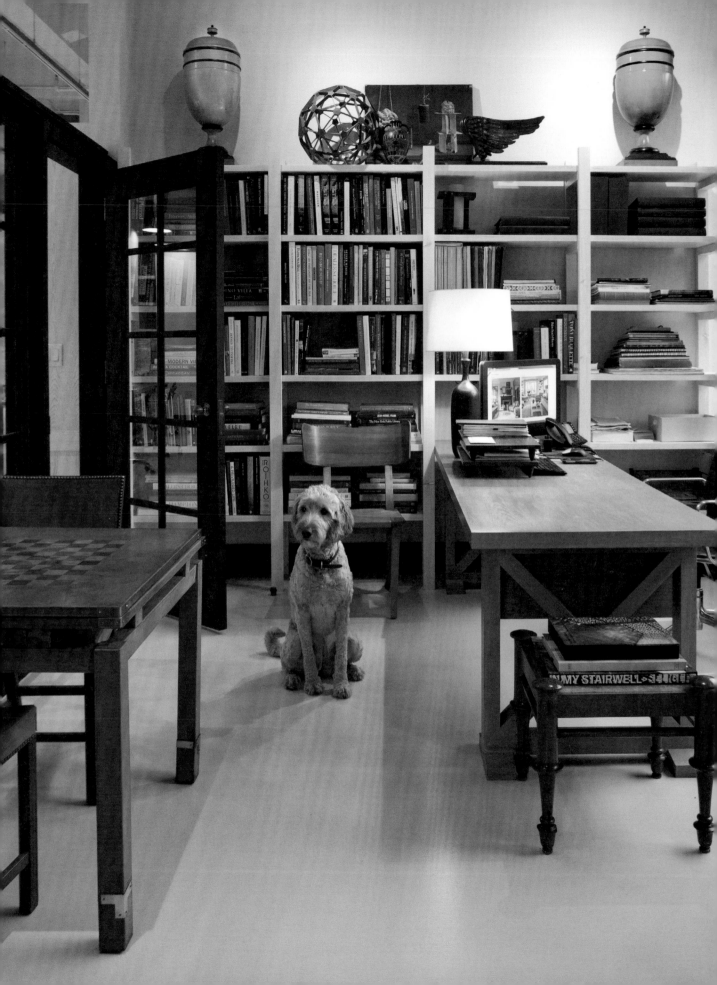

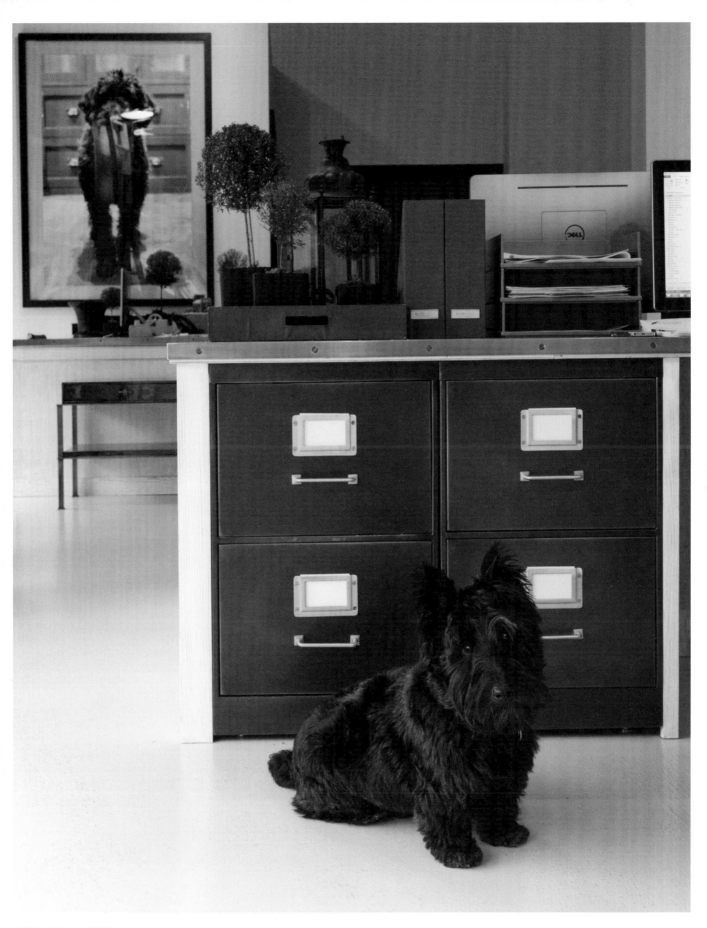

WALLACE, SCOTTISH TERRIER, 3 YEARS OLD
S.R. GAMBREL, INTERIOR DESIGN, SOHO

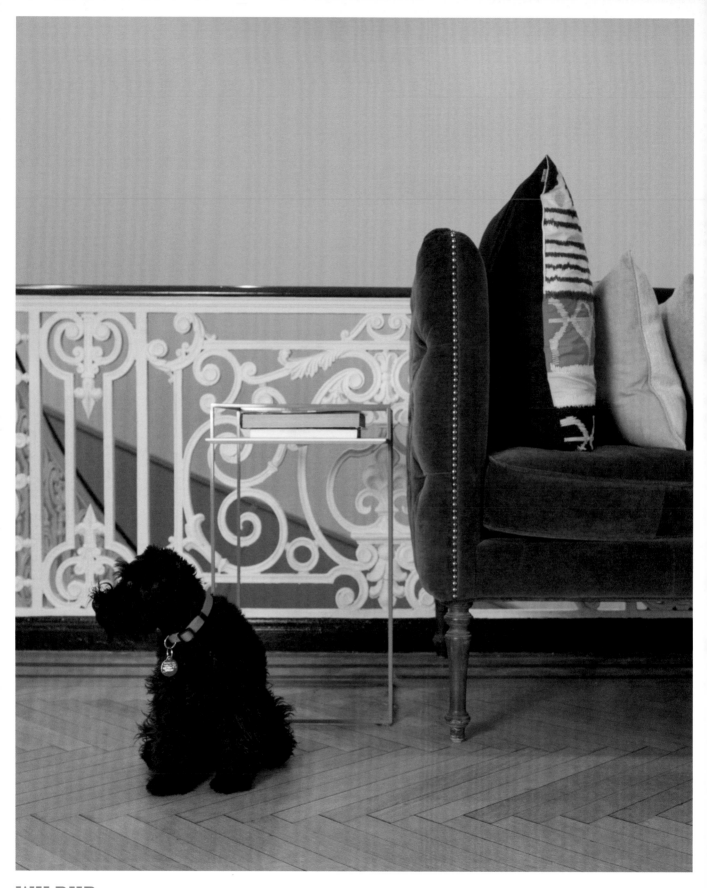

WILBUR, MINI SCHNAUZER, 4 MONTHS OLD, *ABOVE*
ML SEARCH PARTNERS AT WEWORK, ENTERTAINMENT RECRUITERS, MIDTOWN
BOO, BLUE GREAT DANE, 3 YEARS OLD, *OPPOSITE RIGHT*
REES DRAPER WRIGHT AT WEWORK, BOUTIQUE HEADHUNTING AGENCY, MIDTOWN

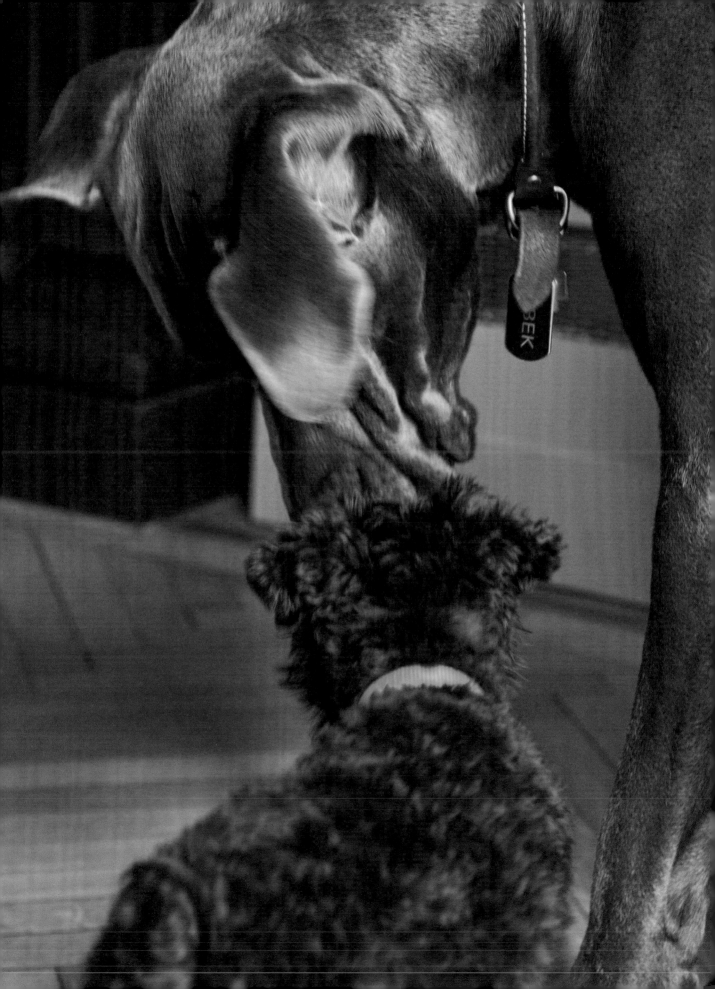

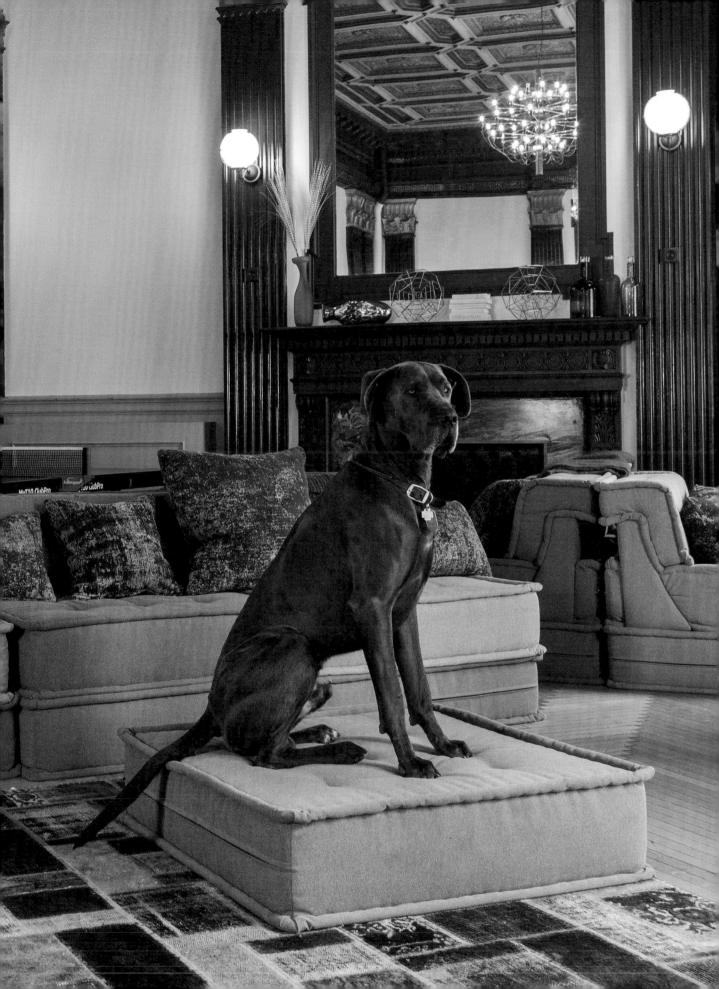

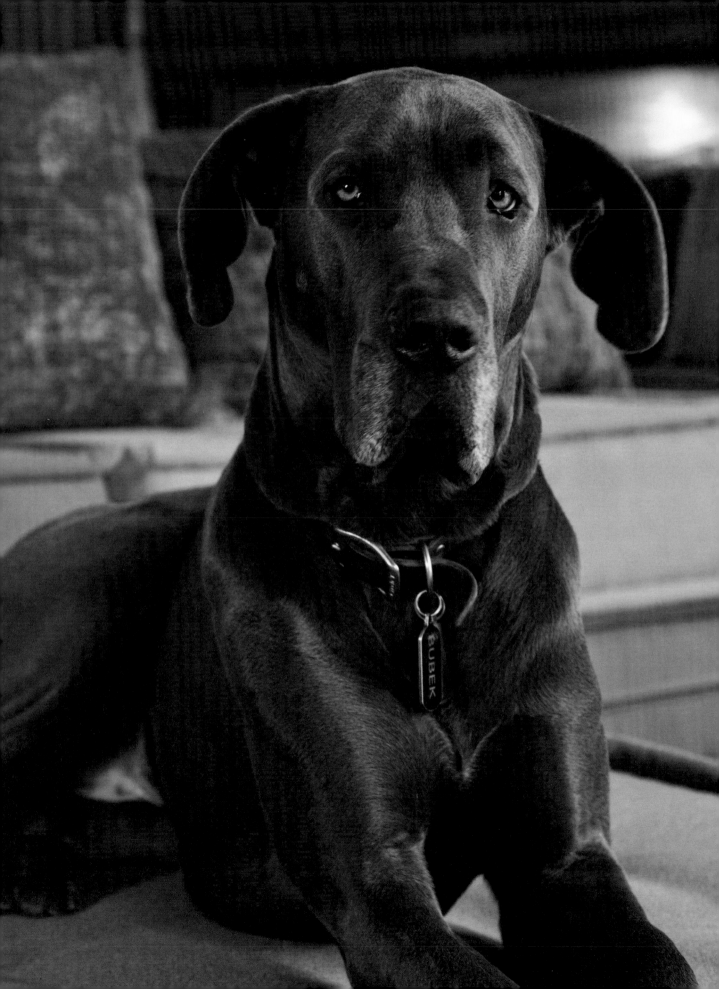

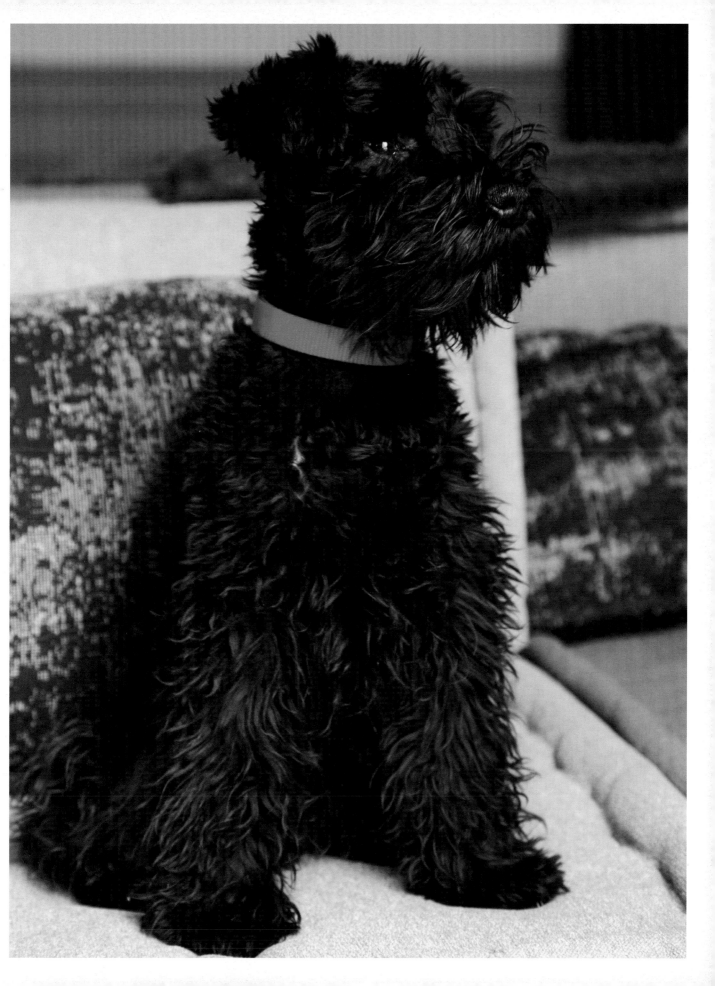

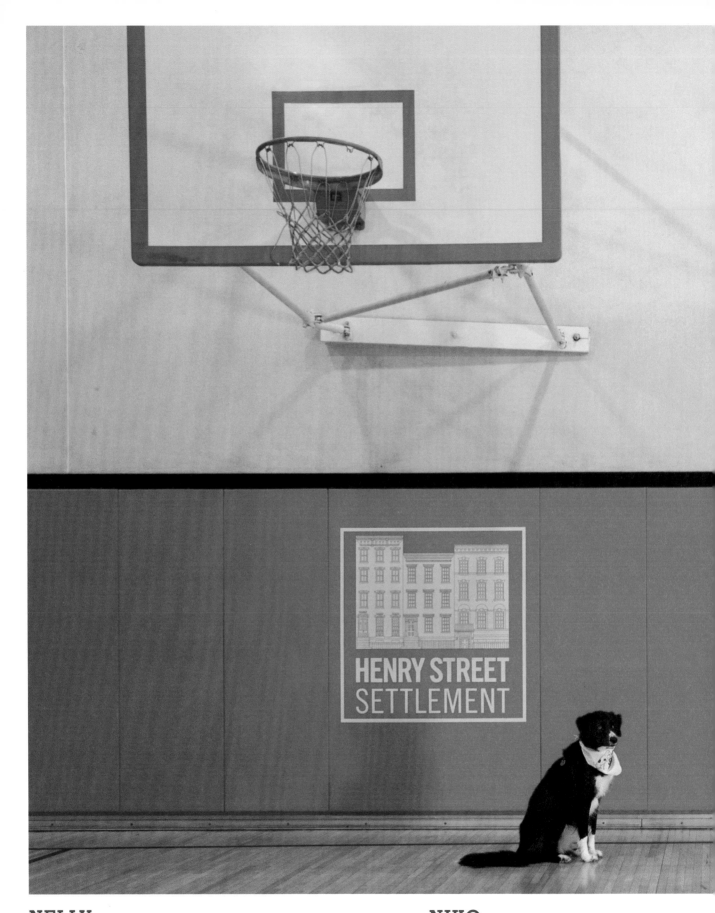

NELLY, RETRIEVER / GREAT PYRENEES MIX, 16 MONTHS OLD, *LEFT* **NIKO**, DOBERMAN, 4 YEARS OLD, *CENTER*
DAKOTA, GOLDEN RETRIEVER, 6 YEARS OLD, *RIGHT*
A FAIR SHAKE FOR YOUTH, YOUTH OUTREACH PROGRAM, ON LOCATION ON THE LOWER EAST SIDE

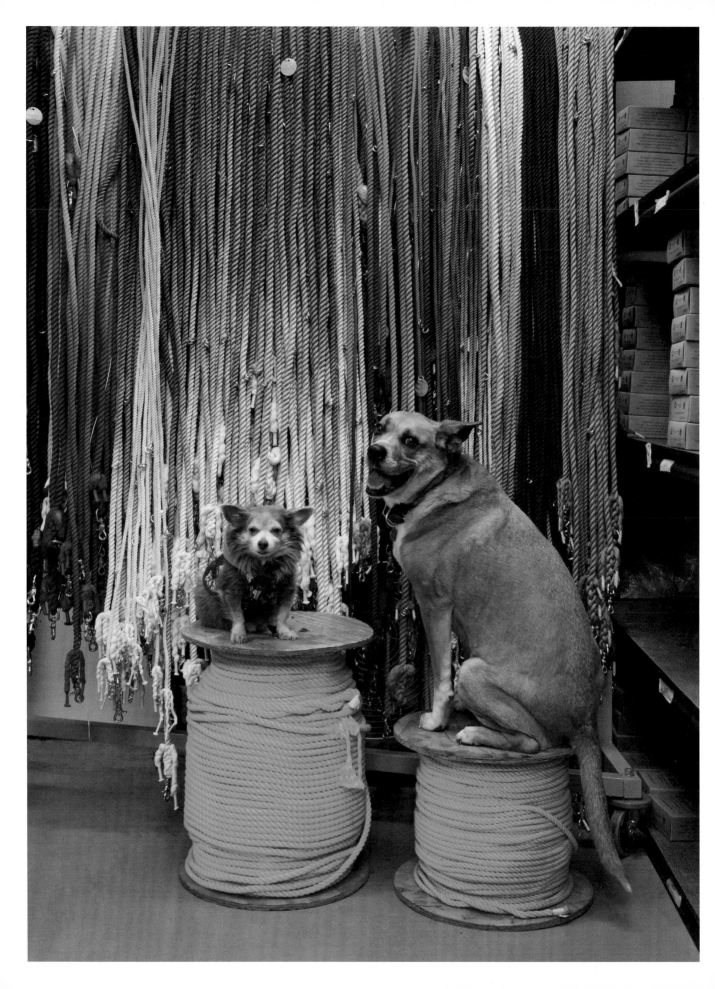

ASSOCIATES

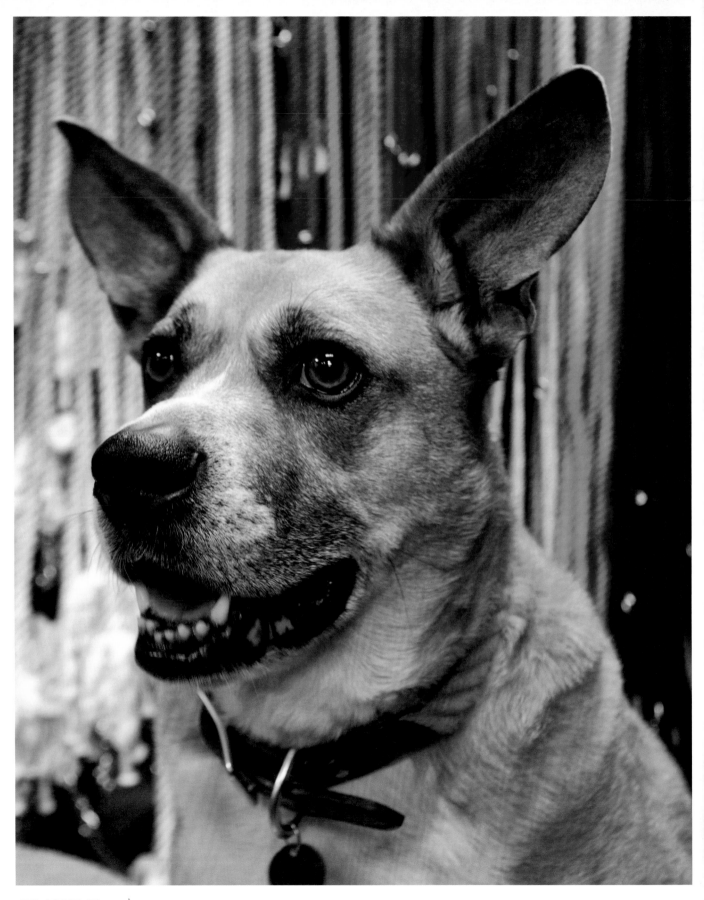

CLAUDE, SHEPHERD MIX, 6 YEARS OLD, *ABOVE*
HENRI, CHIHUAHUA, 11 YEARS OLD, *OPPOSITE*
FOUND MY ANIMAL, ANIMAL ACCESSORIES AND ADOPTION AWARENESS, BEDFORD-STUYVESANT

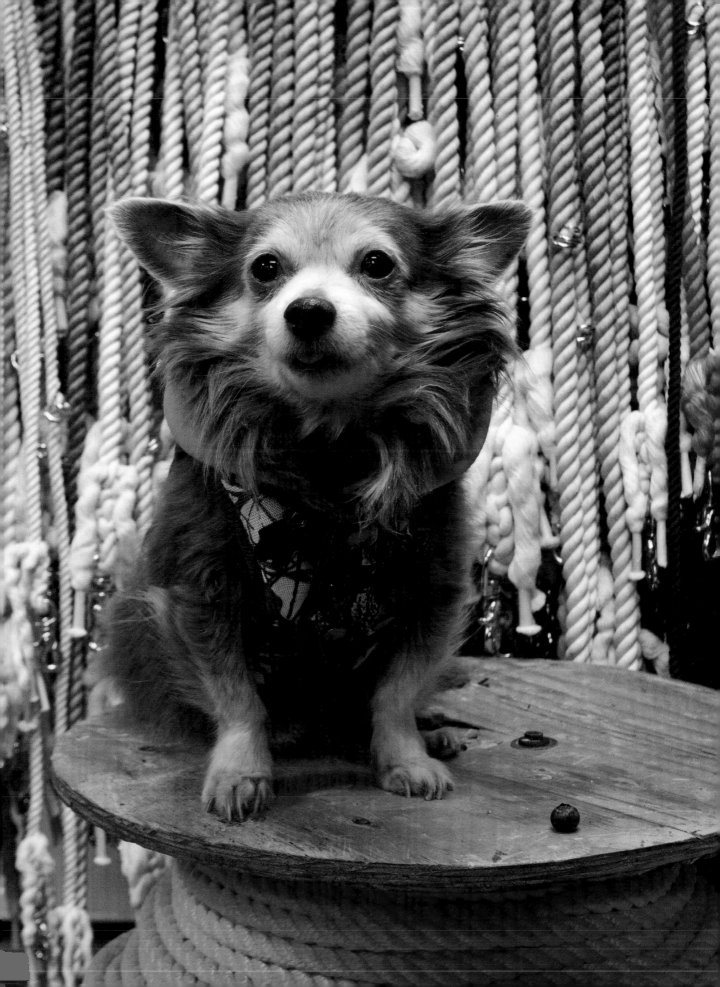

BELLO, ENGLISH / FRENCH BULLDOG MIX, 4 YEARS OLD
MF PRODUCTIONS, SPECIAL EVENTS PRODUCTION, CHELSEA

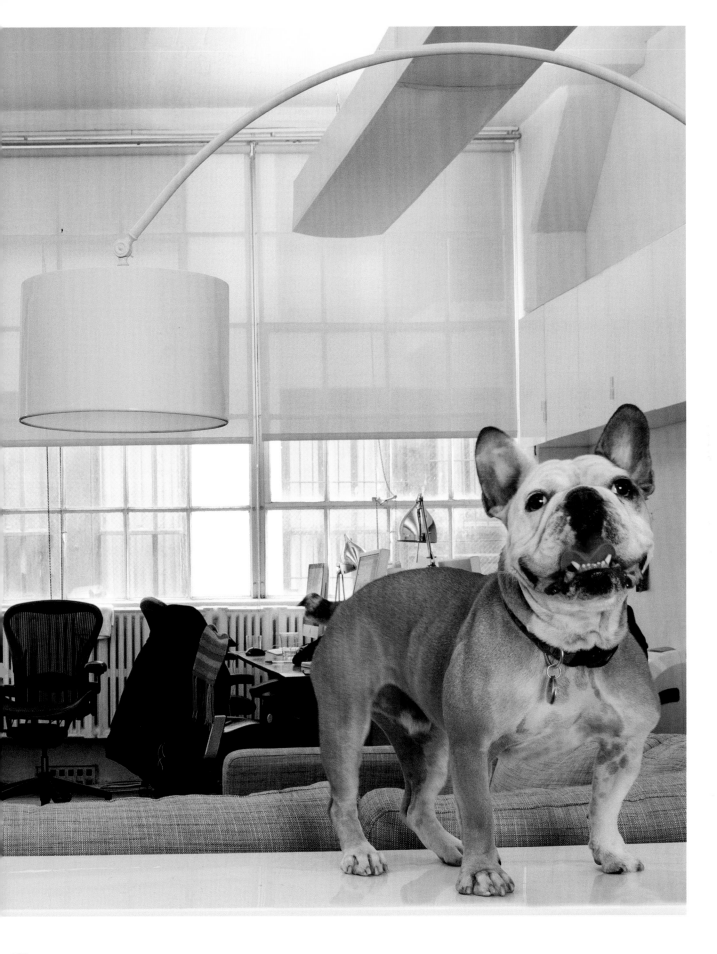

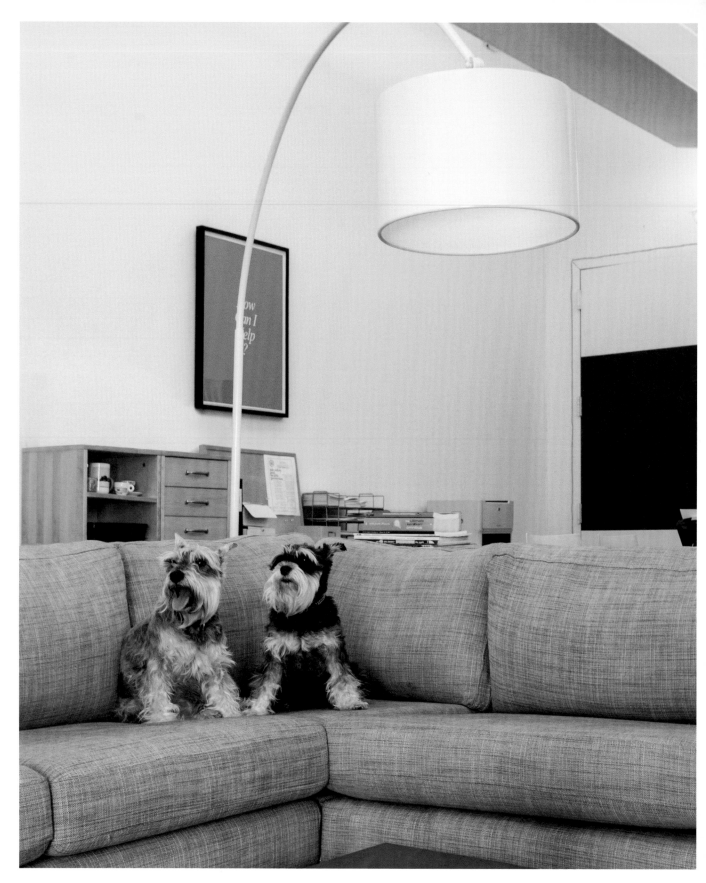

OSCAR MITCHELL, SCHNAUZER, 10 YEARS OLD, *ABOVE LEFT*
SCHATZIE MARIE, MINI SCHNAUZER, 5 YEARS OLD, *ABOVE RIGHT*
BUG, LAB / WHIPPET / PITBULL MIX, 3 YEARS OLD, *OPPOSITE MIDDLE,* AND **BELLO**
MF PRODUCTIONS, SPECIAL EVENTS PRODUCTION, CHELSEA

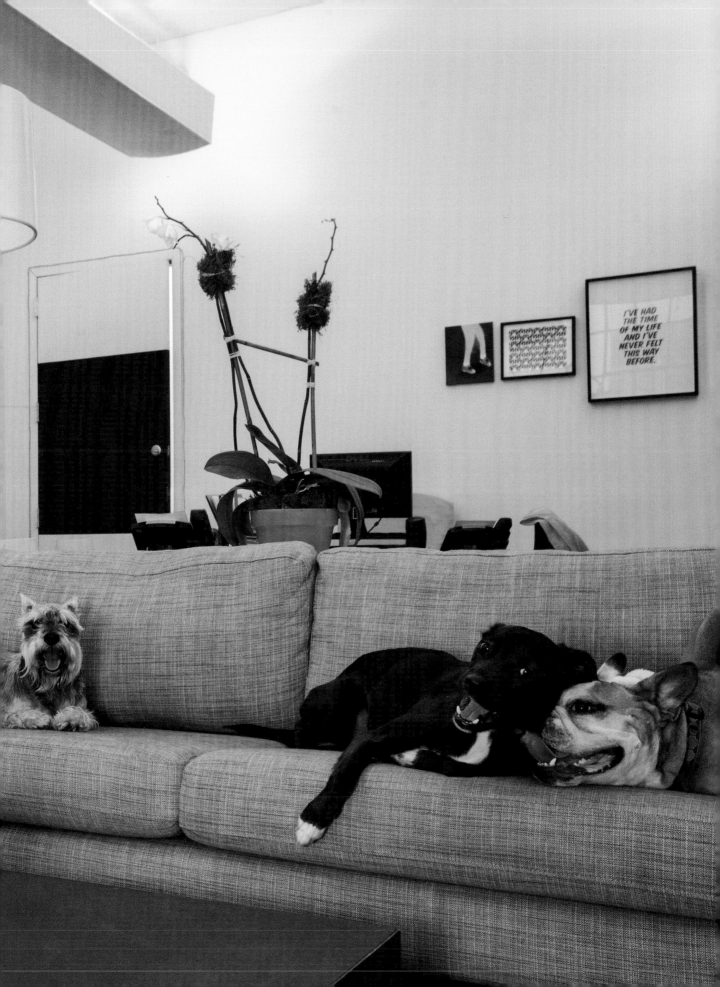

GRACE, DACHSHUND, 16 YEARS OLD, *LEFT*
BEA, DACHSHUND, 11 YEARS OLD, *RIGHT*
ART-DEPT, ILLUSTRATION DIVISION, ILLUSTRATION AGENCY, CHELSEA

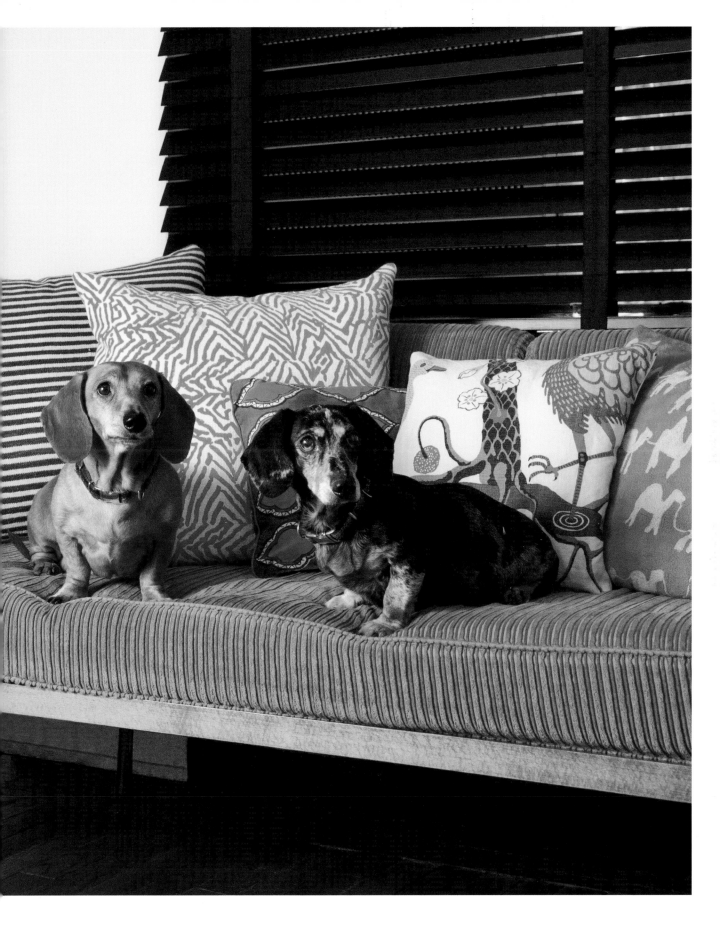

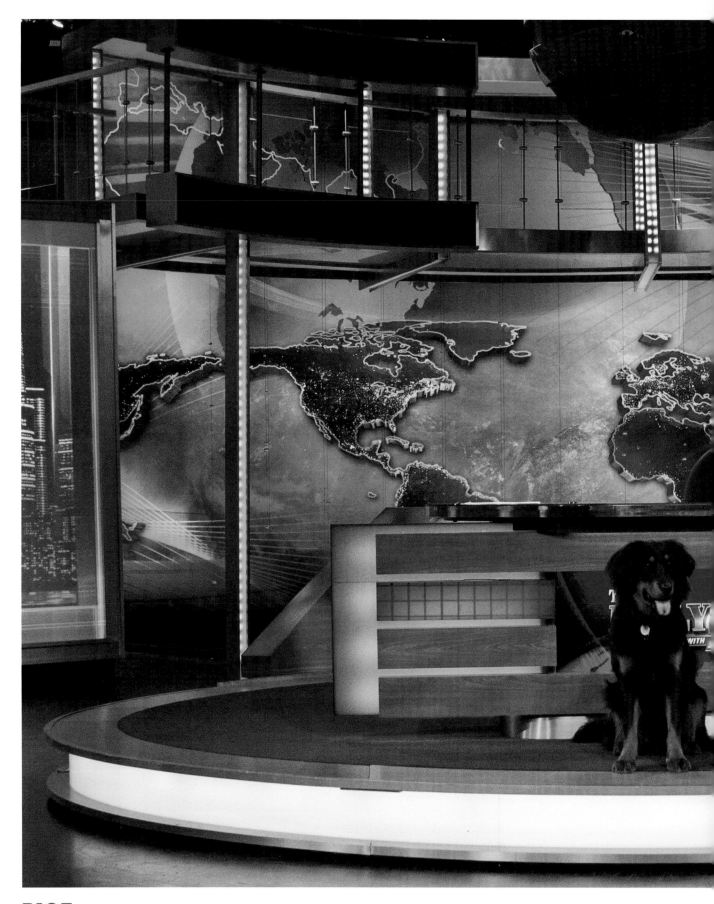

RIOT, SHEPHERD MIX, 1 YEAR OLD, *LEFT*
PARKER, BLACK LAB MIX, 10 YEARS OLD, *RIGHT*
THE DAILY SHOW WITH JON STEWART, TELEVISION STUDIO, HELL'S KITCHEN

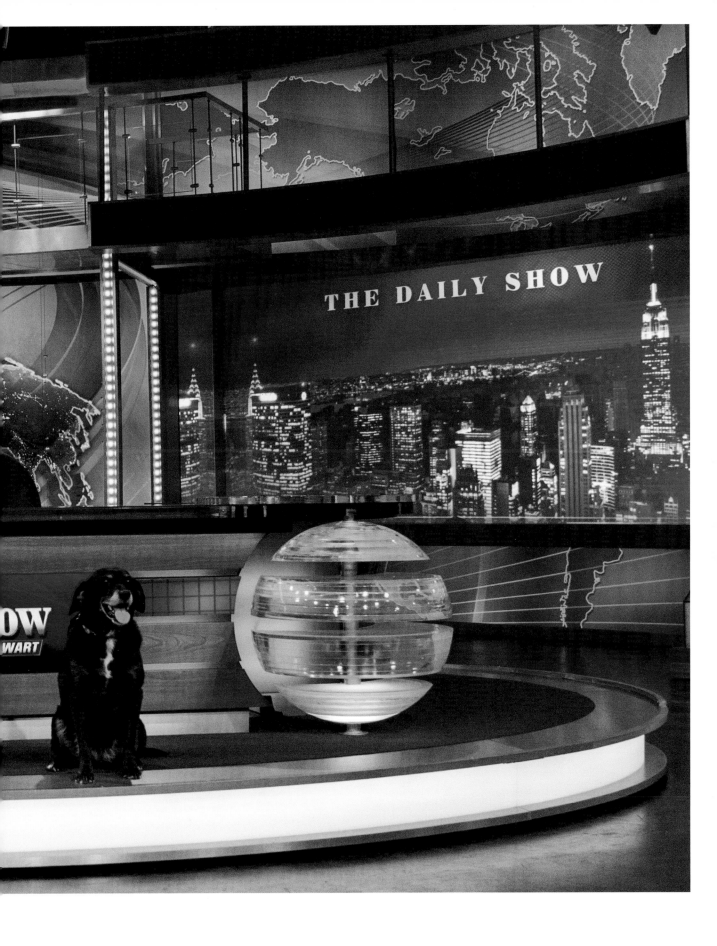

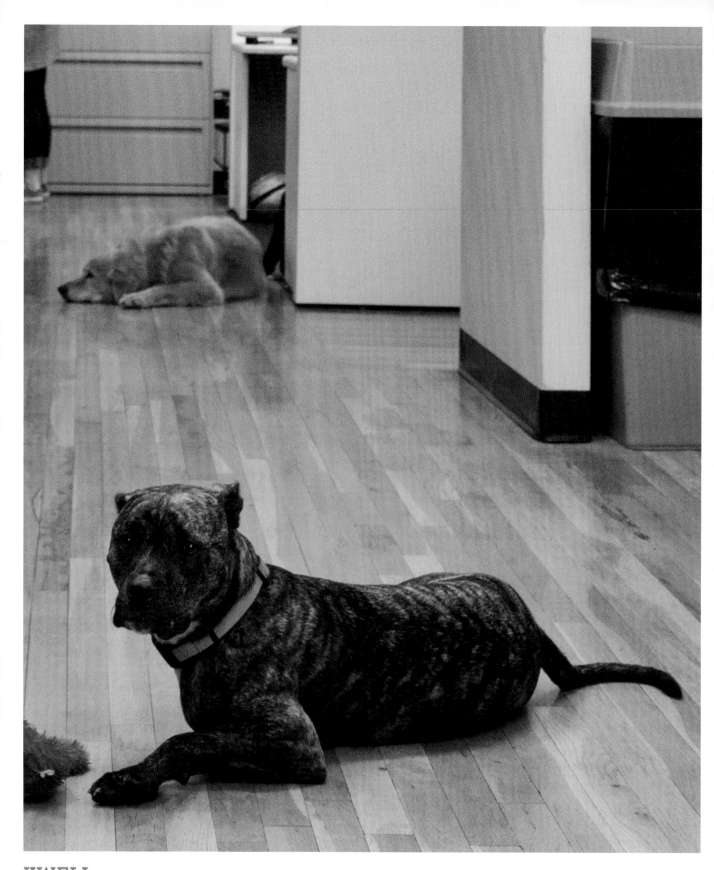

KWELI, CHOW CHOW / SHEPHERD / GOLDEN RETRIEVER / BORDER COLLIE MIX, 11 YEARS OLD, *ABOVE TOP AND OPPOSITE BOTTOM LEFT* **DIPPER**, BRINDLE PITBULL, 2 YEARS OLD, *ABOVE BOTTOM* **MYRNA**, BEAGLE MIX, 9 YEARS OLD, *OPPOSITE TOP LEFT* **STRANGER**, BERNESE MOUNTAIN DOG, 5 YEARS OLD, *OPPOSITE TOP RIGHT* **ALLY**, GERMAN SHORTHAIRED POINTER / BEAGLE MIX, 7 YEARS OLD, *OPPOSITE BOTTOM RIGHT* THE DAILY SHOW WITH JON STEWART, TELEVISION STUDIO, HELL'S KITCHEN

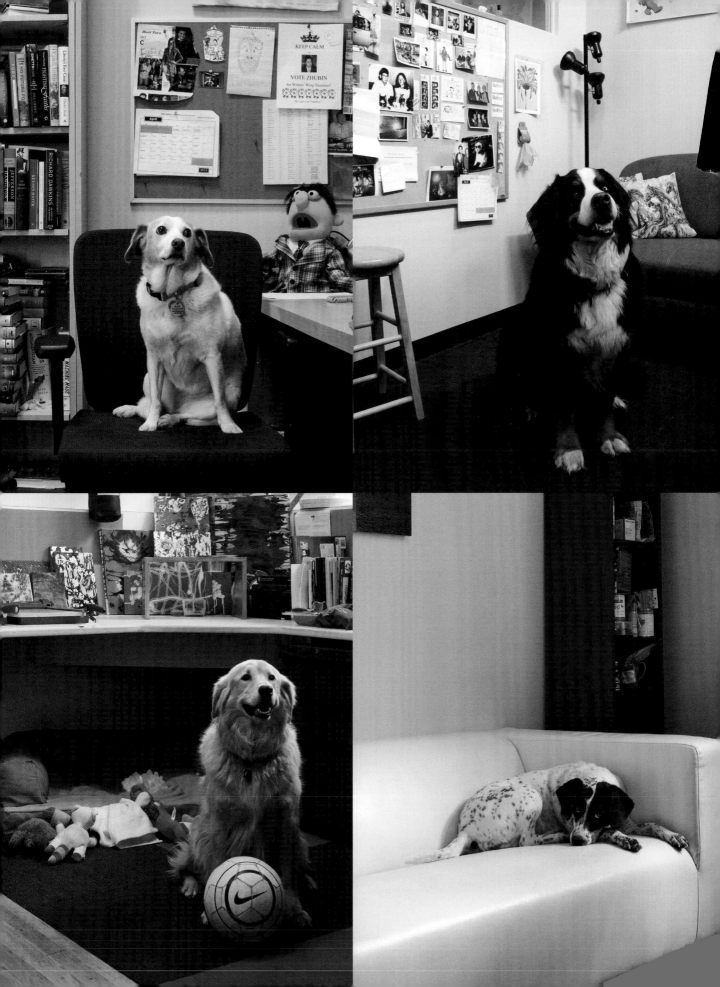

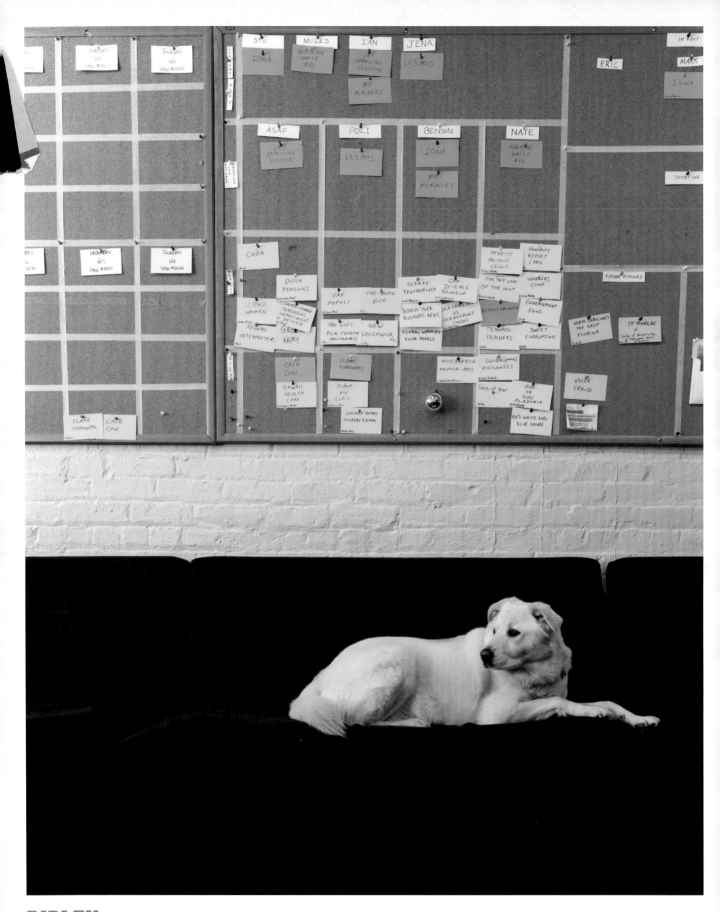

RIPLEY, LAB MIX, 5 YEARS OLD, *ABOVE*
ZELDA, FRENCH BULLDOG / BOSTON TERRIER MIX, 1 YEAR OLD, *OPPOSITE*
THE DAILY SHOW WITH JON STEWART, TELEVISION STUDIO, HELL'S KITCHEN

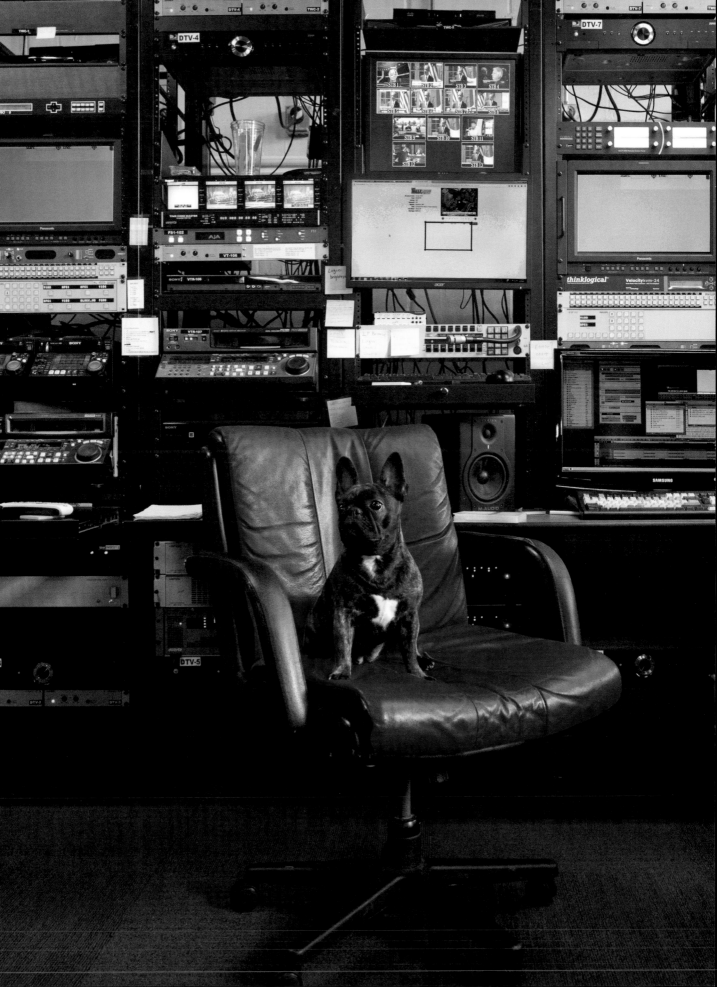

FRANCESCA, MINI DACHSHUND, 6 YEARS OLD, *ABOVE LEFT*
ARCHIE, WEST HIGHLAND WHITE TERRIER, 2 YEARS OLD, *ABOVE RIGHT*
CAMILLA DIETZ BERGERON LTD, ANTIQUES AND ESTATE JEWELRY STORE, UPPER EAST SIDE

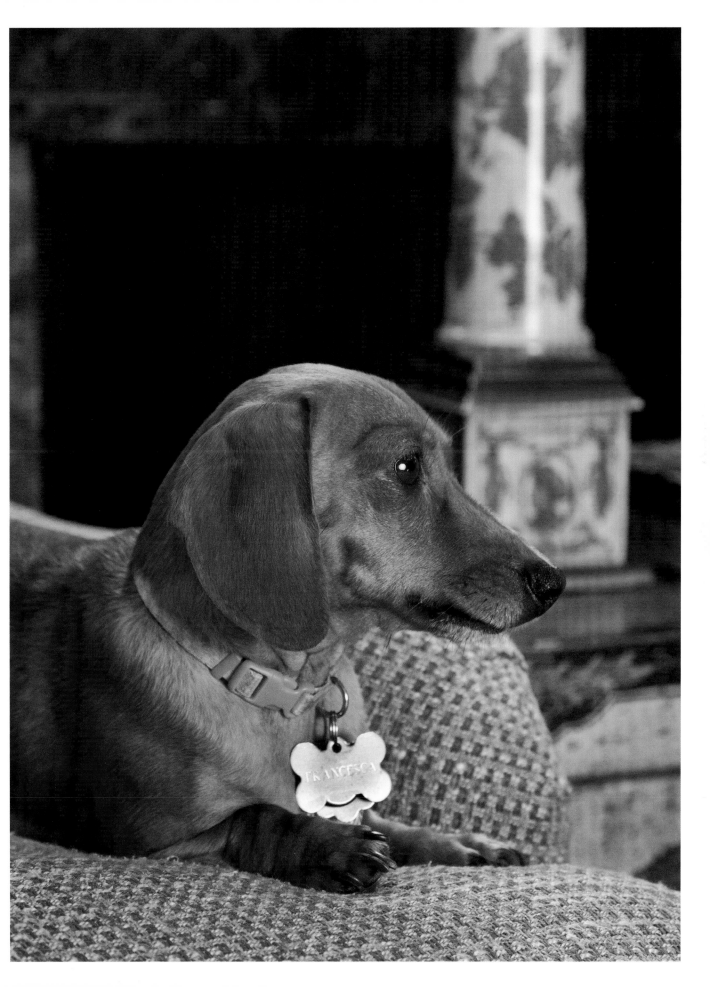

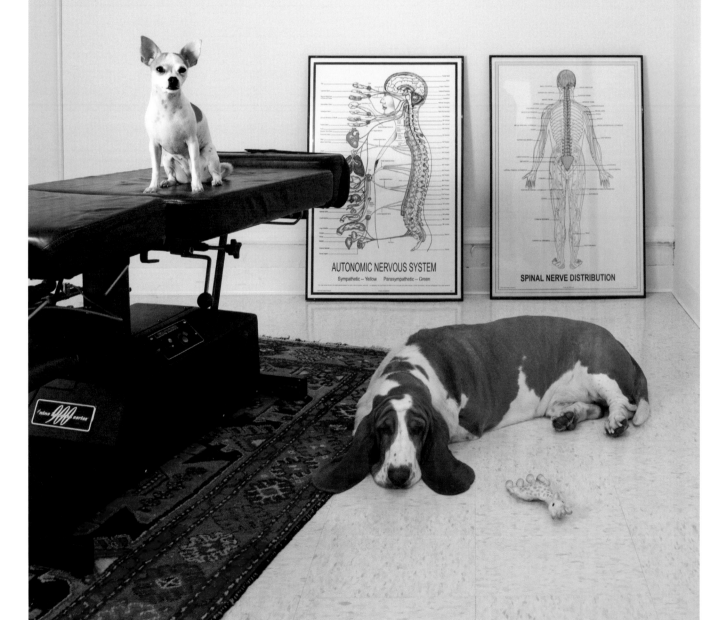

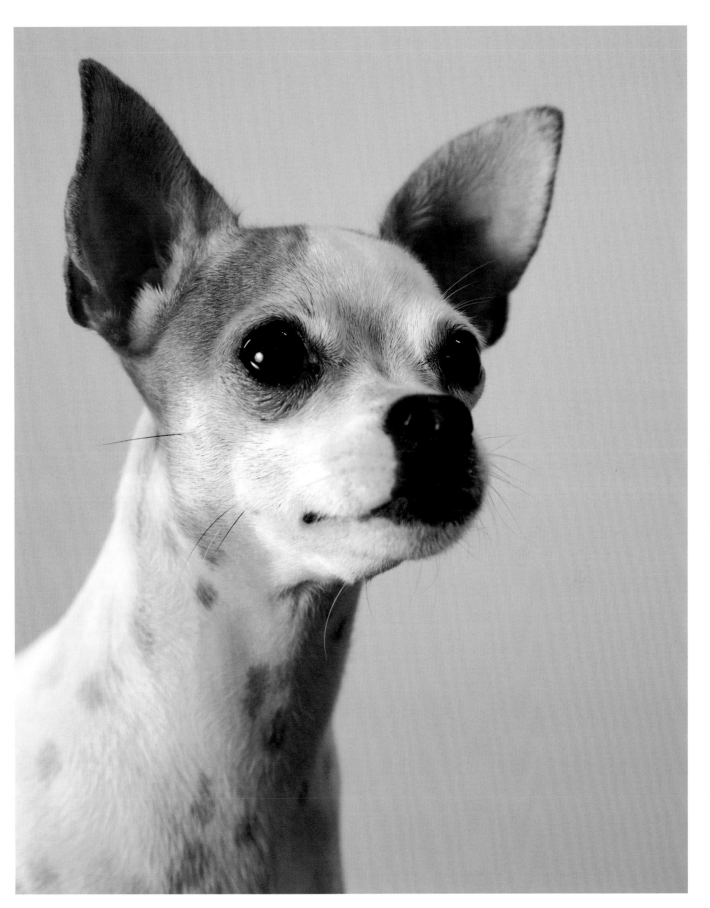

LUPITA, CHIHUAHUA, 1 YEAR OLD, *OPPOSITE LEFT*
EDDIE, BASSET HOUND, 4 YEARS OLD, *OPPOSITE RIGHT*
DR. LILA WOLFE, LIFE CHIROPRACTIC, FINANCIAL DISTRICT

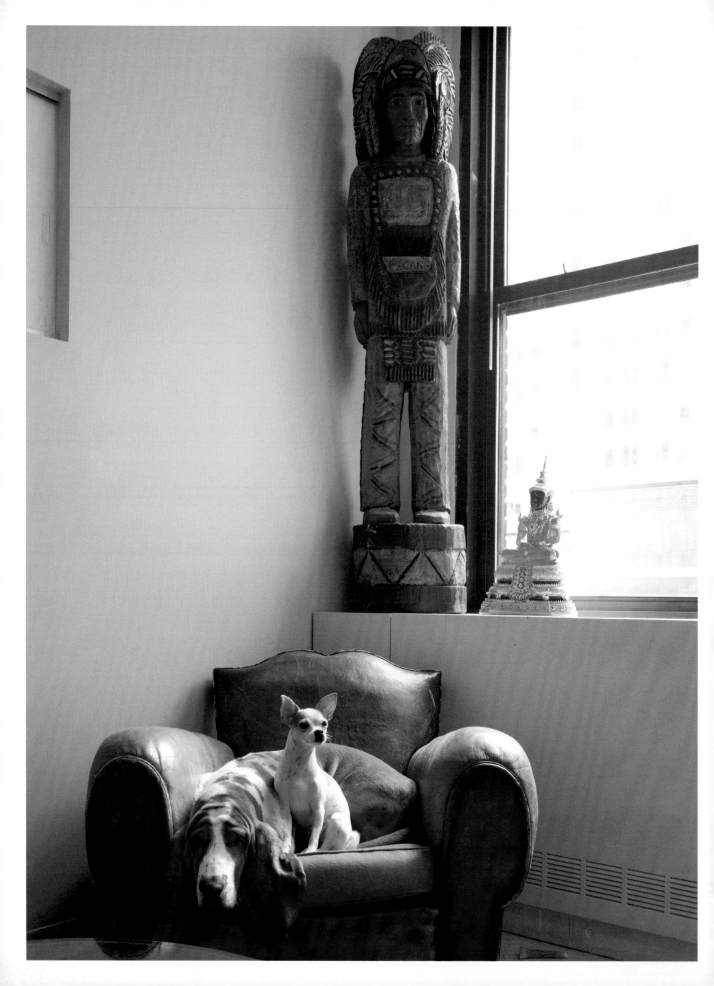

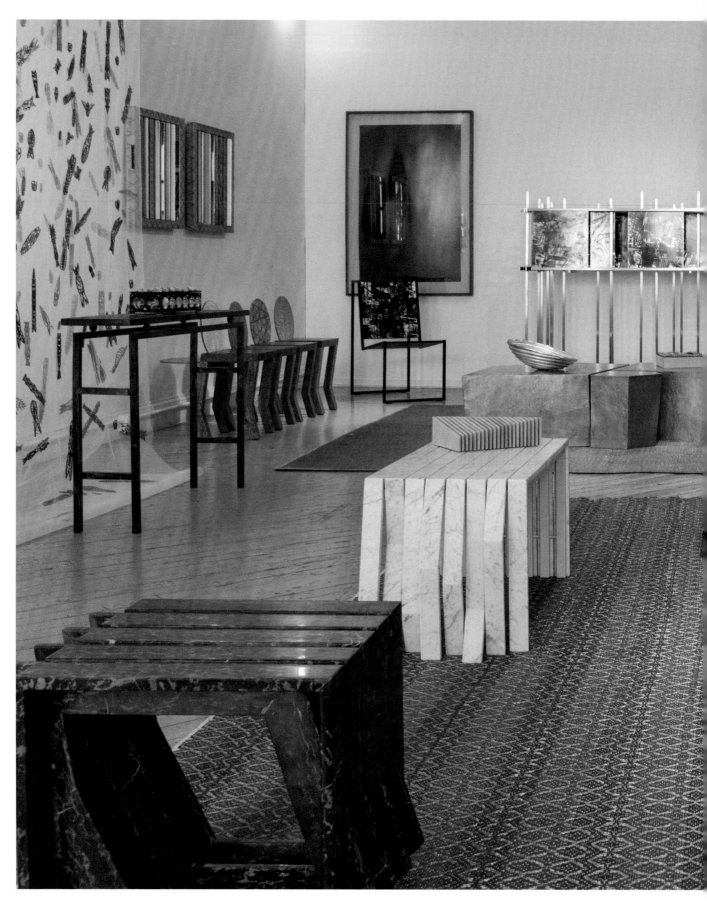

NIKKI, MUTT, 6 YEARS OLD. *LEFT*
STEVIE, MUTT, 3 YEARS OLD, *RIGHT*
CRISTINA GRAJALES GALLERY, SOHO

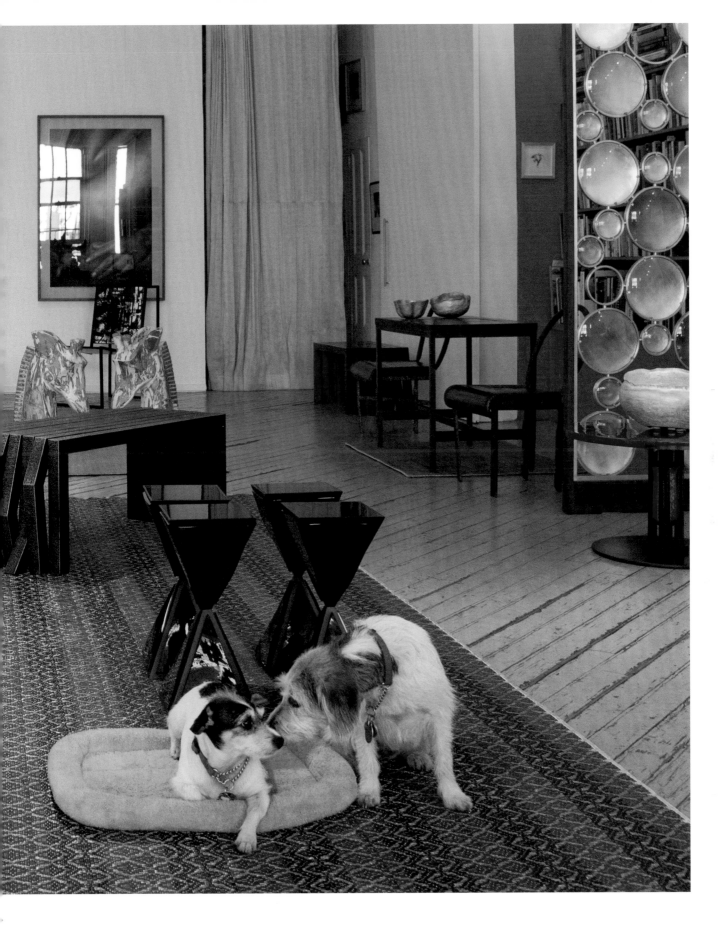

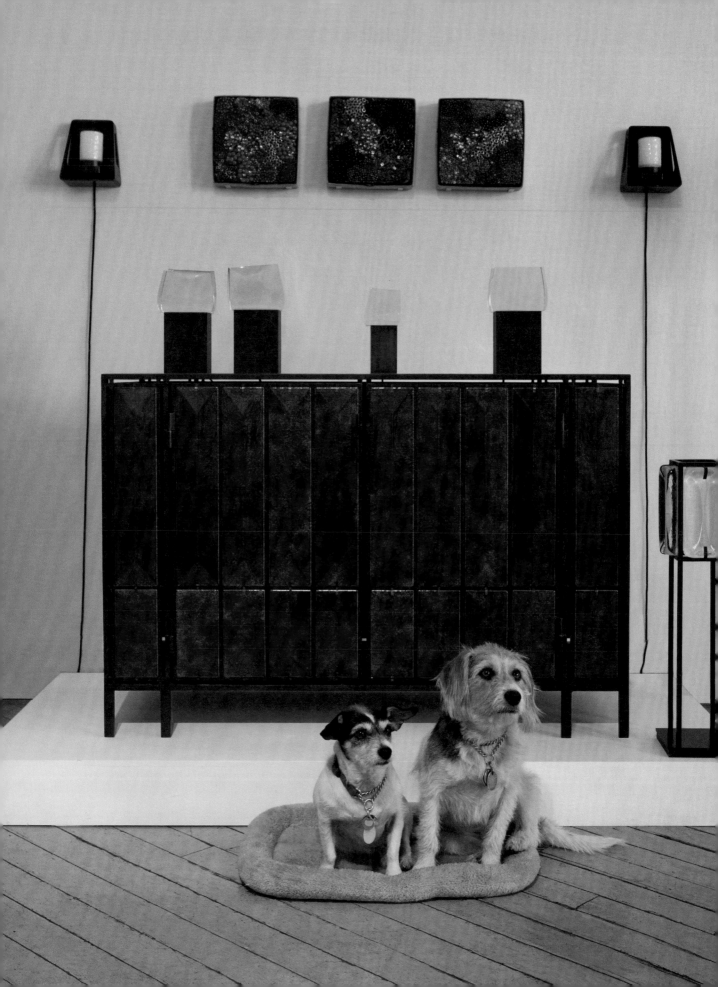

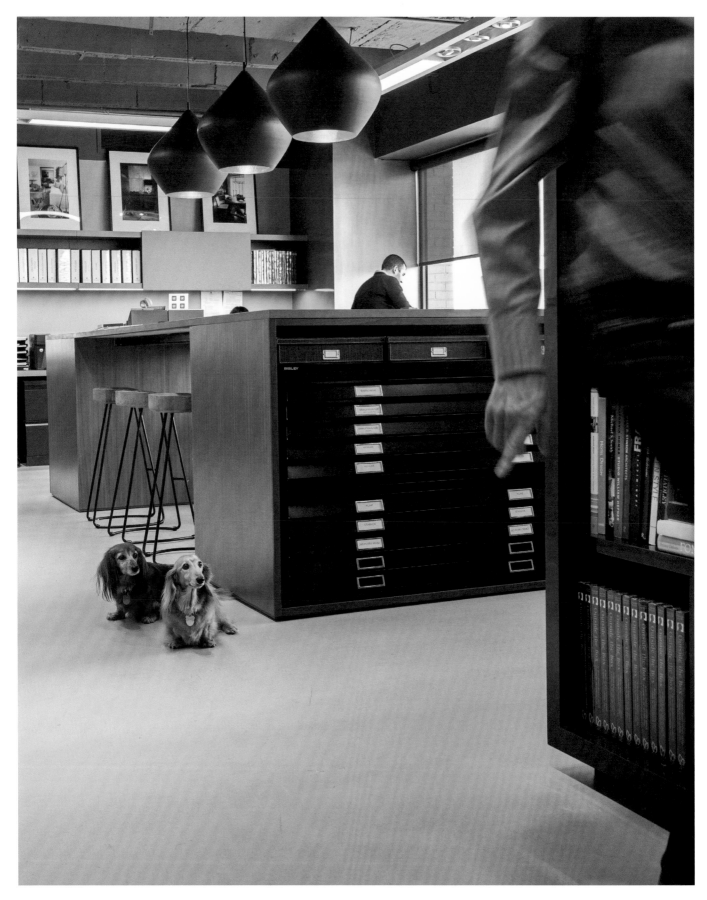

JOSIE, LONG HAIRED DACHSHUND, 14 YEARS OLD, *ABOVE LEFT*
ETHAN, LONG HAIRED DACHSHUND, 15 YEARS OLD, *ABOVE RIGHT*
DAVID SCOTT INTERIORS, INTERIOR DESIGN, MIDTOWN

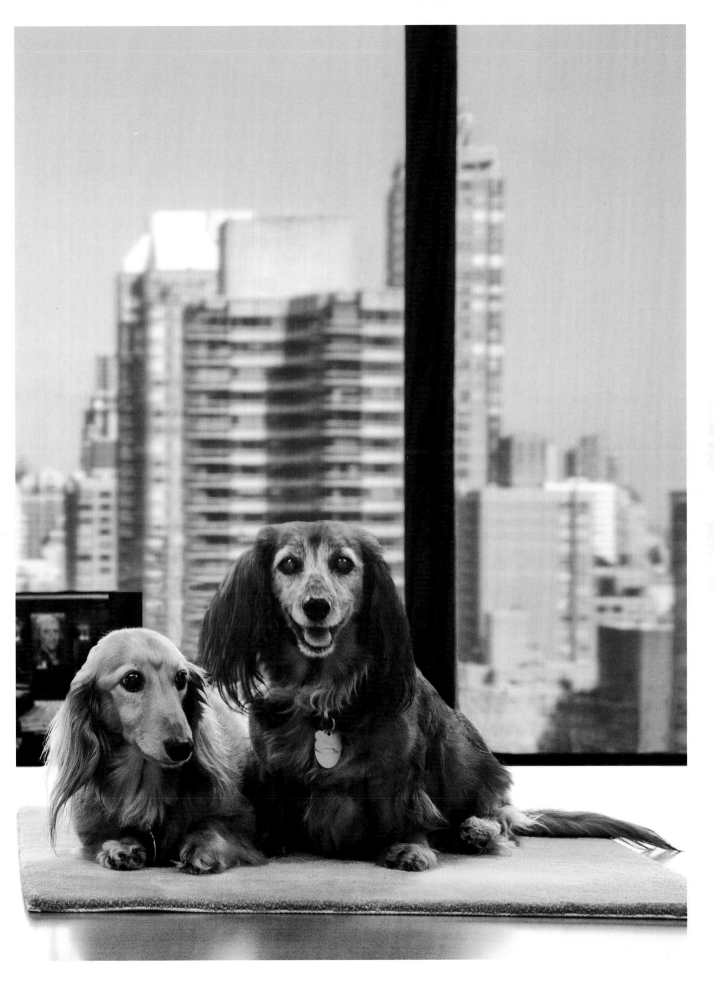

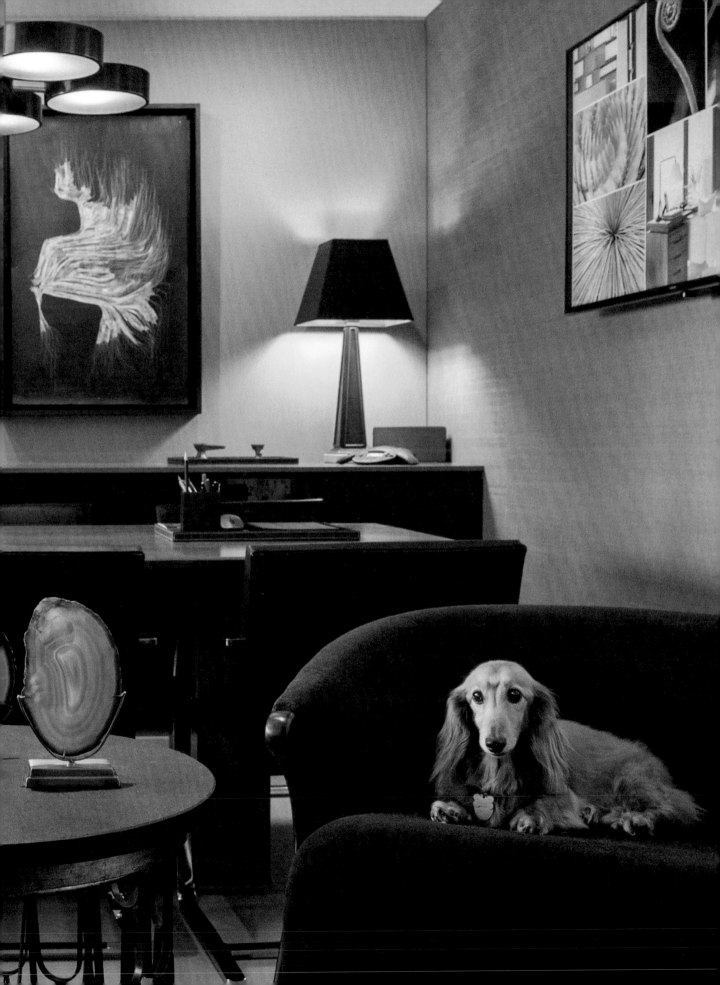

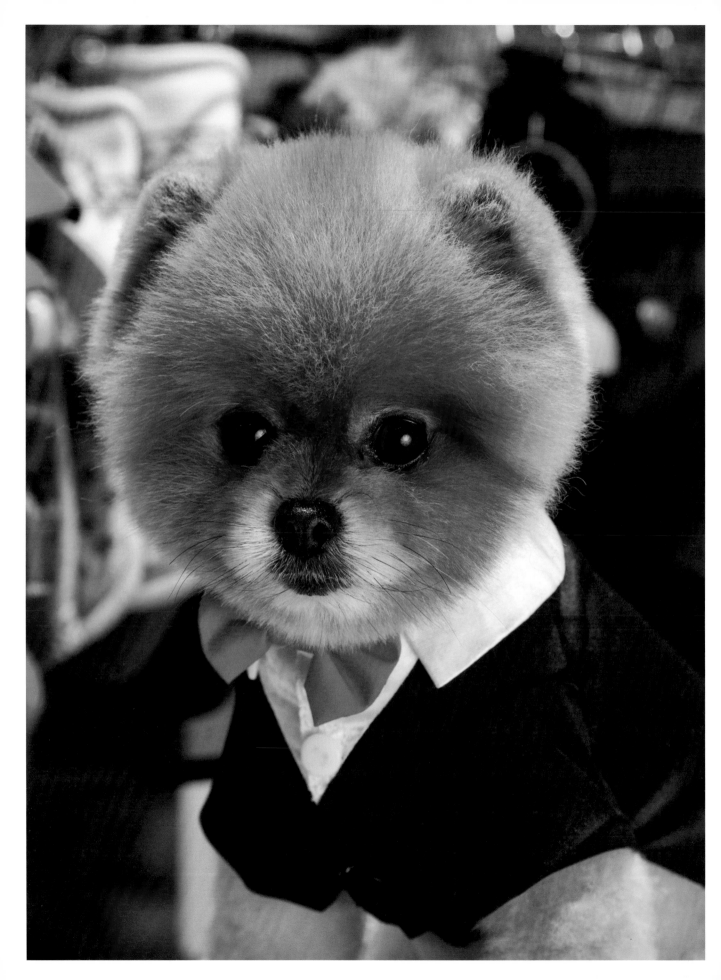

5

OFFICE MANAGERS

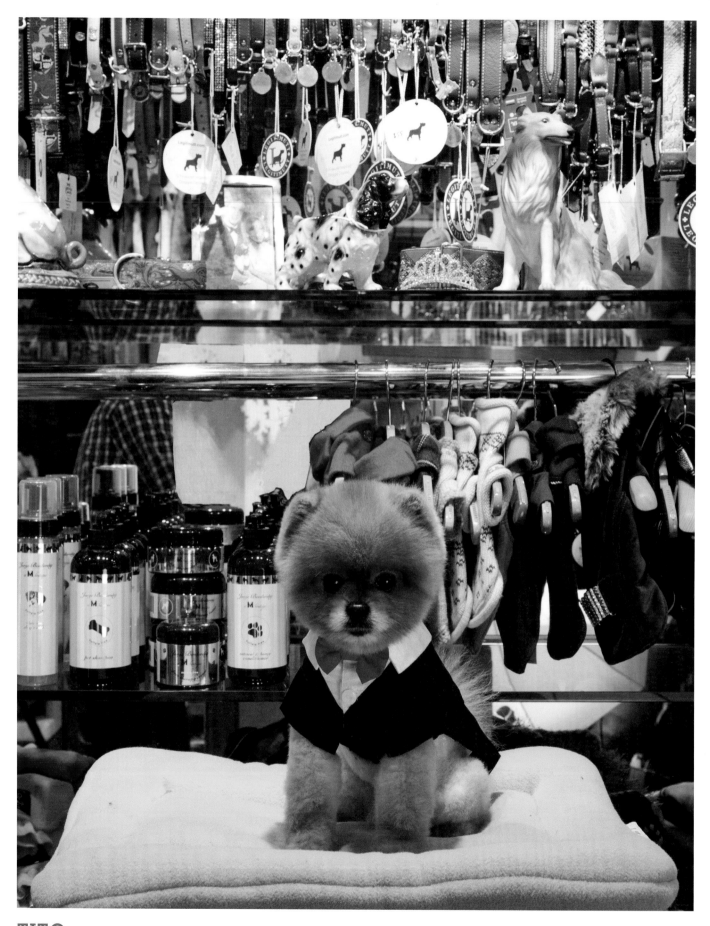

TITO, POMERANIAN, 2 YEARS OLD
PLANET JORGE / DOG GROOMER, ON LOCATION AT THE DOG STORE / GROOMING SALON, UPPER EAST SIDE

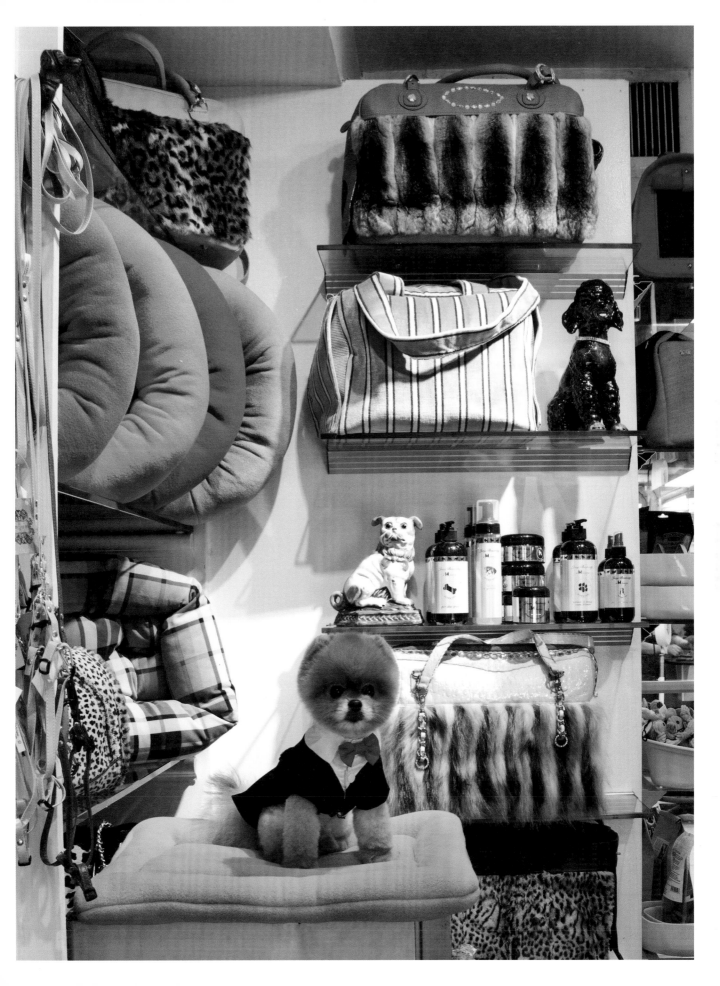

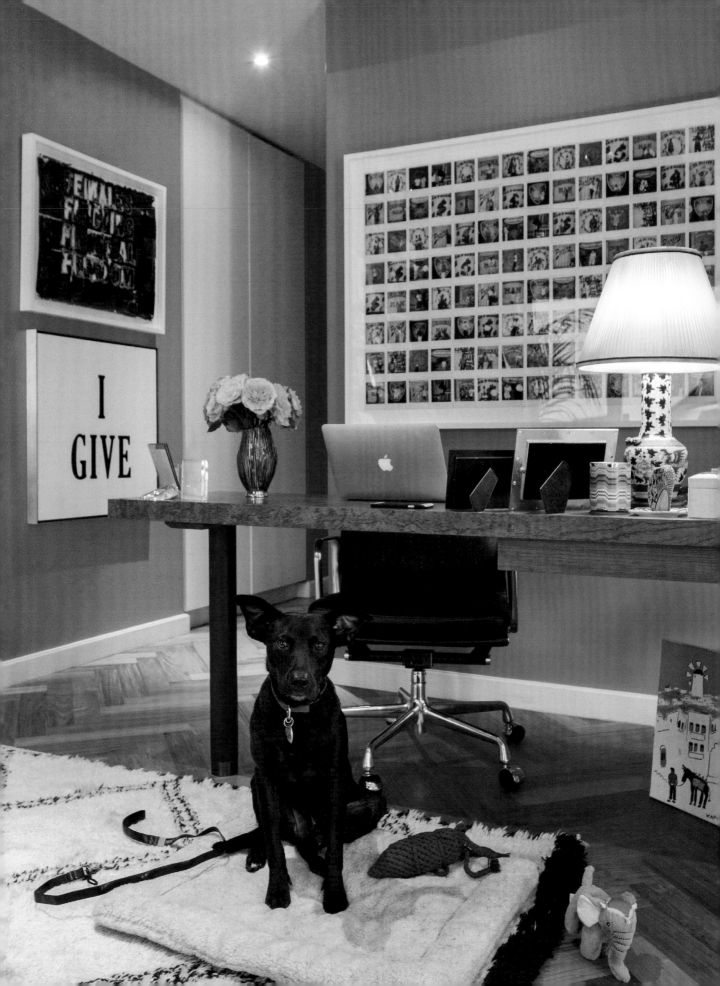

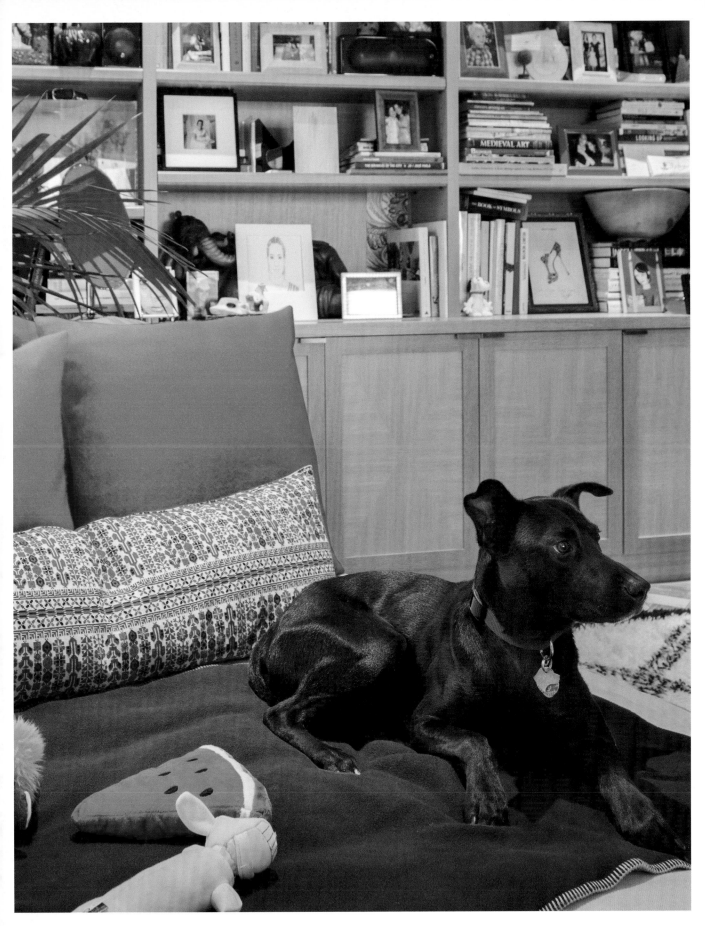

GEORGE, MUTT, 1 YEAR OLD
PIPPA COHEN, INDEPENDENT ART CONSULTANT AND CURATOR, WEST VILLAGE

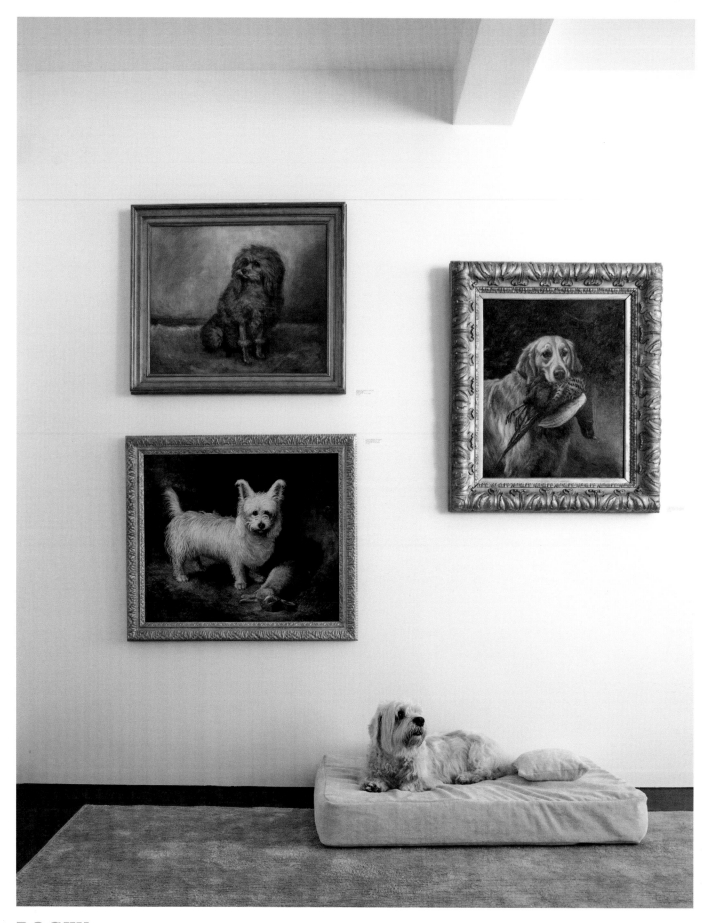

ROCKY, DANDIE DINMONT TERRIER, 11 YEARS OLD
WILLIAM SECORD GALLERY, CHELSEA

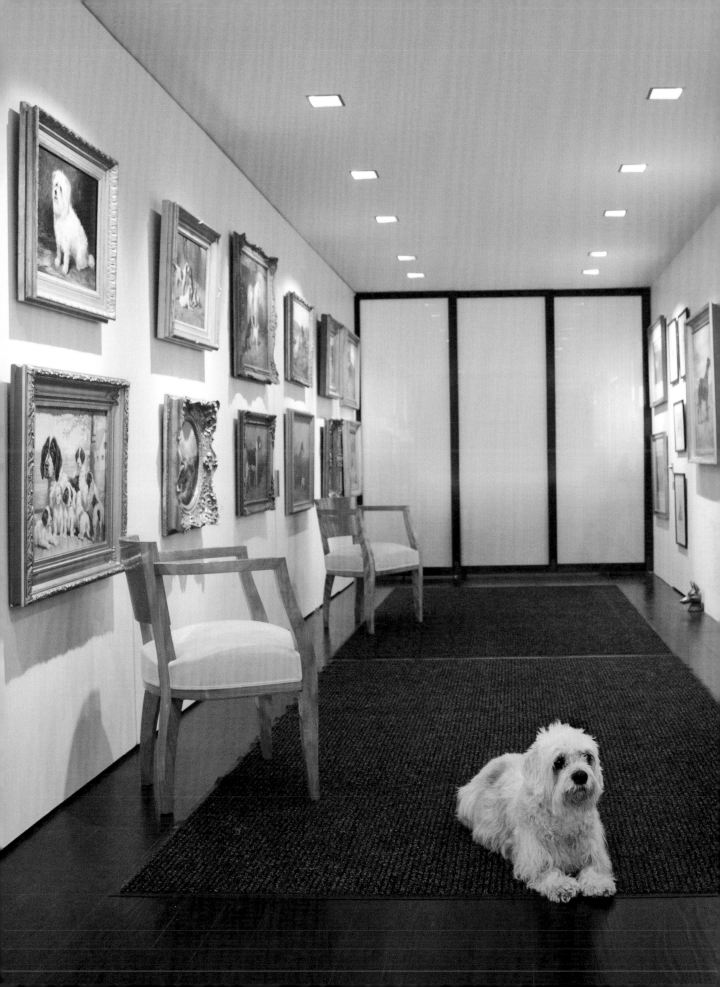

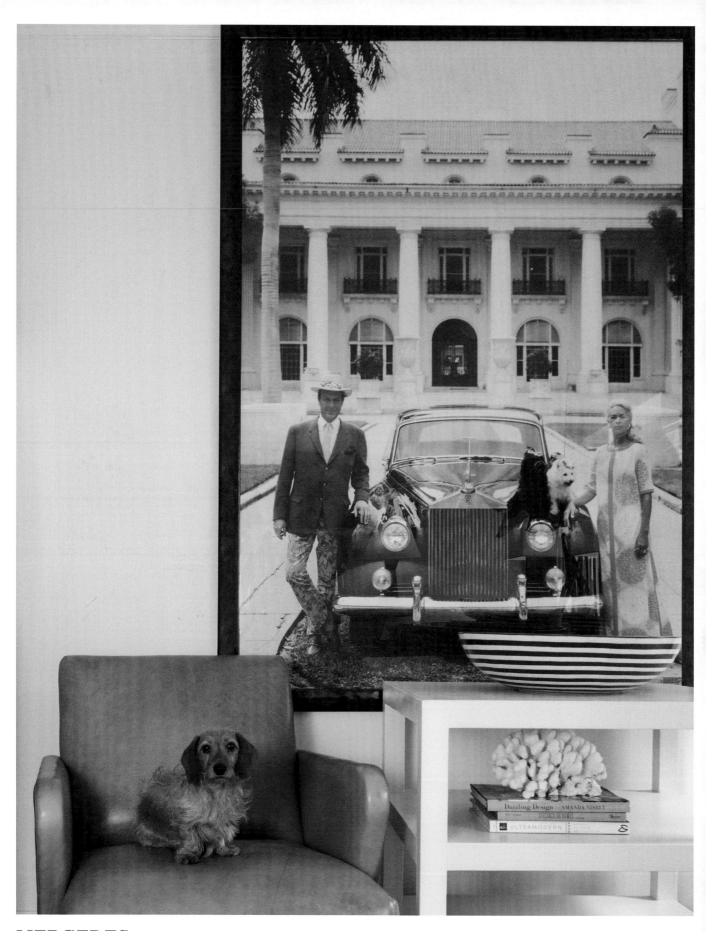

MERCEDES, WIRE HAIRED DACHSHUND, 1 YEAR OLD
MECOX GARDENS, ANTIQUE FURNITURE, UPPER EAST SIDE

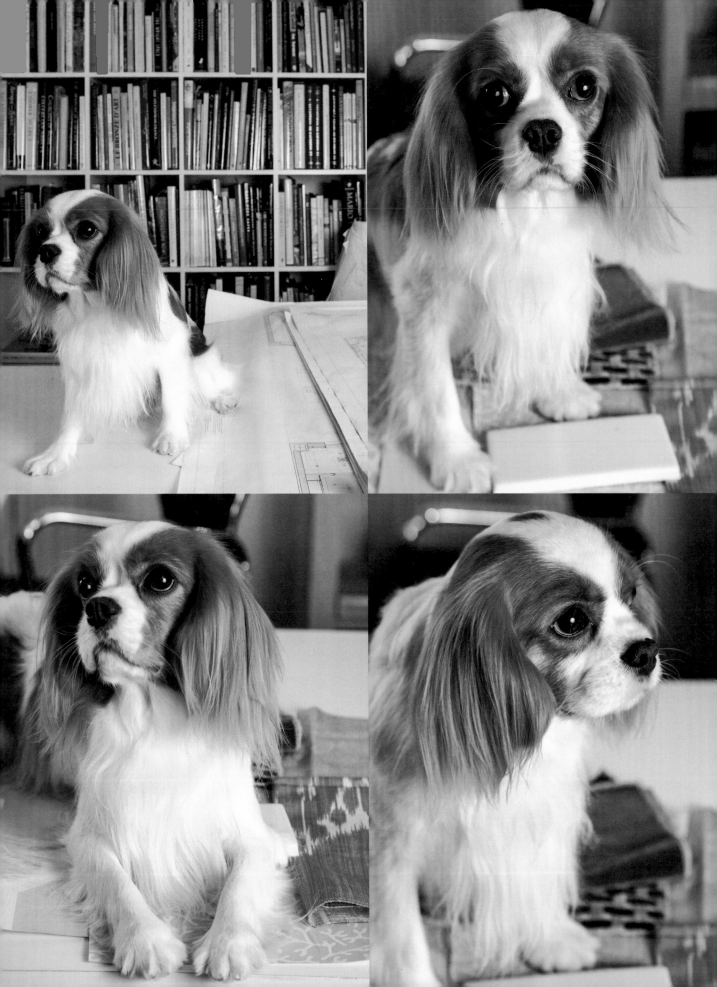

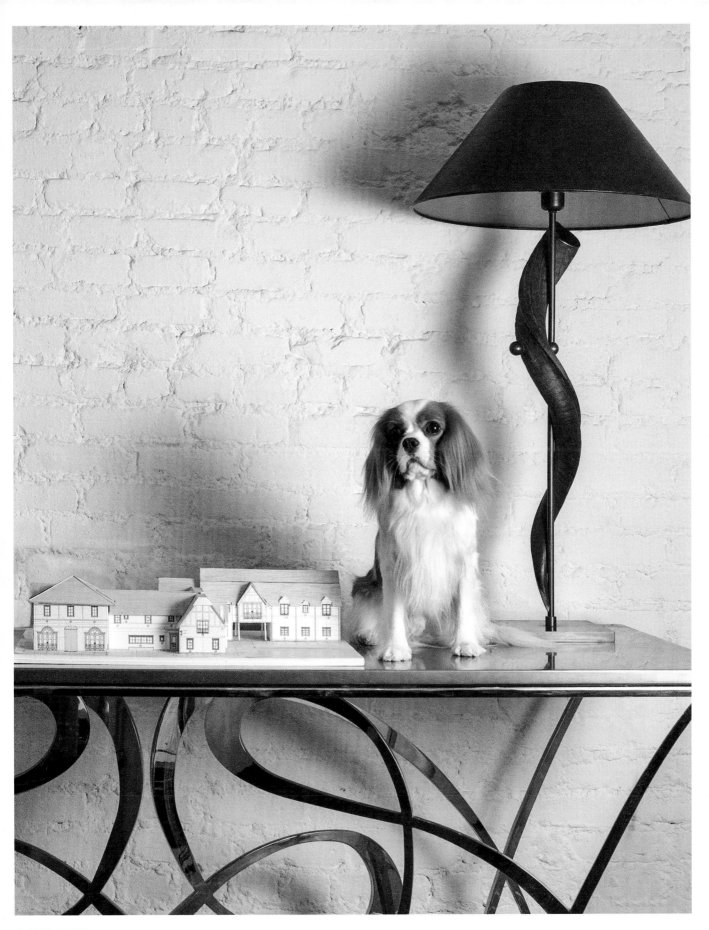

BUDDY, CAVALIER KING CHARLES SPANIEL, 3 YEARS OLD
COFFINIER KU DESIGN, INTERIOR DESIGN, MIDTOWN

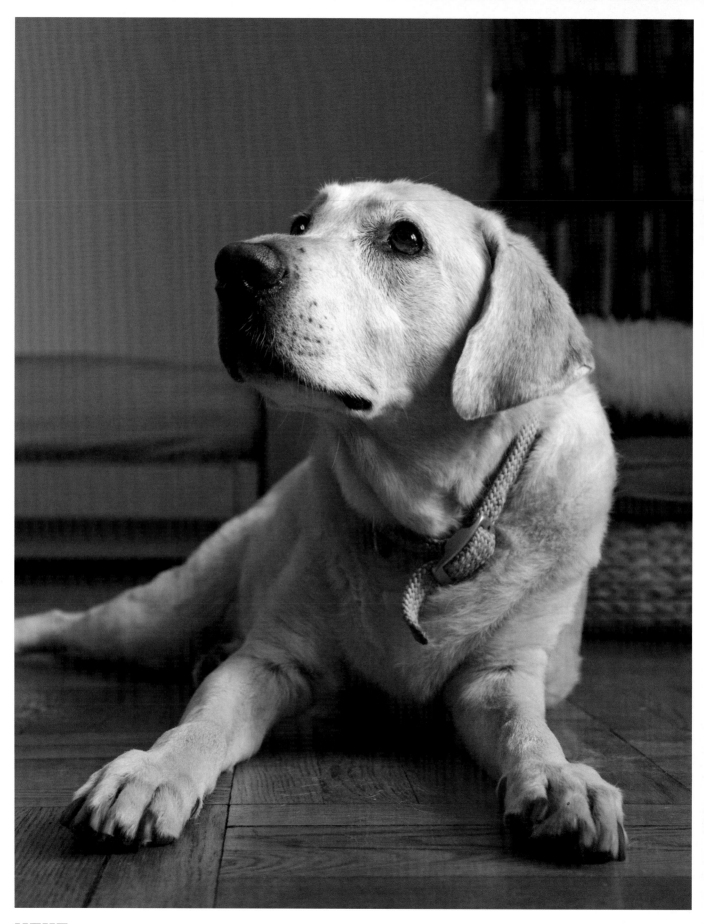

NEVE, YELLOW LABRADOR, 10 YEARS OLD
OGM-USA, PRINTER'S REPRESENTATIVE, ASTORIA

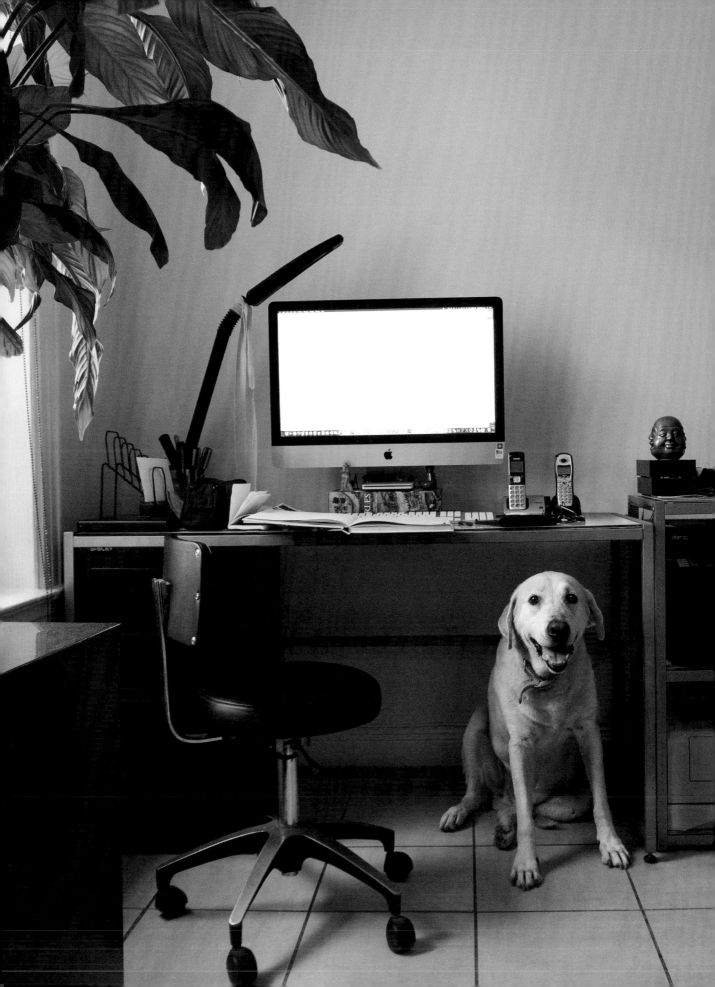

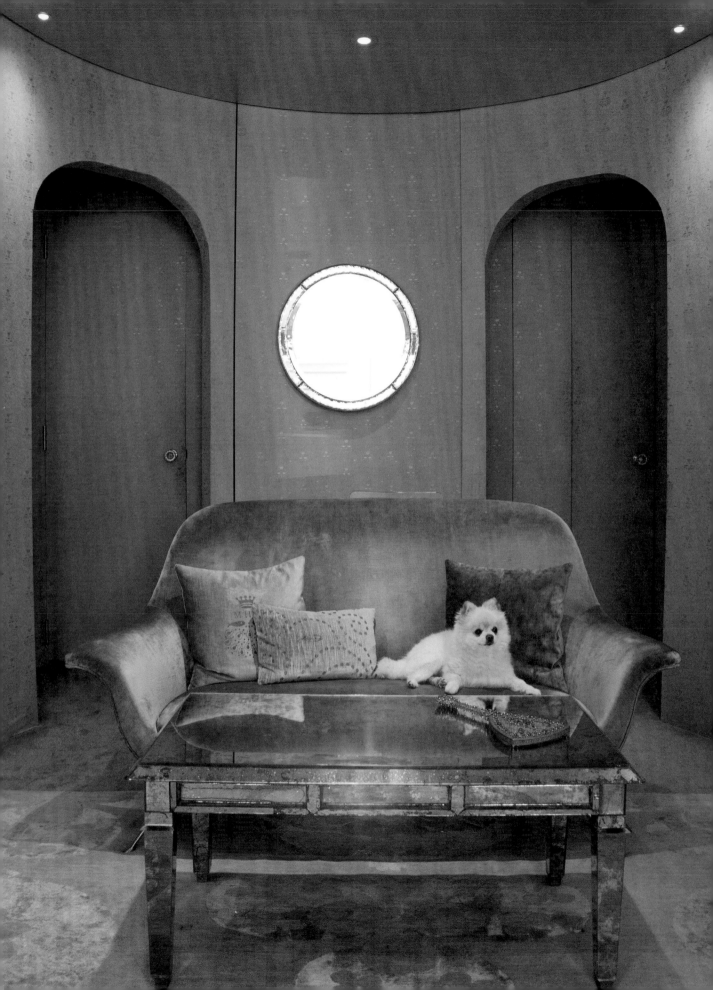

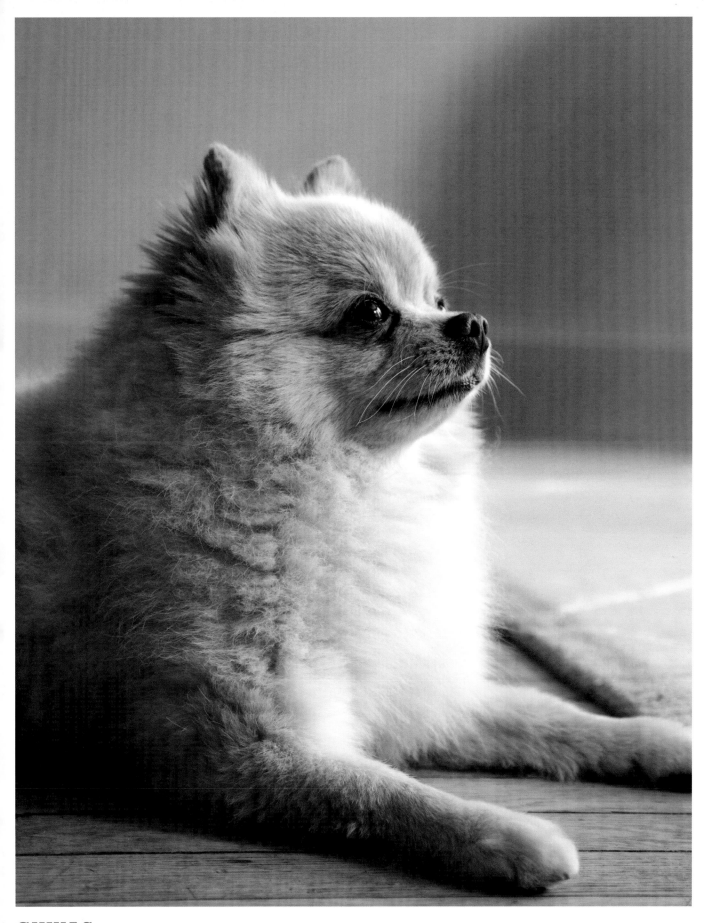

CHIVAS, TEACUP POMERANIAN, 6 YEARS OLD
MARIE HÉLÈNE DE TAILLAC, DESIGNER JEWELRY STORE, UPPER EAST SIDE

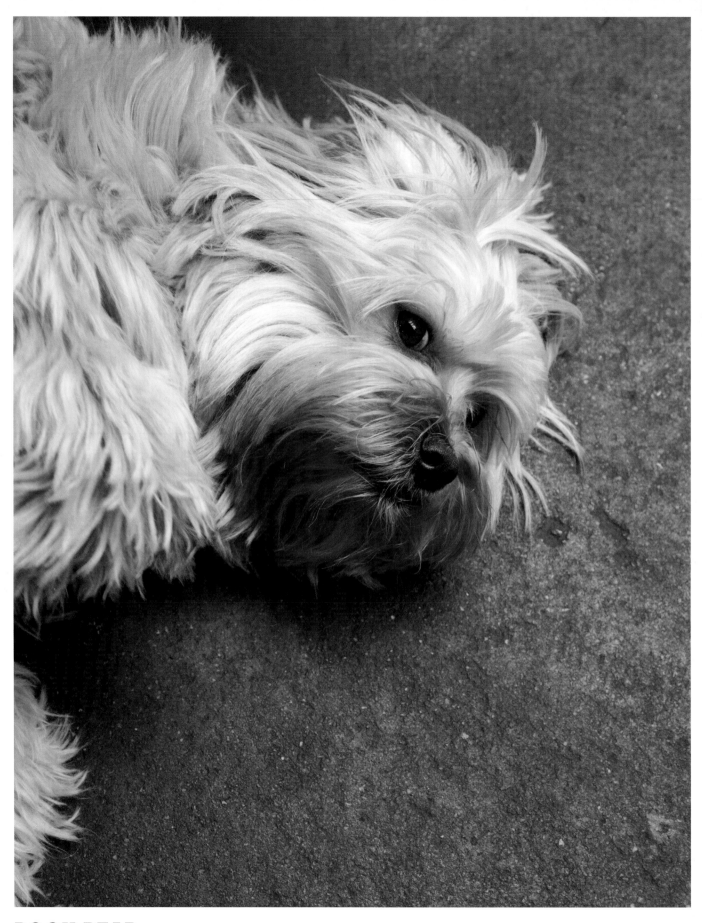

POOH BEAR, LHASA APSO MIX, 3 YEARS OLD
IZHAR PATKIN, ARTIST'S STUDIO, EAST VILLAGE

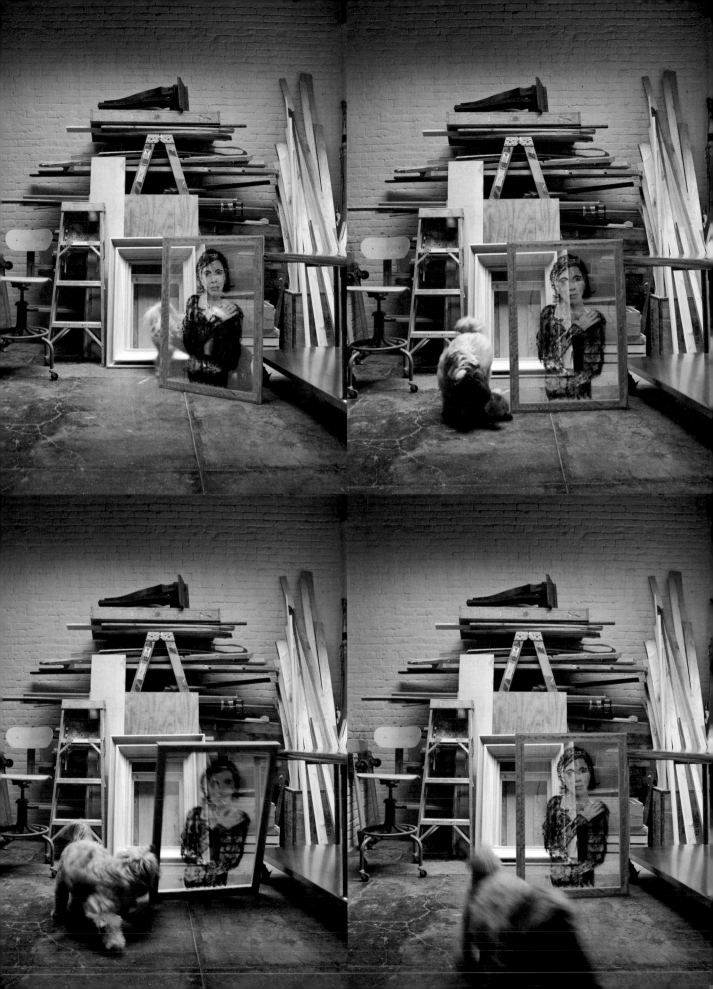

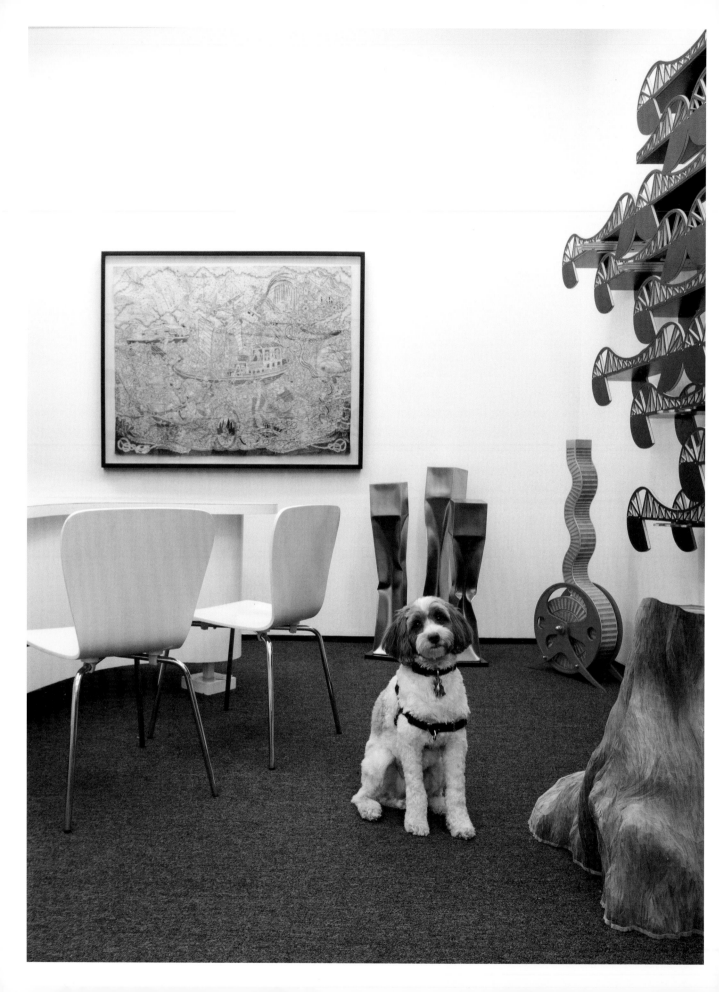

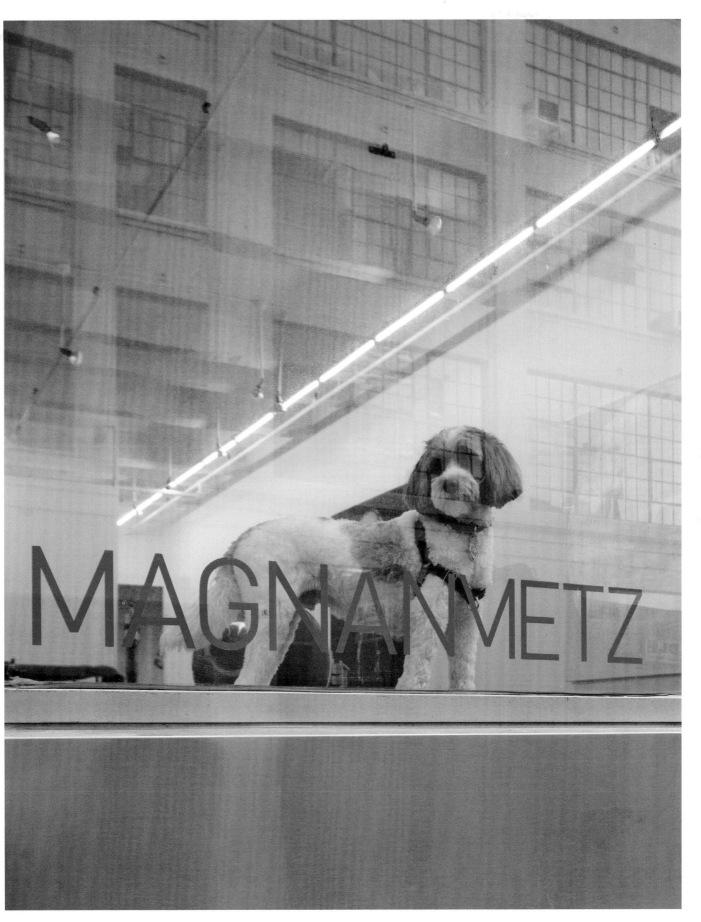

MARBLE, LABRADOODLE, 3 YEARS OLD
MAGNAN METZ GALLERY, CHELSEA

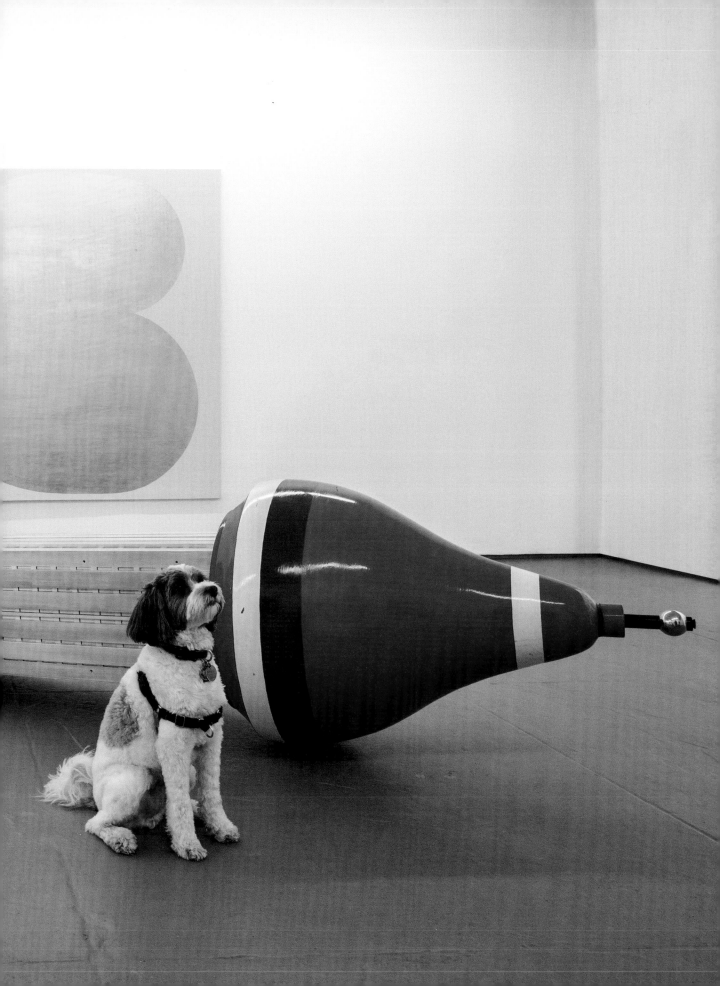

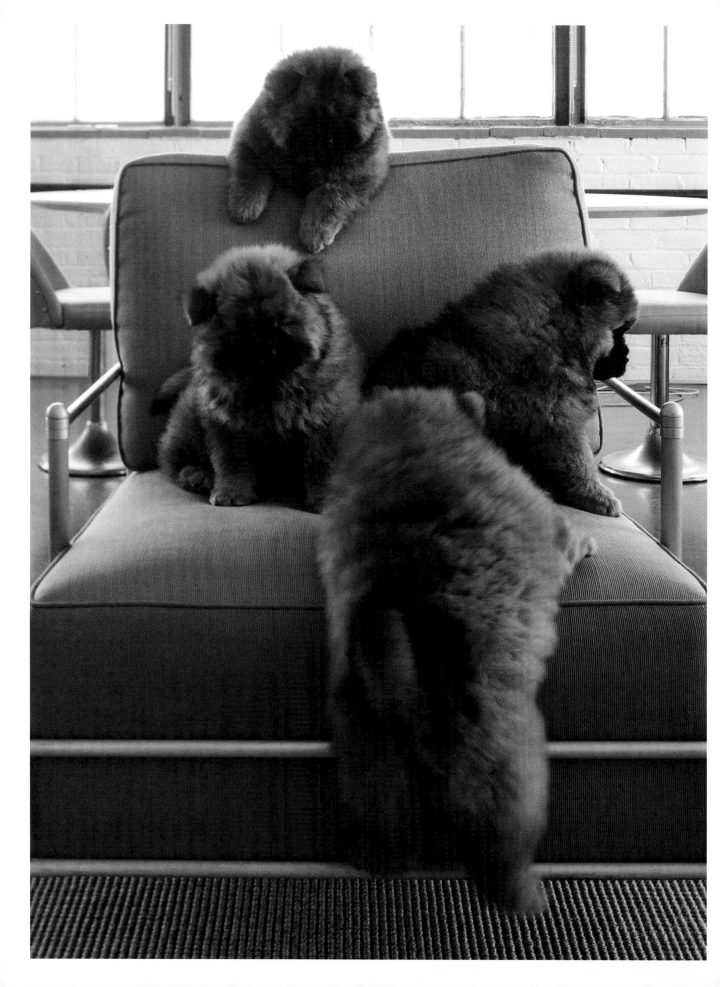

6 SECRETARIAL POOL

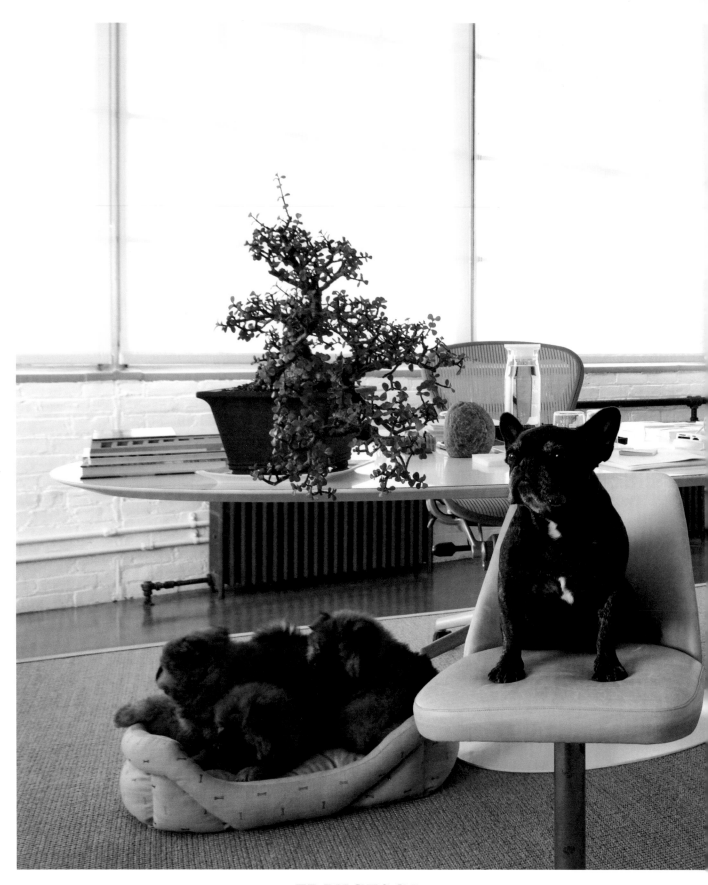

CHOW CHOW PUPPIES, YET TO BE NAMED, *ABOVE* FRANCESCA, FRENCH BULLDOG, 11 YEARS OLD,
ABOVE RIGHT SHARKEY, FRENCH BULLDOG, 10 YEARS OLD, *OPPOSITE LEFT*
GENGHIS KHAN, CHOW CHOW, 6 YEARS OLD, *OPPOSITE RIGHT*
MARTHA STEWART LIVING OMNIMEDIA, MEDIA AND MERCHANDISING COMPANY, CHELSEA

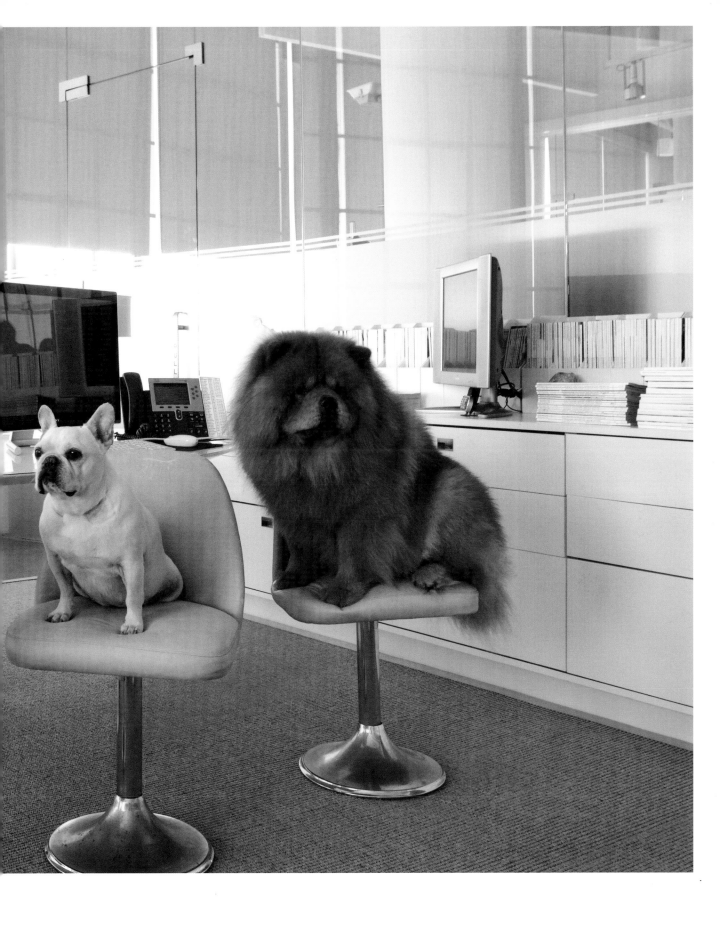

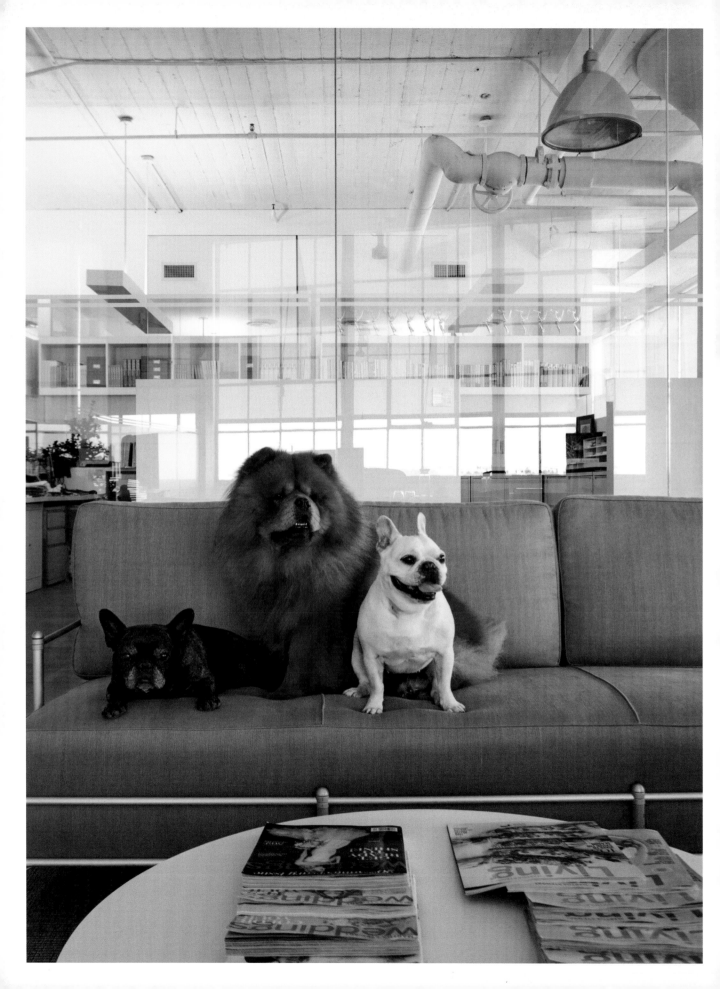

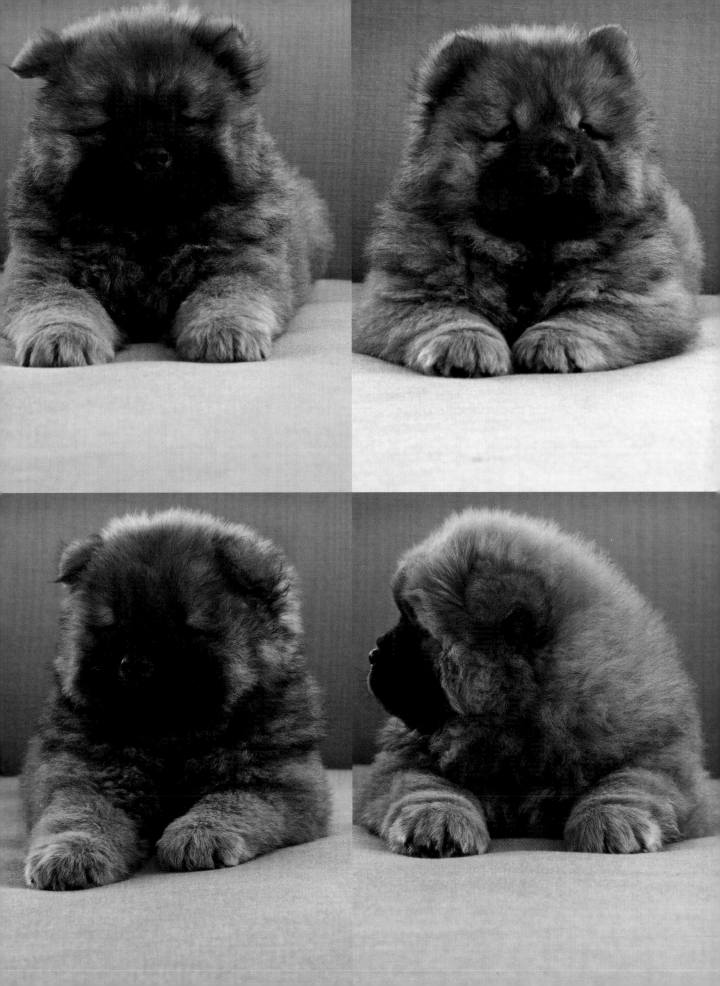

FRANK, ENGLISH BULLDOG, 3 YEARS OLD, *ABOVE* **ZUKE**, MUTT, 1 YEAR OLD, *OPPOSITE TOP*
MISSY, GOLDEN RETRIEVER, 2 YEARS OLD, *OPPOSITE CENTER* **CORKY**, BEAGLE / BLUETICK COONHOUND MIX,
3 YEARS OLD, *OPPOSITE BOTTOM* **PUMPKIN SCHMITZ**, YORKIEPOO, 9 YEARS OLD, *OVERLEAF, FAR LEFT*
SIR BENJAMIN BARKINGTON, MUTT, 2 YEARS OLD, *OVERLEAF, SECOND FROM LEFT*,
WITH FRANK, AND **FRANK**, MORGI, 3 YEARS OLD, *OVERLEAF, FAR RIGHT*
BARK & CO., PRODUCTS, MEDIA, AND EVENTS FOR DOGS AND DOG-LOVERS, CHINATOWN

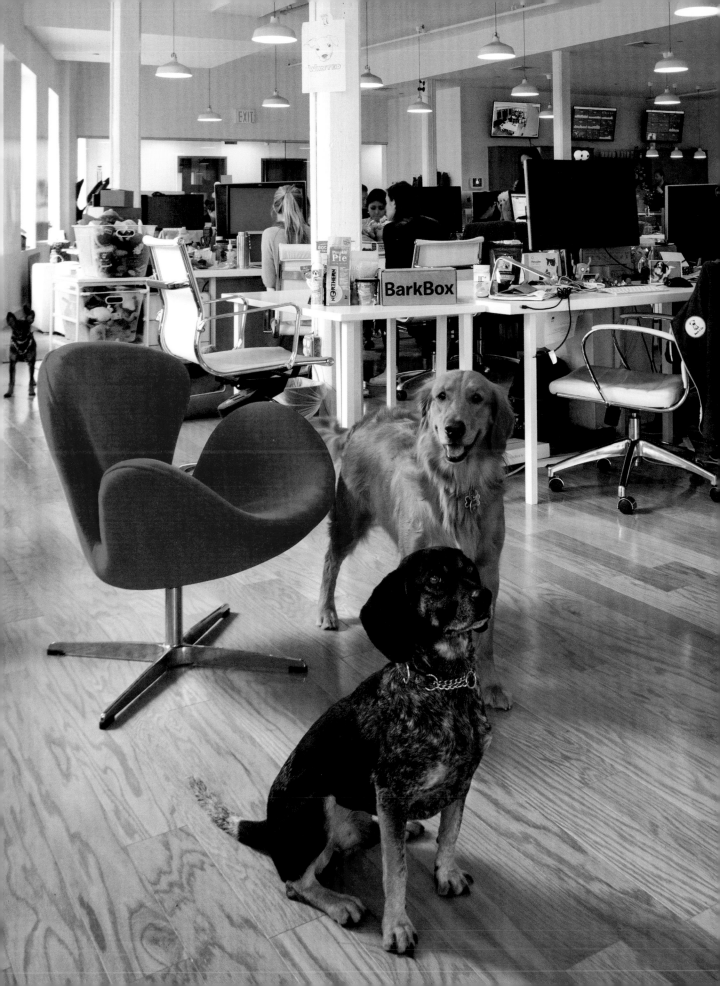

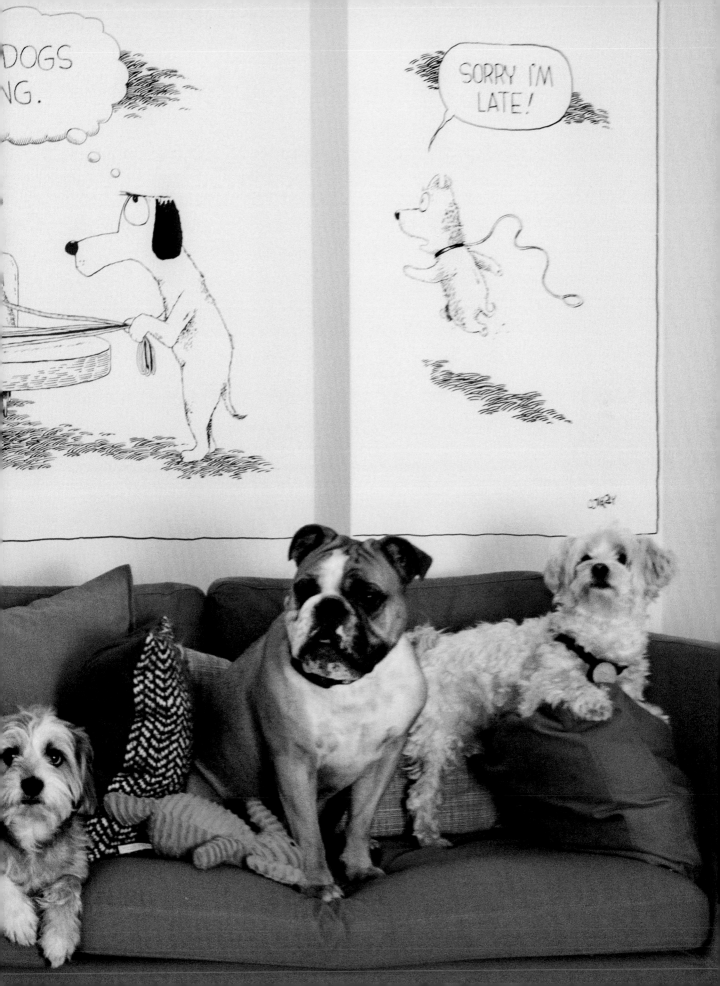

RICKY RHOADS, CHIHUAHUA, 4 YEARS OLD, *OPPOSITE TOP LEFT* **FRANK**, MORGI,
3 YEARS OLD, *OPPOSITE TOP RIGHT* **PIXEL**, SHEPHERD MIX, 1 YEAR OLD, *OPPOSITE BOTTOM LEFT*
ZIGGY, PITBULL / BLUETICK COONHOUND / GERMAN SHEPHERD MIX, 5 YEARS OLD, *OPPOSITE BOTTOM RIGHT*
BARK & CO., PRODUCTS, MEDIA, AND EVENTS FOR DOGS AND DOG-LOVERS, CHINATOWN

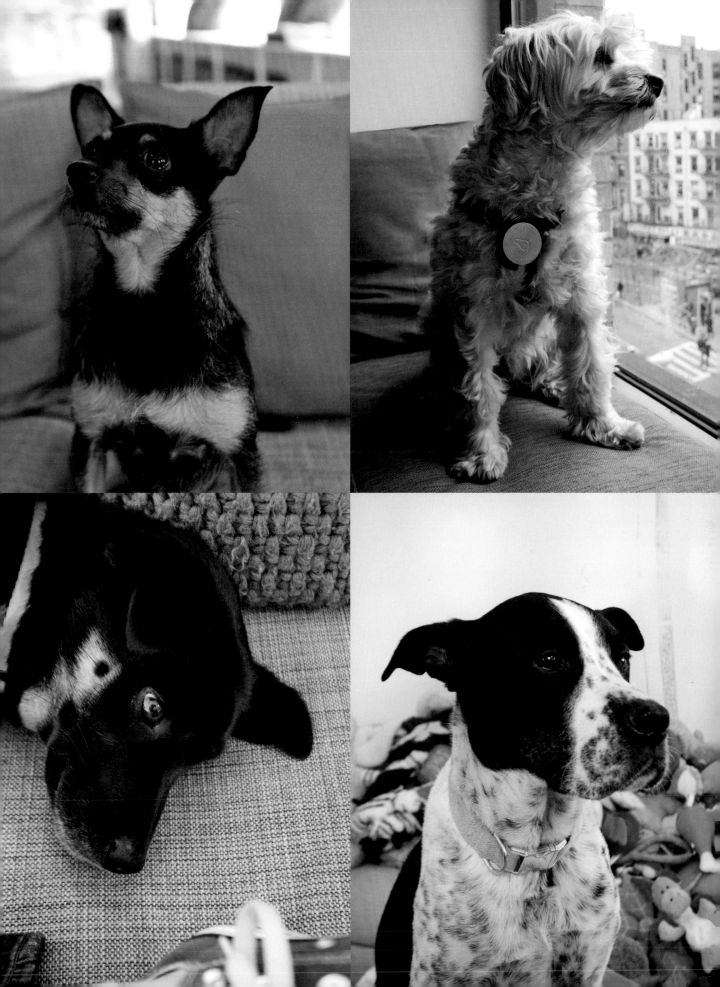

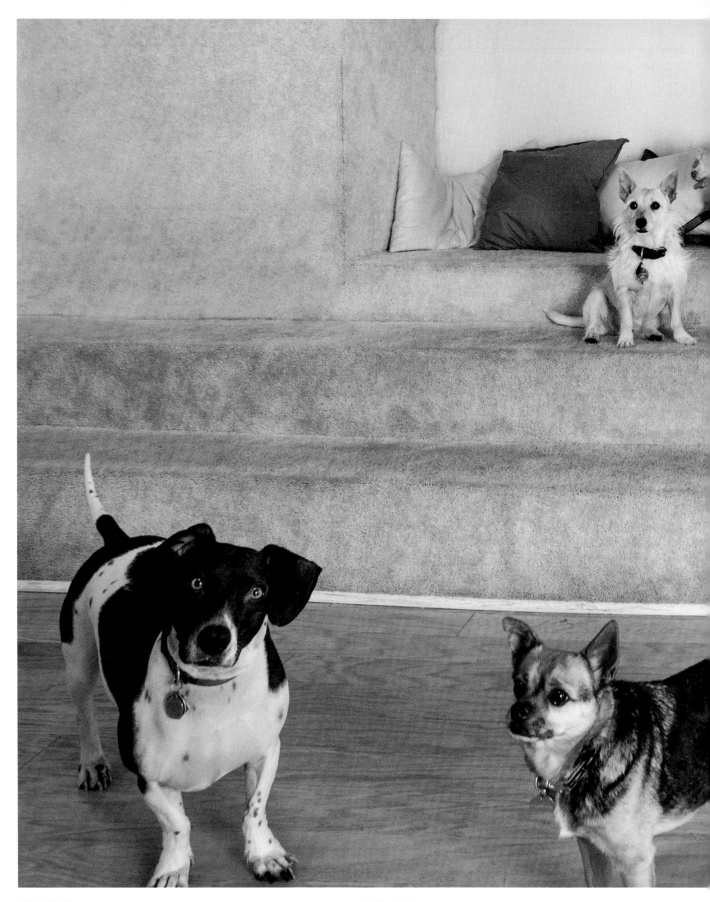

HANS, DACHSHUND / PITBULL MIX, 4 YEARS OLD, *ABOVE* **FIDEL**, CHIHUAHUA / JACK RUSSELL
TERRIER MIX, 10 YEARS OLD, *ABOVE RIGHT* **LOLA**, PORTUGUESE PODENGO PEQUENO, 2 YEARS OLD, *TOP RIGHT*
FRANCES, POODLE MIX, 2 YEARS OLD, *TOP CENTER*

ZIGGY, PITBULL / BLUETICK COONHOUND / GERMAN SHEPHERD MIX, 5 YEARS OLD, *TOP*
CORKY, BEAGLE / BLUETICK COONHOUND MIX, 3 YEARS OLD, *ABOVE*
BARK & CO., PRODUCTS, MEDIA, AND EVENTS FOR DOGS AND DOG-LOVERS, CHINATOWN

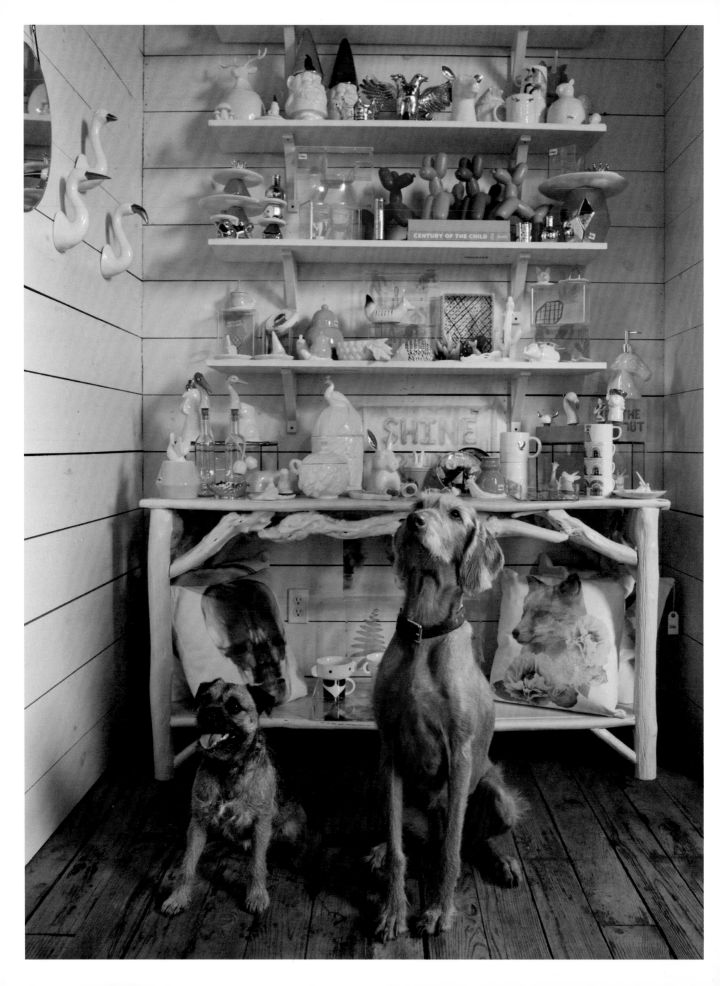

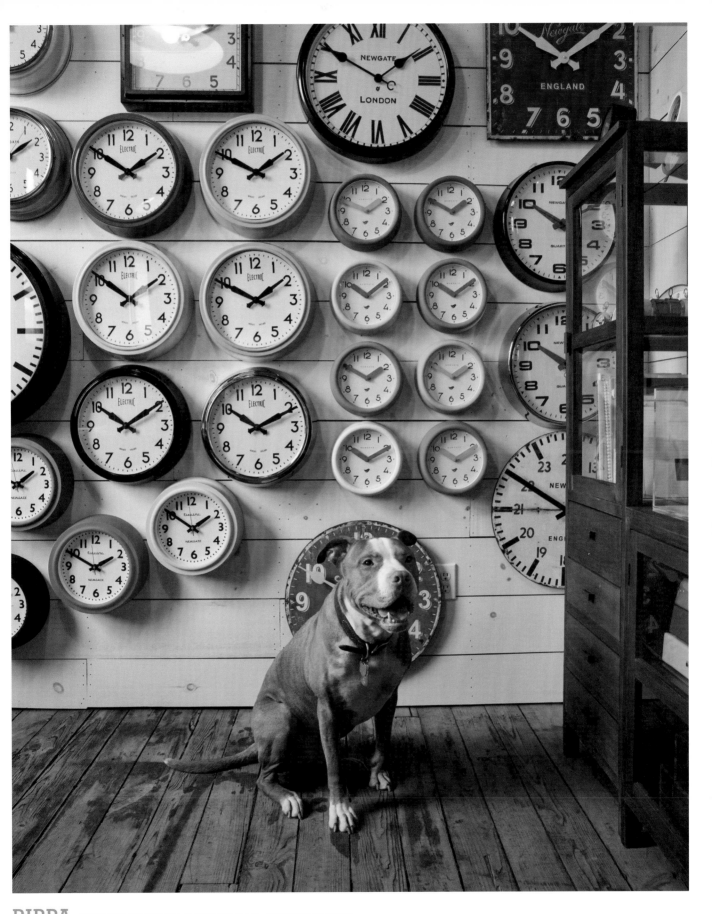

PIPPA, BORDER TERRIER, 3 YEARS OLD, *OPPOSITE LEFT*

EDIE, WIRE HAIRED LISZLA, 7 YEARS OLD, *OPPOSITE RIGHT* **DIGGY**, PITBULL, 3 YEARS OLD, *ABOVE*

AESTHETIC MOVEMENT, CREATIVE CONSULTANCY AND REPRESENTATION, LONG ISLAND CITY

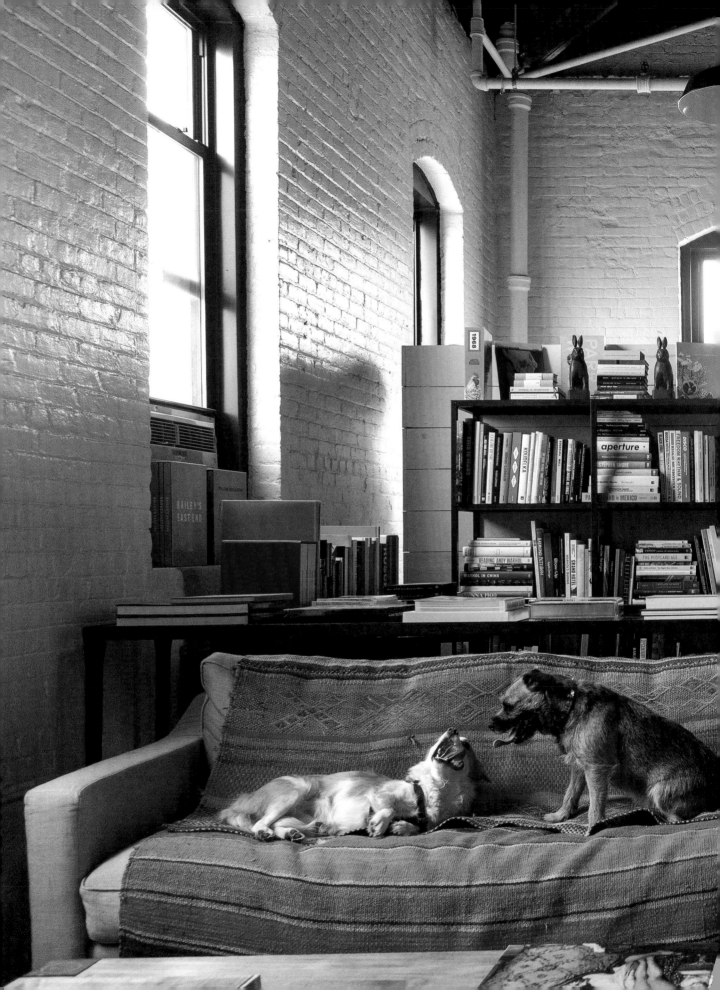

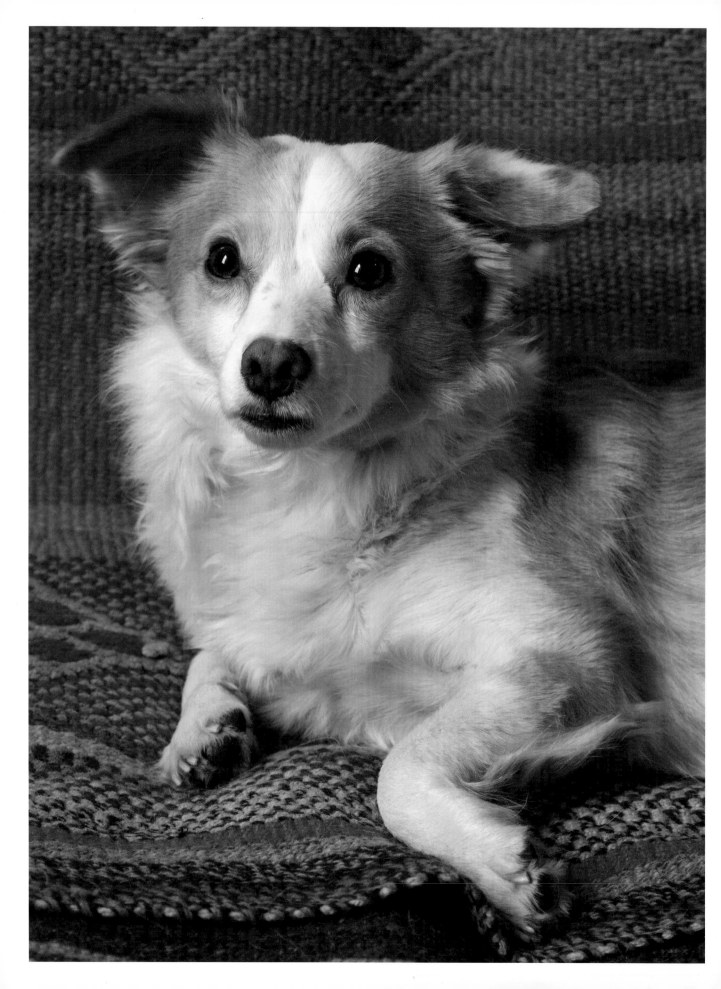

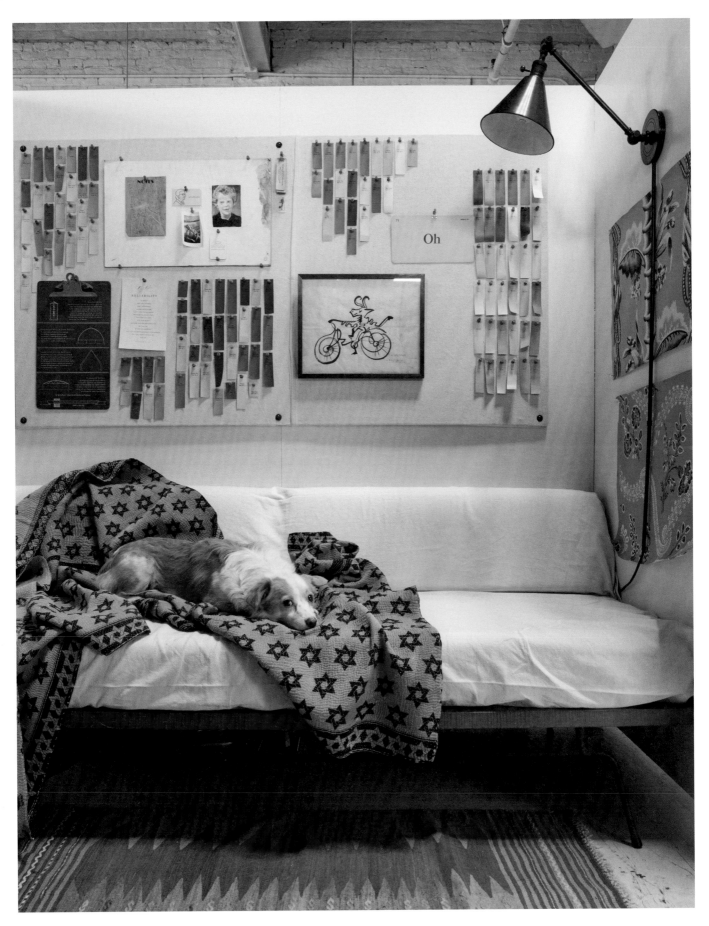

PICKLES, JACK RUSSELL TERRIER / AUSTRALIAN SHEPHERD / DACHSHUND MIX, 2 YEARS OLD
AESTHETIC MOVEMENT, CREATIVE CONSULTANCY AND REPRESENTATION, LONG ISLAND CITY

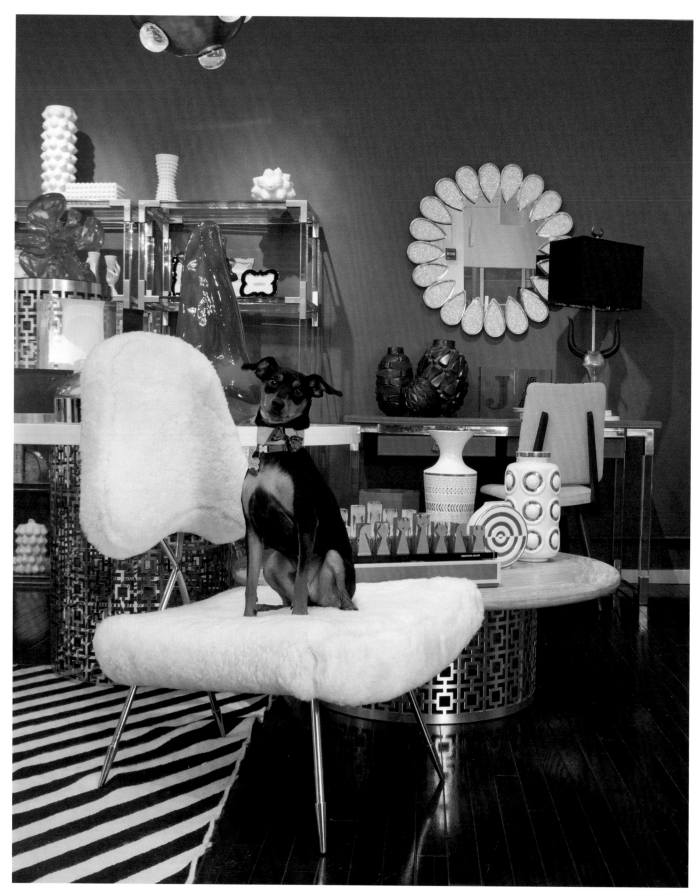

ROCCO, MINI PINSCHER, 2 YEARS OLD, *ABOVE* BONNIE, CHIHUAHUA / JACK RUSSELL TERRIER MIX, 4 YEARS OLD, *OPPOSITE LEFT* ALICE, FRENCH BULLDOG, 3 YEARS OLD, *OPPOSITE RIGHT*
JONATHAN ADLER HQ, MODERN FURNITURE AND MODERN DESIGN, WEST VILLAGE

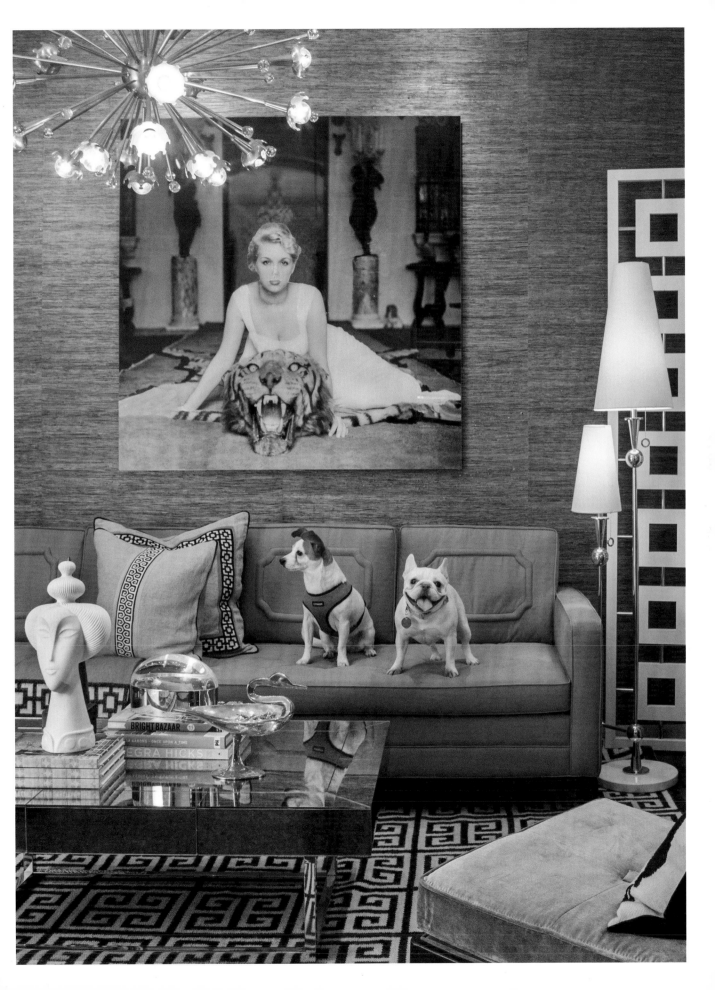

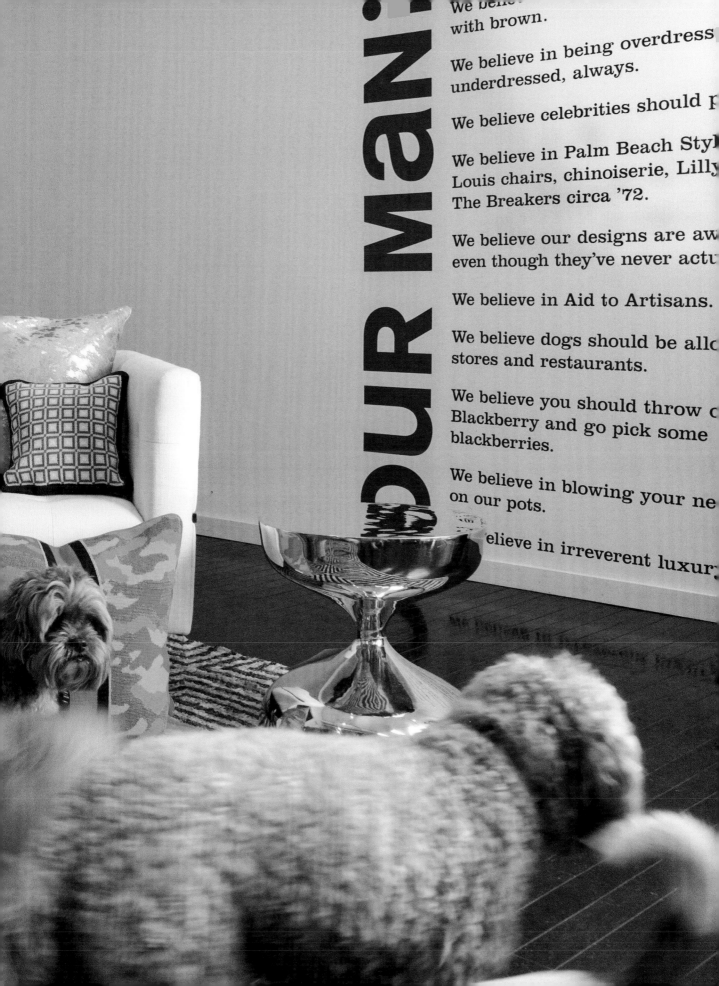

We believ[e] ... with brown.

We believe in being overdress[ed] ... underdressed, always.

We believe celebrities should [...]

We believe in Palm Beach Sty[le] ... Louis chairs, chinoiserie, Lilly ... The Breakers circa '72.

We believe our designs are aw[...] even though they've never actu[...]

We believe in Aid to Artisans.

We believe dogs should be allo[wed in] stores and restaurants.

We believe you should throw o[ut your] Blackberry and go pick some blackberries.

We believe in blowing your ne[...] on our pots.

[We b]elieve in irreverent luxur[y.]

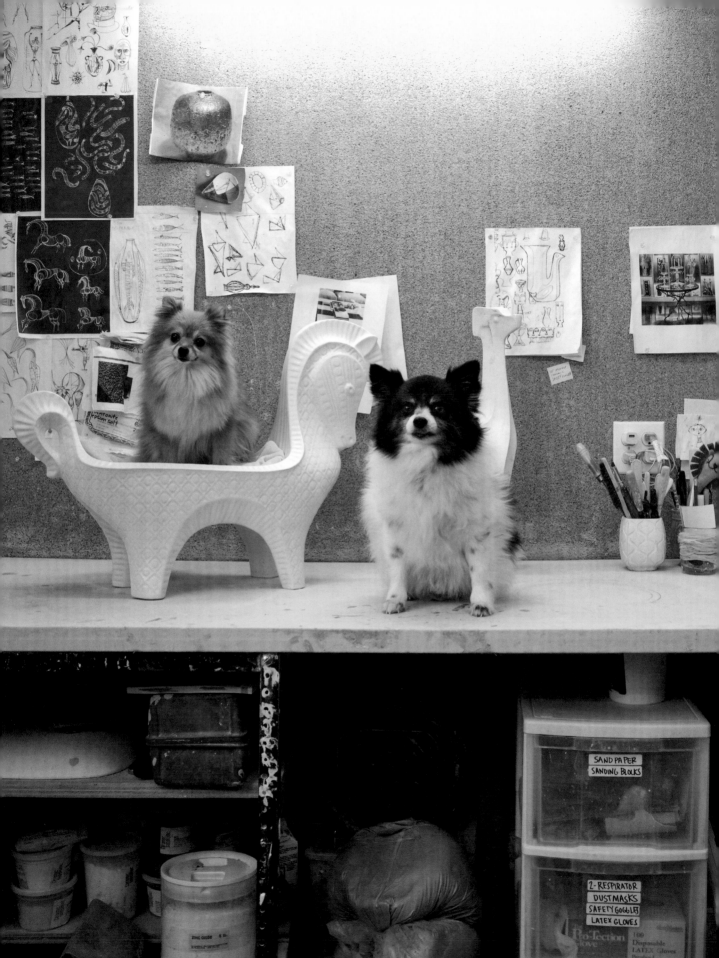

BELLE-FANGLES, CHIHUAHUA / POMERANIAN MIX, 8 YEARS OLD, *OPPOSITE LEFT*
BOOGIE PETER, PARTI POMERANIAN, 7 YEARS OLD, *OPPOSITE RIGHT*
JONATHAN ADLER HQ, MODERN FURNITURE AND MODERN DESIGN, WEST VILLAGE

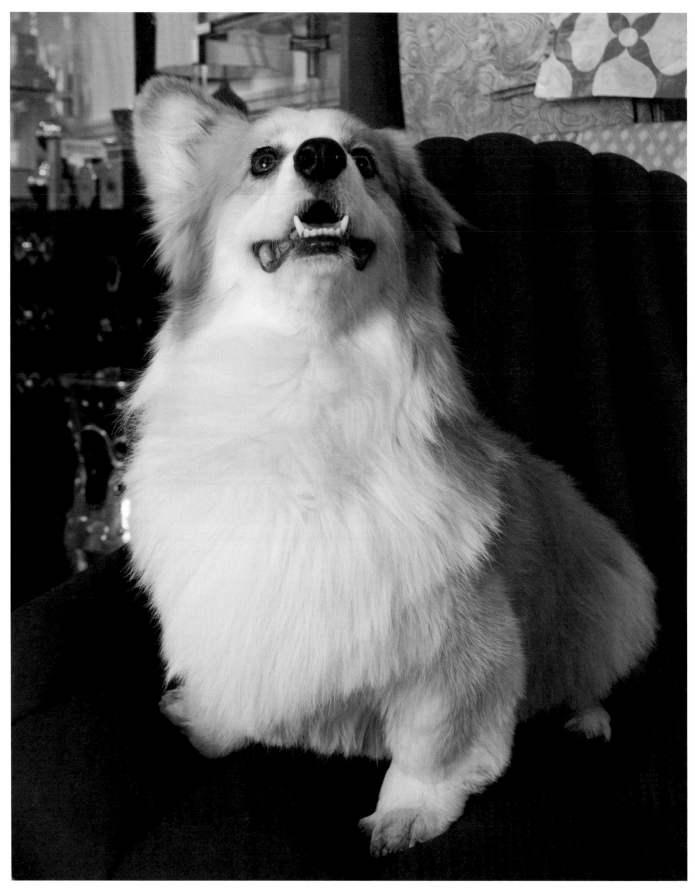

HENRY DOSS, FLUFFY PEMBROKE WELSH CORGI, 3 YEARS OLD, *ABOVE*
COOPER OREO SCHLESINGER BUBBS, SHIH TZU / POODLE MIX, 9 YEARS OLD, *OPPOSITE*
JONATHAN ADLER HQ, MODERN FURNITURE AND MODERN DESIGN, WEST VILLAGE

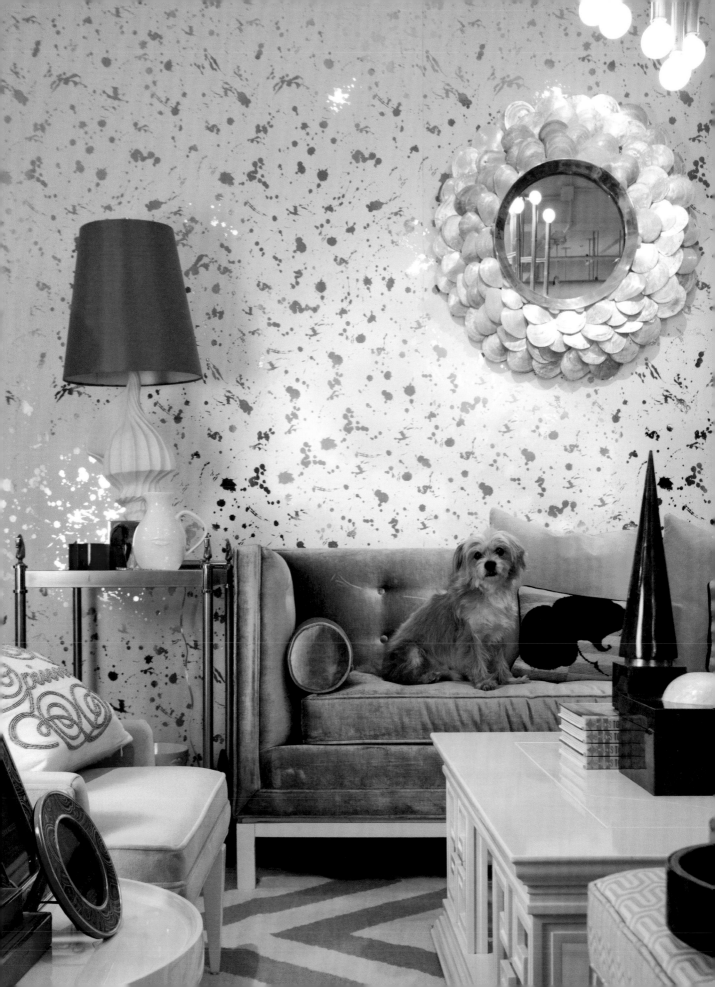

THE WORKPLACES

A Fair Shake for Youth, *122–123*
210 West 101st Street, Suite 7D
New York, New York 10025
917-371-9005
www.afairshakeforyouth.org

Aesthetic Movement, *4, 192–197*
Showroom & Design Studio
9-20 35th Avenue, Suite 3F
Long Island City, NY 11106
718-797-5750
www.aestheticmovement.com

AKT InMotion, *68–71*
244 East 84th Street, 4th Floor
New York, New York 10028
212-858-0305
www.aktinmotion.com

**Alan Wanzenberg Architect
& Design**, *104–105*
48 Miller Road
Ancram, NY 12502
212-489-7980
www.alanwanzenberg.com

Alex Papachristidis Interiors, *36–39*
300 East 57th Street, Suite 1C
New York, New York 10022
212-588-1777
www.alexpapachristidis.com

Alexis Rockman, *56–59*
www.alexisrockman.net

Architecture in Formation, *110–111*
526 West 26th Street, Suite 422
New York, NY 10001
212-714-1006
www.aifny.com

**Art-Dept, Illustration
Division**, *132–133*
420 West 24th Street, #1F
New York, NY 10011
212-243-2103
www.illustrationdivision.com

Barbara Toll Fine Arts, Inc., *72–75*
Barbara@btollarts.com

Bark & Co, *184–191*
www.bark.co

Brian J. McCarthy Inc., *44–47*
140 West 57th STrret, #5B
New York, NY 10019
212-308-7600
www.bjminc.com

**Camilla Dietz Bergeron
Ltd.**, *140–141*
818 Madison Avenue, 4th Floor
New York, NY 10065
212-794-9100
www.cdbltd.com

Coffinier Ku Design, *164–165*
249 East 57th Street, #2R
New York, NY 10022
212-715-9699
www.coffinierku.com

Cristina Grajales Gallery, *146–149*
152 West 25th Street, 3rd Floor
New York, NY 10001
212-219-9941
www.cristinagrajalesinc.com

David Monn LLC, *40–43*
135 West 27th Street, Suite 2
New York, NY 10001
212-242-2009
www.davidmonn.com

David Scott Interiors, *150–153*
150 East 58th Street, 25th Floor
New York, NY 10155
212-829-0703
www.davidscottinteriors.com

DuBois Architects, *76–77*
14 East 4th Street, Suite 508
New York, NY 10012
212-420-8600
www.boishaus.com

Found My Animal, *124, 126–127*
718-384-6203
www.foundmyanimal.com

Garren New York, *16, 18–19*
www.garrenny.com

Izhar Patkin, *170–173*
www.izharpatkin.com

Jed Johnson Associates, *7, 106–107*
32 Sixth Avenue, 20th Floor
New York, NY 10013
212-707-8989
www.jedjohnson.com

Jonathan Adler, *198–205*
www.jonathanadler.com

Julie Saul Gallery, *60, 62–65*
535 West 22nd Street
New York, NY 10011
212-627-2410
www.saulgallery.com

**jumP Media Productions
Agency**, *82–85*
625 Broadway, 8th Floor
New York, NY 10012
212-228-7474
www.jumpny.tv

Life Chiropractic, *142–145*
160 Broadway, Suite 1012
New York, NY 10038
212-425-5433
www.drlilawolfe.com

Lorin Marsh, *34–35*
979 Third Avenue, Suite 720
New York, NY 10022
212-759-8700
www.lorinmarsh.com

Lynch Tham Gallery, *86–87*
175 Rivington Street
New York, NY 10002
212-387-8190
www.lynchtham.com

**Madeline Weinrib
Showroom**, *98–103*
126 Fifth Avenue, 2nd Floor
New York, NY 10011
212-414-5978
www.madelineweinrib.com

Magnan Metz Gallery, *174–177*
521 West 26th Street
New York, NY 10001
212-244-2344
www.magnanmetz.com

Find your next "employee" through the American Kennel Club, or from one of the many organizations that help you adopt. Below, we have listed only a few of these wonderful places.

Animal Care and Control Center of New York www.nycacc.org
Animal Haven
www.animalhavenshelter.org
Animal Rescue Fund of the Hamptons (ARF)
www.arfhamptons.org
ASPCA
www.aspca.org
Brooklyn Animal Rescue Coalition (BARC)
www.barcshelter.org
Pet Adoption League of New York
www.petadoptleague.org
The Humane Society of New York
www.humanesocietyny.org
The SATO Project
www.thesatoproject.org

IN LOVING MEMORY OF ETHAN, JOSIE, ROCKY, AND ERNIE

WE'D LIKE TO THANK OUR GRACIOUS SUBJECTS FOR POSING PRO-BONE-O.

Pointed Leaf Press would also like to thank Michelle Rose for bravely taking on this project with us; Kelly Koester for coordinating the shoots and taking care of "hair and makeup"; Bashkim Dibra for writing the preface and taking such good care of our dogs when we are away; to the owners and staffs of all the offices we invaded during the workday; to all the "other moms and dads" of our wonderful subjects including Kostas Anagnopoulos, Bruce Bierman, Etienne Coffinier, Benoist Drut, Arthur Dunnam, Jim Dunning, Melissa Feldman, Steven Gambrel, Audrey Hendler, Michael Kaye, Leonard Kowalski, Ed Ku, Sherry Mandell, Joyce Marlow, Scott Nelson, Bethany Obrecht, Daniel Sager, Rino Varrasso, Scott Weston, and Peter Wilson. We are also grateful to our friends who led us to some of our star subjects. They include Suzanne Bressler, Elizabeth Cronk, Marion D. S. Dreyfus, Maureen Footer, Steven Learner, Wendy Newman, Scott Sanders, Michael Steinberg, and Elaine Wrightman.

MICHELLE ROSE was born and raised in the mountain community of Richwood, West Virginia, where she sold her motorcycle to purchase her first 35mm camera. For the past 20 years she has been living and working in New York, most recently photographing projects for the renowned architect Alan Wanzenberg. Her work has been published in *Architectural Digest*, *Architectural Digest Germany*, *Elle Decor*, *The Wall Street Journal*, and the *New York Times*. Her photographs have been included in *Nice House* (The Monacelli Press), *Journey: The Life and Times of an American Architect* by Alan Wanzenberg (Pointed Leaf Press), and *Tile Makes the Room: Good Design by Heath Ceramics* (Ten Speed Press.) *K9–5: New York Dogs at Work* is her first monograph.

Midwesterner **KELLY KOESTER** graduated from the University of Iowa with a major in art history, and soon thereafter packed up and moved to New York for an internship at *ARTnews*. In 2013, she joined Pointed Leaf Press as an assistant editor. This is her first independent publishing project.

BASHKIM DIBRA is an internationally known pet expert, celebrity dog trainer, and author of numerous books. *StarPet: How to Make Your Pet a Star* is his most recent publication.

PUBLISHER/EDITORIAL DIRECTOR **SUZANNE SLESIN** CREATIVE DIRECTOR **FREDERICO FARINA**

WWW.POINTEDLEAFPRESS.COM

PRINTED AND BOUND IN ITALY. FIRST EDITION

ISBN: 978-1-938461-30-9 LIBRARY OF CONGRESS CONTROL NUMBER: 2015953705